GLORIA

GLORIA

ALLORA & CALZADILLA

Lisa D. Freiman

U.S. Commissioner
54th International Art Exhibition — La Biennale di Venezia

Essays by
Lisa D. Freiman, Carrie Lambert-Beatty,
and Yates McKee

Indianapolis Museum of Art

DelMonico Books · Prestel Munich London New York

For Amy Aaland, 1962–2011

and Ramón Luis Lugo, 1955–2011

In Memoriam

FOREWORD

The Indianapolis Museum of Art is deeply honored to support the installation in the United States Pavilion at the 54th International Art Exhibition — La Biennale di Venezia. Thanks to the imagination and perseverance of Dr. Lisa Freiman, IMA's senior curator and chair, Department of Contemporary Art, the artistic duo of Jennifer Allora and Guillermo Calzadilla has created an exciting, challenging, and groundbreaking experience for the hundreds of thousands of visitors who will tour the pavilion in Venice this summer and fall.

The origins of the Biennale may be traced to a quest for national identity. The desire to celebrate the silver anniversary of King Umberto and Queen Margherita of Savoy yielded what would in effect metamorphose into an art competition, the Biennale di Venezia, in 1895, a year before the relaunch of a sports competition, the modern Olympic Games, in Athens. Both initiatives were aimed at codifying nationhood, though from very different claims on authority. In the case of Greece, the claim rested on the ancient heritage of Hellas and the burnishing of a storied past of athletic competition that brought strife and warfare to a halt, at least temporarily. In the case of Italy, which became a unified country in 1861 (and is celebrating its 150th anniversary this year), the impulse was the opposite. Rather than lionizing the Savoy dynasty with a monument or festival harking back to the glorious past of ancient Rome, the decision was made to launch a recurring opportunity for the world to experience the art of the present moment by means of an international invitational that would become the world's leading art exhibition. Despite the great transformations that have occurred since then, interestingly enough, our world has not changed very much in one cardinal

respect: the nationalistic spectacles of the Olympics and the Biennale have a persistent subtext in the glorification of national identity and the export of new talent to a finite place and time on the world stage.

Allora & Calzadilla have very successfully mined the terrain of nationhood in a variety of ways, which is precisely why they were commissioned to create new work in Venice, a signal opportunity that allowed them to turn the dial up very high in a claim on our collective attention. The integration of civic and corporate insignia and symbols in the realms of combat, commerce, and competition is the powerful, whimsical subject of the United States Pavilion for the first time. In a period when fledgling democracy movements have sprouted unexpectedly and forcefully in different parts of the world, it is bracing and comforting that the U.S. Department of State is willing to stand behind an art installation that so directly investigates the manifestations of American national identity around the world, and that a midwestern museum is the one to promote this investigation.

On behalf of the IMA's Board of Governors, staff, and volunteers, I thank all of those involved in the presentation of these powerful works of art. It is our hope that the 54th International Art Exhibition will be remembered as an occasion when the United States' cultural identity helped people around the world see contemporary America as a beacon of free expression, truly open to debate and self-examination.

Maxwell L. Anderson

The Melvin & Bren Simon Director and CEO
Indianapolis Museum of Art

ACKNOWLEDGMENTS

In the fall and winter of 2009, Jennifer Allora, Guillermo Calzadilla, and I developed a detailed proposal to submit to the U.S. Department of State and the National Endowment for the Arts' Federal Advisory Committee on International Exhibitions (FACIE), which resulted in the remarkable works on view in the U.S. Pavilion at the 54th International Art Exhibition — La Biennale di Venezia. I am grateful to all of the people involved in that competitive and complex process, including Pennie Ojeda, Anita Decker, and the FACIE committee. In the Department of State's Bureau of Educational and Cultural Affairs, Alan Cross and Veronica R. Thompson worked diligently throughout the development and execution of this exhibition to ensure its success.

Gloria is the result of countless talented individuals' ingenuity, openness, and fierce determination, and I am indebted to Jennifer Allora and Guillermo Calzadilla for partnering with the Indianapolis Museum of Art on this ambitious, unprecedented project. Their work is an intelligent and provocative response to the challenges and necessity of free speech. I am grateful to Richard Armstrong, director, Solomon R. Guggenheim Foundation and Museum, and Philip Rylands, director, Peggy Guggenheim Collection (PGC), and to all of the PGC staff, especially Chiara Barbieri, manager of publications and special projects. Chiara's knowledge of the U.S. Pavilion and the Venice Biennale has made her a generous collaborator who knows how to resolve any predicament. Additional thanks go to Roger Zuccolo, IT and technical coordinator; Elena Minarelli, manager for education; and Anita Todesco, education assistant. The PGC's consulting architect, Giacomo di Thiene/Studio Architetti di Thiene, was an integral part of exhibition planning, ensuring that the pavilion did not collapse under the weight of a 60-ton tank, a 500-pound bronze statue, and a 6-ton ATM/pipe organ. Thanks also to David Mees, cultural attaché, and the U.S. Embassy in Rome.

At the IMA, a team of individuals has tirelessly overseen this project. First and foremost, I owe an infinite amount of gratitude to Maxwell L. Anderson, The Melvin and

Bren Simon Director and CEO, for granting me permission to throw my hat in the ring for Venice and for sharing my conviction that this was an important opportunity for the museum and for the history of art more broadly. His unwavering support of this initiative in the midst of a historic economic recession was visionary. The IMA is only the second midwestern museum in history, after the Art Institute of Chicago, to receive the prestigious honor of organizing the U.S. Pavilion. The IMA was founded in 1883, but its contemporary program was established only in 1985. Max has been a staunch advocate as I've sought to transform the IMA's contemporary program into a robust model for encyclopedic museums in the United States. The U.S. Pavilion in Venice is surely one of our institution's proudest moments.

David Hunt, the IMA's project manager who oversaw this multinational project — from gymnastic leotard design, to airplane seat specifications, to tank sourcing and ATM engineering—has been a calm and elegant problem-solver. Amanda York, curatorial assistant for contemporary art, has steadfastly seen to almost every exhibition detail imaginable and has coordinated the production of the catalogue with clarity, patience, and intelligence. Gabriele HaBarad, senior coordinator for contemporary art, has worked indefatigably behind the scenes as the liaison for all aspects of this endeavor, and there are no words to express the extent of my gratitude to her. IMA chief operating officer Nick Cameron, deputy director of collections and exhibitions Kathryn Haigh, chief financial officer Jennifer Bartenbach, and chief development officer Cynthia Rallis have helped manage the most complex special project ever undertaken by the IMA, and I am indebted to them for their professionalism, support, and vision. In public affairs, deputy director Katie Zarich, assistant director Meg Liffick, and Candace Gwaltney, Jenny Anderson, and Erica Marchetti have been a dazzling team, spearheading an incredibly far-reaching public relations and marketing effort. Their talents have been amplified by Resnicow Schroeder, particularly David

Resnicow, Ilana Simon, and Abby Margulies, who have provided intelligent guidance for navigating this complex experience.

Associate director of facilities Mike Bir and senior installer Brad Dilger have industriously seen to every detail great and small here and abroad to ensure an impeccable presentation of the artists' six new commissioned projects. Matthew Taylor and Laurie Gilbert have managed the graphic design for all collateral exhibition materials. Our grants officer, Aubrey DeZego, meticulously shepherded the ninety-five-page grant submission and follow-up reports for the State Department. Lori Grecco, assistant director of development, has been a steady, resolute fundraiser, ensuring wide support of this project. To Jane Rupert, senior manager of events and donor relations, and Jacqueline Buckingham Anderson, the IMA's First Lady, thank you for envisioning and realizing the spectacular opening celebrations that launched *Gloria* so beautifully.

Linda Duke, former director of visitor engagement, Tariq Robinson, senior coordinator of youth programs, and Tiffany Leason, manager of higher education and research assessment, have envisioned and implemented a life-changing cultural exchange program for teenagers in Indianapolis, Venice, and Ponce, Puerto Rico, that enables them to learn about contemporary art and international identity in unexpected ways. At the Museo d'Arte de Ponce, CEO and director Agustin Arteaga, chief curator Cheryl Hartrup, and curator of education Taína Caragol Barreto have been supportive, enthusiastic collaborators throughout the development of this project.

Chief information officer Rob Stein, director of information technology Yvel Guelcé, Daniel Beyer, Rachel Craft, and Emily Lytle-Painter have developed our microsite, smartphone tour, and video content related to the exhibition. The efforts of Tascha Horowitz, manager of publications and photo editor, Anne Young, rights and reproduction coordinator, and Julie Long, assistant photo editor, were essential in enabling us to produce an exhibition catalogue that will be an important, lasting historical document

of the 2011 U.S. Pavilion. Many other IMA staffers have contributed in countless ways, including: Lauren Amos, Rebekah Badgley, Jillian Ballard, Jessica Borgo, Christian Brown, Phil Day, Alba Fernàndez-Keys, Jane Graham, Sarah Green, Anne Laker, Phil Lynam, Laura McGrew, and Molly White.

The production of the sculptures for *Gloria* required the ingenuity of numerous expert fabricators: Barnacle Brothers, Los Angeles (Alessandro "Smilee" Barnacle and Theresia Rosa Kleeman); Grappa Studio, Paris (Philippe Picoli, Grazia Cattaneo Picoli, and Andrea Soffientino); and Johannes Klais Orgelbau GmbH & Co. KG, Bonn (Philipp C. A. Klais, head of the project and head of the workshop, Gesa Graumann, technical construction, Stefan Strasser, electrical engineer, Peter Hoenisch, journalist, in close cooperation with Klais, and Pia Steinhaus, team assistant).

I gratefully acknowledge the contributions of our enlightened partners and collaborators: U.S.A. Gymnastics (Leslie King, director of communications, Luan Peszek, publications director, Sam Kilgore, manager of media relations and communications, and Adrienne Willy, marketing coordinator); Trystan Parry of Contour and Tracy Bevington of Delta Airlines; U.S.A. Track and Field (Susan Hazzard, associate director of communications, and Michael McNees, interim chief executive officer); Jonathan Bailey (composer); Anthony Ballard (computer programmer); Banca Nazionale del Lavoro (Mauro Iannucci); and Diebold Italy (Sandro Bacchetti).

David Durante, our 2011 Venice athlete coordinator and the 2007 U.S. all-around men's gymnastics champion, came on board early in the development of *Body in Flight (American)* and *Body in Flight (Delta)*. Working with Allora & Calzadilla and choreographer Rebecca Davis, Durante helped to develop a new language of bodily movement performed by a host of extraordinary gymnasts: Matt Greenfield, Olga Karmansky, Steve McCain, Chellsie Memmel, Mike Moran, Rachel Salzman, and Sadie Wilhelmi. *Track and Field* required the talents of runners, including 1996

Olympic Gold Medalist Dan O'Brien along with Jordan Fairley, Gary Morgan, Greg Mueller, Lisa Mueller, and Wamsi Muthiorah.

Mary DelMonico at DelMonico Books took on this project with gusto and enthusiasm, and working with her and designer Abbott Miller at Pentagram has been a delight. This elegant publication was developed by Miller with the assistance of Kimberly Walker, Karen Farquhar, and our astute copy editor Michelle Piranio. Art historians Carrie Lambert-Beatty and Yates McKee contributed thoughtful essays that enrich our understanding of the work of Allora & Calzadilla. My thanks to principal exhibition photographer Andrew Bordwin and his assistant Nick D'Emilio, who trekked out to Circus Warehouse in Long Island City to document the gymnasts' rehearsals and across the Atlantic to document the dress rehearsals and first performances, and whose impeccable eyes, humor, and boundless support brought so much to the project. I thank James Meyer, the smartest reader I've ever known, for his insights on earlier versions of my catalogue essay.

The IMA is exceedingly grateful to our major sponsor Hugo Boss, who epitomizes the important relationship between corporate philanthropy and contemporary art. Many individuals and corporations generously gave in support of this project, including: Diana and Moisés Berezdivin, Ignacio J. López and Laura Guerra, Donald R. Mullen Jr., Christina and Carlos Trápaga, Café Yaucono, Christie Digital Systems USA, Inc., and Diebold. We also thank the Friends of Allora & Calzadilla: Susan and Sebastian Beck Almrud, Ann and Steven Ames, Gay and Tony Barclay, Alice R. Berkowitz, Matthew and Susan Blank, James Keith Brown and Eric Diefenbach, Melva Bucksbaum and Raymond Learsy, Archibald Cox, Dirk Denison, Russell and Penny Fortune III, Michelle and Perry Griffith, Tom and Nora Hiatt, Ginny H. Hodowal, Stephen and Pamela Hootkin, Barbara Jakobson, Kay F. Koch, Peter S. and Jill G. Kraus, Michael and Rebecca Kubacki, James E. and Patricia J. LaCrosse, Aaron and Barbara Levine,

Myrta Pulliam, Steve and Livia Russell, Mary Sabbatino, Jay Smith, Sidney & Kathryn Taurel Foundation, David Teiger, and James P. and Anna S. White.

Special thanks to all of the staff members of the 54th International Art Exhibition—La Biennale di Venezia, including Paolo Baratta, president, Andrea Del Mercato, general director, Manuela Luca Dazio, managing director, Visual Arts and Architecture Department, and Maria Cristiana Costanzo, head of Press Office for Visual Arts.

Gladstone Gallery in New York has been an unflagging advocate for the artists and the U.S. Pavilion since the preliminary planning stages of this project. I am thankful for the overwhelming support, encouragement, and professionalism of Barbara Gladstone and Angela Brazda, in particular, and appreciative as well for the assistance of Sascha Crasnow and Ed Lopez with many of the catalogue details. My sincere gratitude also extends to Chantal Crousel, Niklas Svenning, and Lara Blanchy at Galerie Chantal Crousel, Paris; Monica Manzutto and Jose Kuri at Kurimanzutto, Mexico City; and Alex Logsdail at Lisson Gallery, London.

As always, but even more this time around, I am grateful for my family, Ed, Michaela, and Tess Coleman, who have sacrificed greatly so that I could realize this project; my extraordinary parents, Elsa and Michael Freiman; and my inspiring brother, Jonathan.

Lisa D. Freiman

U.S. Commissioner
54th International Art Exhibition—La Biennale di Venezia

Senior Curator and Chair
Department of Contemporary Art, Indianapolis Museum of Art

"OF SHAPES TRANSFORMED TO BODIES STRANGE":[1] ON SURREALIST TACTICS IN THE ART OF ALLORA & CALZADILLA

Lisa D. Freiman

For Maxwell L. Anderson and James Meyer

Metaphor is a primary resource in questioning the limits and boundaries of all so-called truths. By means of creative combination or substitution, metaphors can produce new insights and meanings. Because metaphor has the ability to transform, it can be a powerful tool when applied to the social arena where meaning is consensually fixed. It can become a tangible force in reshaping how the world appears to us, thus opening new possibilities for subjective, individual, and communal identifications. We see this function as both aesthetic—shaping form to create new sensibilities and perceptions—and political—making possible new meanings which can influence someone's choices in how they relate to a given subject.[2] Jennifer Allora

"**ONE MUST DREAM**," said Lenin. "**ONE MUST ACT**," said Goethe. Surrealism has never maintained anything else, for practically all its efforts have tended towards the dialectic resolution of this opposition.[3] André Breton

This year there is a dramatic and unexpected sight in front of the U.S. Pavilion: Jennifer Allora and Guillermo Calzadilla's performative sculpture *Track and Field* features a massive 60-ton overturned military tank that has been repurposed by superimposing a functioning treadmill above its right track. An athlete affiliated with U.S.A. Track and Field, the national governing body for track and field, long-distance running, and race walking in the United States, runs on the treadmill at regularly scheduled intervals throughout the exhibition [FIG. 1]. At first glance, one might perceive *Track and Field* as a critical intervention, a pejorative commentary on the United States' international military hegemony. A more additive reading of the work, however, acknowledges its aesthetic and semiotic generosity. A classic example of hybridity and inversion, *Track and Field* brings together two unexpected entities, and this juxtaposition stimulates the activity of free association, a constructive metaphoric process that requires the beholder not only to decipher new meanings of the works, but also, as art historian Carrie Lambert-Beatty later describes in this catalogue, to witness and enact "new processes."

1 Ovid, *Metamorphoses*, 1.1, trans. Arthur Golding (1567). See http://www.editoreric.com/greatlit/translations/ Metamorphoses.html.

2 Jennifer Allora in an interview with Carlos Motta, "Allora & Calzadilla," *Bomb*, no. 109 (Fall 2009): 69.

3 André Breton, *Position politique du surrealism* (1935), reprinted in Julien Levy, *Surrealism* (New York: De Capo Press, 1995), 54.

Track and Field can be understood literally as a reference to the athletic activities associated with this competitive sport, aspects of which date back to the origins of the Olympics in Ancient Greece and the cessation of war that enabled athletes and spectators to participate in the games. This essay, however, is not concerned with the literal; rather, it focuses on the metaphoric and neo-surrealist tactics of Allora & Calzadilla's most recent works created for the exhibition *Gloria* at the United States Pavilion for the 54th International Art Exhibition — La Biennale di Venezia. The title *Gloria*, which translates from Italian and Spanish to "glory," points to the pomp and splendor of the U.S. Pavilion, and by extension to all of the national pavilions in Venice. *Gloria* references military, religious, Olympic, economic, and cultural grandeur, as well as the numerous pop songs the word has inspired.[4] For the pavilion, Allora & Calzadilla conceived six new commissions — *Track and Field*, *Armed Freedom Lying on a Sunbed*, *Body in Flight (Delta)*, *Body in Flight (American)*, *Algorithm*, and *Half Mast\Full Mast*[5] — all of which resuscitate and transform certain strategic devices associated with historic surrealism, including free association, estrangement, and metaphoric substitution.[6] Although the artists have consistently

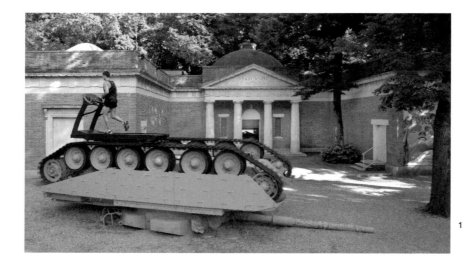

1

explored these aesthetic tactics in many past projects, including *Returning a Sound* (2004), *Hope Hippo* (2005), *Under Discussion* (2005), *Clamor* (2006), *Internal Combustion (eye of the needle)* (2007), and *Stop, Repair, Prepare: Variations on "Ode to Joy" for a Prepared Piano* (2008), to name a few, to date their work has not been considered in relation to the history and legacy of surrealism.

1. ***Allora & Calzadilla*** **Track and Field**, 2011; Centurian MK3 tank, motor, treadmill, and runners; 25 × 12 × 10 ft. (7.6 × 3.7 × 3 m); courtesy of the artists and Lisson Gallery, London

Historic surrealism began in Paris as an outgrowth of Dada and then spread throughout the world, influencing art, literature, poetry, music, cinema, politics, and phi-losophy. André Breton, the founder of surrealism, believed that the psychoanalytic practice of free association could be adapted in art as a means to unleash the revolutionary power of the unconscious and human imagination. During World War I, Breton practiced medicine at a neurological hospital where Sigmund Freud's psychoanalytical techniques were being used to treat traumatized soldiers. Freud developed his method of dream interpretation, which incorporated free association and analytic observation, in his early writings and reformulated the complete theory in *The Interpretation of Dreams*. This book, first released in 1900, was central to the formulation of historic surrealism and to many of the aesthetic strategies associated with the liberation of the imagination. Surrealism was a response to social, cultural, political, and aesthetic debates around the bourgeoisie and the irrationality of war. It was, as noted by surrealist scholar Mary Ann Caws, "directed against habit and against the predictable," meant to upset normal ways of seeing.[7] Breton believed that people could reconstruct reality through the reconciliation of their exterior and interior worlds. And as such, he sought to transform dreams into action, disrupting the stability and dullness of the human experience in order to allow one to discover the poetic condition of the "Marvelous."

In the *Surrealist Manifesto*, Breton defined the movement in terms of "pure psychic automatism." He believed that people could use automatic drawing to express "the real functioning of thought" or the unmediated, irrational contents of the unconscious.[8] Breton invented the collaborative "exquisite corpse" game, in which one person draws or collages part of a body on a piece of paper, folds it to conceal the marks, and then gives it to the next participant to do the same, and so on. During the heyday of historic surrealism, Breton created exquisite corpse drawings with artists and poets such as Yves Tanguy, Marcel Duchamp, Jacques Prévert, Benjamin Peret, and Pierre Reverdy.

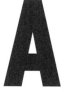**A**lthough quite different from the exquisite corpse game, Allora & Calzadilla's collaborative interpersonal practice informs the aesthetic underpinnings of their work. Using associative play, they engage in a constant dialogue that generates a juxtaposition of "different backgrounds, subjectivities, and ideas."[9] Sources of their inspiration can be found almost

4 Popular songs include U2's "Gloria," which overtly references the glory of God in relation to biblical psalms, as well as Jim Morrison's and Van Morrison's renditions of "G-L-O-R-I-A" and Gloria Estefan's album *Gloria*.

5 This essay will not address *Half Mast\Full Mast* in depth as it is the focus of Yates McKee's essay in this catalogue. The film is the third part of a series that includes the artists' earlier works *Returning a Sound* (2004) and *Under Discussion* (2005).

6 Numerous writers over the years have acknowledged these characteristics in the artists' works without contextualizing

them in relation to surrealism. See, for example, Eva Klerck Gange, "Allora & Calzadilla: Inversion and Opposition," in the exhibition catalogue *Allora & Calzadilla* (Oslo: Nasjonalmuseet for Kunst, Arkitektur og Design, 2009), 57–78.

7 Mary Ann Caws, "Translator's Introduction," in André Breton, *Mad Love* [*L'Amour fou*, 1937] (Lincoln: University of Nebraska Press, 1987), xii–xiii.

8 André Breton, "The Surrealist Manifesto" (1924), in *Manifestoes of Surrealism*, trans. Richard Seaver and Helen R. Lane (Ann Arbor: University of Michigan, 1969), 26.

9 Allora interview with Motta, "Allora & Calzadilla," 71.

anywhere—not only in images and ideas from such diverse origins as the Internet, antique books, etymological dictionaries, and out-of-print journals, but also in particular gestures and different kinds of music. Allora & Calzadilla's work—specifically their use of appropriation, site-specificity, impermanence, accumulation, and hybridization—demonstrates what art critic Craig Owens famously described as an "allegorical impulse." Owens's important theory analyzed the aesthetic tendencies found in the work of the so-called Pictures artists of the 1970s and 1980s, including Troy Brauntuch, Sherrie Levine, and Robert Longo.[10]

In their recent book *Allora & Calzadilla & Etcetera*, the artists include isolated, grainy photographs of remarkable objects and images they have encountered in diverse contexts over the course of a decade: the underside of a human tongue, an upturned tank, an ATM, and a pipe organ, to name just a few.[11] The curious compilation is reminiscent of Breton's book *Mad Love* in which he juxtaposes photographs of compelling found objects, places, and artworks with fragmented excerpts from his theory of "Mad Love" and "Convulsive Beauty."[12] While Breton's words appear to function somewhat like explanations for the pictures, Allora & Calzadilla's images exist without captions other than the literal name of what we see: armpit hair, basalt columns, the esophagus. These photographs float on the pages as provocateurs, reinforcing the dislocation of any precise reading. They are emptied of their specific contexts, allowing for substituted interpretations that can accumulate freely. In "The Allegorical Impulse," Owens described the way that many postmodern artists were appropriating film stills, photographs, or drawings at the time. Their manipulation of preexisting representations emptied them of their "authoritative claim to meaning." Owens explained that in some cases, when artists used particular images without captions, they became opaque, allowing for a "supplemental" allegorical meaning that displaced a preceding one.[13] This nuanced definition of allegory is important for an understanding of Allora & Calzadilla's treatment of found images.

Some of the pairings in *Allora & Calzadilla & Etcetera*, including the juxtaposed ATM and pipe organ, have led to the development of new work featured in the U.S. Pavilion. But mostly the images in that book appear as strange and fascinating unrelated phenomena, selected intuitively and accumulated as they were encountered over time. The artists have explained the additive quality of their work:

10 See Craig Owens, "The Allegorical Impulse: Toward a Theory of Postmodernism," in *Beyond Recognition: Representation, Power, and Culture*, ed. Scott Bryson (Berkeley: University of California Press, 1992), 52–69. Owens's discussion focuses on artists associated with the Pictures generation. For more information about Pictures, see Douglas Crimp, "Pictures," in Brian Wallis, ed., *Art After Modernism: Rethinking Representation* (New York: New Museum of Contemporary Art, 1984), 175–88. In addition, see the recent exhibition catalogue *The Pictures Generation: 1974–1984*, ed. Donald Ecklund (New York: Metropolitan Museum of Art, 2009).

11 Jennifer Allora and Guillermo Calzadilla, *Allora & Calzadilla & Etcetera* (Cologne: Verlag der Buchhandlung Walther König, 2009).

12 See Breton, *Mad Love*.

Recently our process has become defined more by *and, and, and* as opposed to *or, or, or*. We have become increasingly interested in substituting the conjunction "and" for "or" in resolving issues related to our works' production—by this we mean, instead of this "or" that artistic strategy, material, temporality, context, which implies a type of reconciliation, we put this "and" that interest, association, and motivation that we find relevant together. Processes of juxtaposition, assemblage, and collage are very useful legacies for us at the moment.[14]

They have referred to this unresolved accumulative practice of metaphoric combination as a kind of "poetic glue," or "an adhesive that can join different things together," producing a hybrid form.[15] Their description of this practice of accumulation recalls Freud's classic account of dream condensation in *The Interpretation of Dreams*. Because the mind cannot represent aspects of language without the anchors of concrete meaning, such as foreground and background, conditions, digressions, and counterarguments, the unconscious condenses disparate dream images into composite forms. Conjunctions or words that indicate logical thought relations—"because," "but," "either-or"—disappear.[16] Dreams compress psychic material so that the logical links that held the material together are lost. As a result, dream imagery tends to be discontinuous and fragmented. Hybrid, dreamlike forms abound throughout historic surrealism and are especially apparent in the Surrealist Object, which historian Maurice Nadeau defines as "any alienated object, one out of its habitual context, used for purposes different from those for which it was intended … a strange object, [a] catalyst of a host of unconscious desires."[17]

The historic Surrealist Object serves as one powerful sculptural model for Allora & Calzadilla's art making. Meret Oppenheim's infamous *Object* (1936), for instance, presents a cup and saucer covered entirely in animal fur [FIG. 2]. The hybrid object generates new material and erotic associations, "images of concrete irrationality," as Salvador Dalí called them, that proliferate in the world.[18] Allora & Calzadilla's practice of "gluing" objects together echoes the activity of the unconscious mind during dream work and links them to a host of aesthetic traditions not only historically within surrealism but more recently as well. Breton acknowledged that surrealism, and the Marvelous in particular, "is not the same in every period of history: it partakes in some obscure way of a sort of revelation only the fragments of which come down to us: they are the romantic ruins, the modern mannequin, or any other symbol capable of affecting the human sensibility for a period of time."[19] He cited like-minded predecessors such as Freud and poets François Villon, Jean Racine, Charles Baudelaire, Arthur Rimbaud, and Guillaume Apollinaire.

13 Owens, "The Allegorical Impulse," 54.
14 Jennifer Allora and Guillermo Calzadilla, e-mail message to the author, February 4, 2011.
15 Angela Rosenberg, "Interview," in *Allora & Calzadilla: Compass* (Berlin: Temporäre Kunsthalle Berlin, 2009), 16.
16 Sigmund Freud, *The Interpretation of Dreams*, trans. and ed. James Strachey (New York: Avon Books, 1965), 78.
17 Maurice Nadeau, *The History of Surrealism*, trans.

Richard Howard (Cambridge, Mass.: Belknap Press of Harvard University Press, 1995), 185. First published in French in 1944.
18 Salvador Dalí famously wrote about paranoic-criticism and surrealist objects in *Conquest of the Irrational* (New York: Julien Levy Gallery, 1935).
19 "First Manifesto of Surrealism" (1924), in *Manifestoes of Surrealism*, 16.

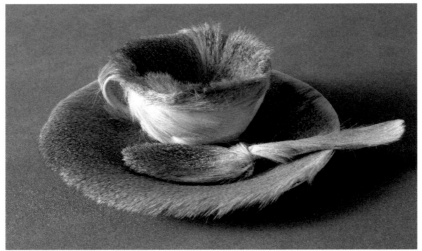

2

Critic Annette Michelson echoed this understanding of surrealism as a sensibility in the 1960s, explaining that it is constantly in the process of reinventing itself because it is "neither style, period, manner nor canon."[20] There are many examples of artists working with revived surrealist tactics, especially in the late 1950s and early 1960s in tendencies such as assemblage, environments, and happenings.[21] Robert Rauschenberg's combines, Jasper Johns's targets, Louise Nevelson's assemblages, Claes Oldenburg's sculptures, Christo's early wrapped objects, and Eva Hesse's "eccentric abstractions"[22] all demonstrate the growing use of estrangement and poetic shock as aesthetic strategies. Continuing but amending those strategies, the placement of *Track and Field* in front of the U.S. Pavilion can be understood as a neo-surrealist intervention, an absurd and paradoxical interruption of the norm that begs visitors to reconsider the relationships among militarism, nationalism, and athletic competition.

In all of Allora & Calzadilla's performative sculptures, the site or context, while never fixed, affects the nuances of the work's meaning. The layers of accumulated associations change when the objects are reinstalled or performed in a different place. In Venice, the commissioned works have been installed in and

2. ***Meret Oppenheim*** **Object**, 1936; fur-covered cup, saucer, spoon; cup: 4 3/8 in. (11.1 cm) diameter, saucer: 9 3/8 in. (23.8 cm) diameter, spoon: 8 in. (20.3 cm) long, overall height: 2 7/8 in. (7.3 cm); The Museum of Modern Art, New York, Purchase

around the U.S. Pavilion. Located within the Castello Gardens, this Palladian-style structure, built in 1930 by the architects William Adams Delano and Chester Holmes Aldrich, sits in relation to thirty international pavilions that display contemporary art during the Biennale. The Palladian style echoes the architectural concepts embraced by the Venetian Renaissance architect Andrea Palladio, who revered the symmetry, perspective, and forms of Ancient Roman and Greek temple architecture. The most famous examples of Palladian architecture in the United States are Thomas Jefferson's Rotunda at the University of Virginia in Charlottesville and the White House in Washington, D.C. The latter, in addition to serving as the primary residence for the president and his family, stands as a symbol of the United States government. The decision to build a Palladian-style pavilion in Venice that is reminiscent of the White House suggests a desire to draw a correlation between the United States' representation of itself abroad and the seat of American power at home—a correlation that will never again be so closely tied to associated readings of Allora & Calzadilla's works when they are exhibited in different contexts in the future.

The placement of an upturned tank in front of the U.S. Pavilion and the addition of an Olympic long-distance runner on the treadmill above it are disruptions of the rational world meant to generate unlimited associations among our conceptions of the U.S. military, government, art, and athletic competition.[23] The very name of the work, *Track and Field*, raises the possibility of semiotic play. The word *track*, for instance, is a synonym for imprint, trace, and trail. It suggests not just the track of a tank (or tractor), but also a racetrack, a railroad track, a sound track, or detectable evidence that something has passed. Track also connotes the course along which something moves, a succession of events, or a train of ideas. Free association can be understood as a kind of psychoanalytical track or unconscious, intuitive memory trace. A typically overlooked aspect of Allora & Calzadilla's use of the trace, or what art historian Rosalind Krauss has discussed in terms of indexicality (the relationship between a sign and its physical referent, such as a footprint and a foot), is the work's psychoanalytical or mnemic

20 Annette Michelson, "Breton's Surrealism: The Peripeties of a Metaphor or, A Journey Through Impossibility," *Artforum International* 5, no. 1 (1966): 72.

21 For a detailed history of the revival of surrealism during the 1960s, see the chapter on "Oldenburg's Neo-Surrealism" in Lisa D. Freiman, "(Mind)ing the Store: Claes Oldenburg's Psychoaesthetics" (PhD diss., Emory University, 2001).

22 See Lucy Lippard's landmark early reading of neo-surrealism "Eccentric Abstraction," *Art International* 10, no. 9 (1966): 34–40.

23 A number of recent exhibition catalogues on Allora & Calzadilla consider the artists' investigation into militarism and war in terms of physical objects, historical representations, and sound. See for example: *Land Mark* (Paris: Palais de Tokyo, 2006); *Allora & Calzadilla: Stop, Repair, Prepare: Variations on "Ode to Joy" for a Prepared Piano*, ed. Julienne Lorz (Cologne: Verlag der Buchhandlung Walther König, 2008); *Allora & Calzadilla*, ed. Beatrix Ruf (Zurich: JRP Ringier, 2009); *Allora & Calzadilla: A Man Screaming Is Not a Dancing Bear, How to Appear Invisible*, ed. Sylvia Martin (Krefeld: Kunstmuseen Krefeld, Museum Haus Esters, 2009); *Allora & Calzadilla: Compass* (Berlin: Temporäre Kunsthalle Berlin, 2009); and Eva Klerck Gange and Hou Hanru, *Allora & Calzadilla* (Oslo: Nasjonalmuseet for Kunst, Arkitektur og Design, 2009).

3

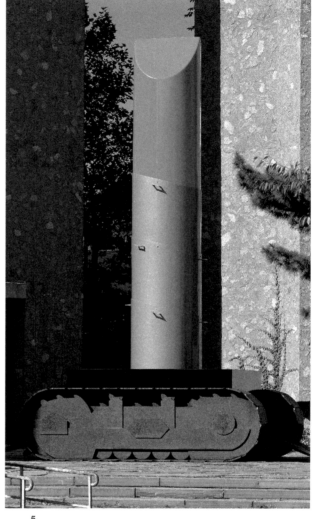

5

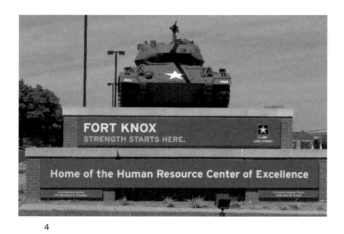

4

3. **Tank image from _Allora & Calzadilla & Etcetera_** 4. Courtesy of the United States Army

5. _Claes Oldenburg_ **Lipstick (Ascending) on Caterpillar Tracks**, 1969; Cor-Ten steel, aluminum; coated with resin and painted with polyurethane enamel; 23 ft. 6 in. × 24 ft. 10 ½ in. × 10 ft. 11 in. (7.2 × 7.6 × 6.4 m); Yale University Art Gallery, Gift of the Colossal Keepsake Corporation

nature.[24] Freud wrote about the incompatibility between consciousness and perception, on the one hand, and the unconscious and the enduring nature of memory traces on the other. The mind itself fills up with memory traces of data (sounds, smells, tastes, gestures, sensations, images, and experiences) from different moments in time, which constantly get rearranged through dream work, resulting in new representations. This psychoanalytic piling up of preexisting images and addition of supplemental interpretive possibilities once again evoke Owens's "allegorical impulse."

 Metaphorically the mind is a psychic field, an open area that accumulates physical, sensory, and psychic stimuli from the world. *To field* means to address, maneuver, or manipulate, and this transitive nuance of the verb suggests the very processes that Allora & Calzadilla enact with their various materials and associated meanings. Field is also a synonym for a clearing, ground, or tract—an open expanse for cultivation, battle, or military exercises. It further suggests a profession, a place for sports, a space on which something is projected or drawn, or an area of vision. The cumulative effect of all of these potential associations in relation to the U.S. Pavilion, the tank, and the runner suggests a seemingly infinite possibility for metaphoric play and endless, almost excessive interpretation.

What happens when a form as evocative as a military tank is coupled with a living professional athlete running in place on a treadmill? As the tank treads and treadmill shift from stillness to motion, they generate a loud grinding, pounding, clanking noise that suggests a roaring beast, disrupting the normalcy of the everyday and signaling an uneasy, even outrageous, shift into the realm of the profane. Allora & Calzadilla included a reproduction of a tank in *Etcetera*, where it is pictured after having flipped onto its nose, its guns pointing into the ground [FIG. 3]. At the U.S. Pavilion, however, the tank appears to have tumbled further, like a gymnast's body in the midst of a forward roll, but rather than completing the rotation, it has stopped upside down, immobilized and exposed. Its tracks crawl futilely like the legs of a dying cockroach, recalling Gregor Samsa, the protagonist in Franz Kafka's 1915 allegorical novella *The Metamorphosis*. Samsa, a traveling salesman, wakes up one morning after a night of uneasy dreams to find himself transformed into a giant insect, lying in bed on his "hard, as it were armor-plated, back."[25] Like Kafka's man-insect, a classic literary example of metamorphosis, here the tank has undergone a radical, absurd change. A machine built for ultimate firepower and protection, and meant to command a battlefield, has been disabled—turned into a brute material object that now serves as an aurally violent pedestal for a beautiful moving body. The tank's displacement in front of the pavilion is

24 For the classic discussion of indexicality, see Rosalind Krauss, "Notes on the Index: Part 1" and "Notes on the Index: Part 2," reprinted in *The Originality of the Avant-Garde and Other Modernist Myths* (Cambridge, Mass.: MIT Press, 1985), 196–219. Also, the most in-depth analysis of the trace in Allora & Calzadilla's work can be found in Yates McKee, "Wake, Vestige, Survival: Sustainability and the Politics of the Trace in Allora and Calzadilla's *Land Mark*," *October* 133 (Summer 2010):

20–48. Another important essay about the relationship between militarism and sound, what the author terms "sonic militarism," is Hannah Feldman's "Sound Tracks," *Artforum International* 45, no. 9 (May 2007): 336–41, 396. She emphasizes the psychological power of the sonic trace, pointing specifically to the "noise of bombs, screams, explosions."

25 Franz Kafka, *The Metamorphosis and Other Stories* (New York: Barnes & Noble Books, 1996), xi.

unexpected, humorous, and even annoying, especially considering the way Americans are used to witnessing tanks secondhand (and quietly disabled), either through media representations or military museum displays. One provocative photograph posted on the official U.S. Army website depicts a decommissioned tank displayed on a pedestal at the entry gates of Fort Knox, accompanied by the slogan "Strength Starts Here" [FIG. 4]. This site includes an array of historical photographs of tanks and soldiers in action during World War II, the Korean War, and Iraq as well as field exercises in Fort Benning, Georgia, and elsewhere. The site also features a special section dedicated to tanks and fighting vehicles, including the headline: "The Heavyweight Champions of the Battlefield."[26] The slogan draws a clear correlation between military might and athletic competition, perhaps repressing the ultimate, irreversible losses that take place on the battlefield. At the U.S. Pavilion, however, the tank moves into the role of museum pedestal on which is exhibited a former Olympic champion, not a relic of military victory. The runner is an idealized specimen of superhuman strength, determination, and competition, a body and mind in peak condition. While the male athletes of Ancient Greece competed in the nude in order to signify a perfect balance of anatomical form and athletic achievement, the runners here (both male and female) are clad in contemporary competitive uniforms that show their allegiance to the United States.

One would be hard-pressed to consider *Track and Field* without thinking of the more recent art historical precedent of Oldenburg's *Lipstick (Ascending) on Caterpillar Tracks* (1969) [FIG. 5]. The artist's first large-scale project, secretly commissioned by a group of Yale architectural students who called themselves the Colossal Keepsake Corporation, it was intended as an aesthetic intervention, and students actually drove the sculpture into Yale University's Beinecke Plaza during the height of the Vietnam War without the administration's consent. This gesture was made even more confrontational by the work's bizarre aesthetic, especially in the context of its being located in the main square of one of the oldest universities in America. The dreamlike antiwar monument was a classic, gigantic, neo–Surrealist Object that generated a wealth of associations related to war, eroticism, and power.[27] One of the important changes that occurred with Oldenburg's neo-surrealist *Lipstick*, and with much of sculpture in the 1960s, was the major shift in scale. Unlike Oppenheim's intimate, handheld teacup and saucer and other Surrealist Objects from the 1930s, Oldenburg's objects were environmentally expansive, outright interventions into the world that transformed small, ordinary items such as lipstick into colossal monumental forms; in the process, the meanings and physical experiences of these works were amplified by the sites in which they were placed.

26 See http://www.goarmy.com/about/army-vehicles-and-equipment/tanks-and-fighting-vehicles.html.

27 One critic wrote: "The lipstick is both phallic, life-engendering, and a bomb, the harbinger of death. Male in form, it is female in subject." See "The Vasari Diary: Can a Three-Story-High Lipstick on Tank Treads Find Happiness Again in a Secluded College Courtyard?," *Art News* 73, no. 10 (December 1974): 18–19. For a detailed discussion of the erotic and aggressive underpinnings of Oldenburg's sculpture, see Freiman, "(Mind)ing the Store," 263–78.

Oldenburg's *Lipstick* came out of the artist's numerous proposals for colossal monuments — collages he made of unlike things from everyday life inserted into representations of real urban sites around the world.[28] And those forms, which ranged from lipsticks and teddy bears to Good Humor bars and baked potatoes, originated, like the subject matter of much Pop art in general, in newspaper and magazine advertisements. Popular magazines were used to very different effect by Martha Rosler, whose series Bringing the War Home (1967–72) [FIG. 6] offers another art historical counterpoint to Allora & Calzadilla's practice. Responding to the Vietnam War's invisibility in daily American life, Rosler made collages of contemporary images of soldiers fighting in Vietnam within *House Beautiful* magazine spreads, using aesthetic disjunction to point to the American media's focus on pristine consumerism and beautifully constructed living environments rather than on the chaos and destruction of the war.

The source material for Pop and neo-surrealist aesthetics has now expanded and multiplied beyond anything that artists or viewers could have anticipated in the 1960s and 1970s. The introduction of hypertext on the World Wide Web in the early 1990s marks an important paradigm shift in the way that humans use technology to access and cross-reference information. Now, instead of relying solely on printed materials accumulated after walking or driving to a library, looking through card catalogues or databases, filling out interlibrary loan forms, waiting weeks for books to arrive, and spending hours photocopying documents, we have immediate and compressed access to texts, tables, images, movies, sounds, and graphics; furthermore, with a push of a button, we can print this information and have it in hand to reconsider and redeploy. We can browse the Internet and follow hyperlinks, producing a web of infinite associations that originate from different contexts, cultures, and historical periods.

For artists, hypertext presents a new model for associative play and the synthetic and hybridized nature of representation — a contemporary counterpart to the surrealist exquisite corpse game and the Parisian flea market of old. Surfing the Internet for words or images results in free associations with the computer that are both desired and surprising. The word *tank*, for example, leads to a string of unexpected texts and images, such as one photograph found on the U.S. Marine Corps' Flickr site that poignantly expresses the hybrid nature of contemporary representation, featuring a seemingly irreconcilable contemporary exquisite corpse.[29] A young Marine who is a bilateral above-knee amputee sits on top of a motorized off-road power wheelchair with treads reminiscent of a tank.

28 Claes Oldenburg, *Proposals for Monuments and Buildings: 1965–69* (Chicago: Big Table Publishing Company, 1969).

29 The official U.S. Marine Corps' Flickr site presents "a select array of imagery from around the Corps." They consider images on the site to be in the public domain. See http://www.flickr.com/people/marine_corps.

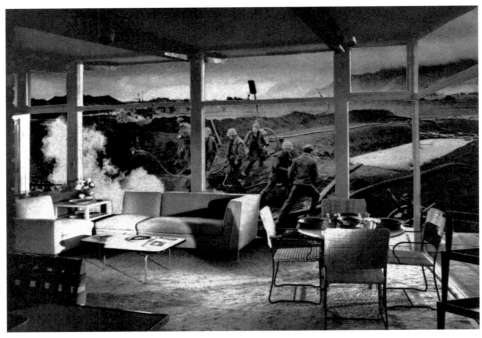

6

7

6. *Martha Rosler* Vacation Getaway, 1967–72 (detail); from the series
Bringing the War Home: House Beautiful; photomontage; 20 × 24 in.
(50.8 × 61 cm); courtesy of the artist and Mitchell-Innes and Nash, New York
7. **Wounded Marine can still hunt Whitetail bucks**; posted on the official
Flickr site of the United States Marine Corps

The camouflage-clad veteran is flanked by two dead white-tailed bucks shot during a recent hunt [FIG. 7].[30] How do we explain this impossible representation that is real: a soldier maimed by firearms who appears to be part man and part machine, and who has taken the lives of two large horned bucks for sport? The picture correlates with what Allora & Calzadilla have described as the "monstrous dimension of art":

> What the phrase seeks to evoke is precisely that which puts conceptual mastery and normative judgment into crisis. It was born not as a single ideal form, but as a composite of heterogeneous parts that do not add up to a whole or fit together to form a stable, finite body.
>
> This monstrous dimension of art has the force of an event, a manifestation that interrupts and alters its context. Its body is comprised of inverted mutilated and doubled parts forming anomalies and contradictions and with it multiple meanings. This resistance to strict categorization has nothing to do with ambiguity, vagueness, an in-between-ness or with the claiming of many different things but nothing in particular. Quite the opposite — the monstrous dimension of art is enacted through an infinity of particularities and specificities that emanate from the multiple and always changing parts that constitute its mutating body.[31]

Breton believed that the collision of human irrationality and rationality produced a Marvelous state. The resolution of these two opposing poles of mind, he argued, would create a new condition characterized by Convulsive Beauty. As Breton famously claimed, "Convulsive Beauty will be veiled-erotic, fixed-explosive, magic-circumstantial, or it will not be."[32] He argued that this type of beauty "affirm[s] the reciprocal relations linking the object seen in motion and in its repose" and gave the example of a photograph of a speeding locomotive abandoned for years in a virgin forest.[33] The tension between and resolution of these polar oppositions helped intensify the passionate quality of poetic beauty. Allora & Calzadilla's work, however, is not aligned with these dialectical underpinnings of historic surrealism. Rather than focusing on the resolution of two or more things, the artists tend to favor methods of appropriation and hybridization that destabilize strict definitions.

The notions of Convulsive Beauty and the monstrous bear some resemblance to what art historian and curator Robert Storr has described as "Our Grotesque" and its recent reappearance in contemporary work by artists such as Louise Bourgeois, Christian Marclay, Robert Gober, Cindy Sherman, and Mike Kelley. Storr does not position the grotesque in relation to its pejorative connotation — something that is ugly or repulsive; rather, he emphasizes its disconcerting nature, how it "rattles right-mindedness," spinning people into a state of "soul dizziness":

30 This image was accompanied by a long caption explaining that the ex-Marine had participated in an outdoor hunt made possible by a nonprofit organization dedicated to giving severely wounded soldiers adventures and dream hunts. The caption attempts to anchor the difficult representation with an optimistic and altruistic slant, but the image resists a simple explanation, instead reasserting the violence done both to and by the solider.

31 Yates McKee, "Allora & Calzadilla: The Monstrous Dimension of Art," *Flash Art*, no. 240 (January–February 2005): 96.

32 Breton, *Mad Love*, 19.

33 Ibid., 11.

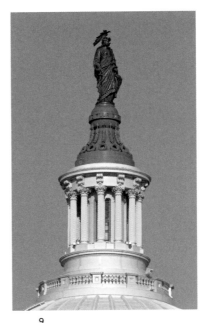

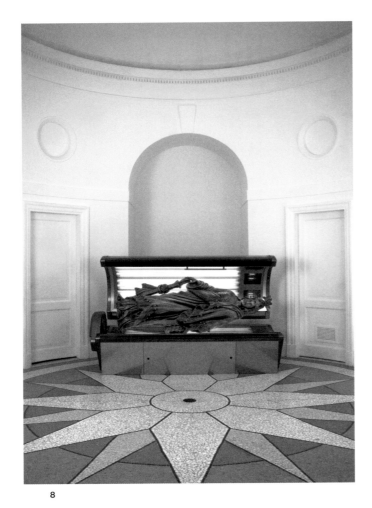

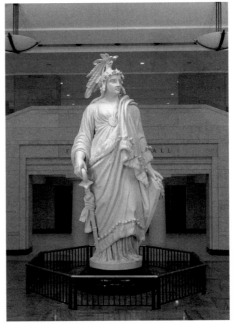

8. *Allora & Calzadilla* **Armed Freedom Lying on a Sunbed**, 2011; ETS Solaris 442 tanning bed and bronze; Edition 1/3; 96 × 54 in. (243.8 × 137.2 cm); courtesy of the artists and Gladstone Gallery, New York 9. *Thomas Crawford's* **Statue of Freedom** (1857–62); atop the United States Capitol Dome; bronze; 19 1/2 ft. (5.9 m) tall 10. *Thomas Crawford* **model for the Statue of Freedom**, 1857; plaster; installed in Emancipation Hall

To be grotesque something must be in conflict with something else yet indivisible from it. To result in "soul dizziness" that conflict must in some fashion already exist within the mind of the beholder such that the confusion stems not only from the anomaly that is revealed within us. Humanism, that much abused idea, enters into the equation to the extent that the dualities of which we are composed—the parts that don't match and the gaps between them—are made more rather than less apparent by our awareness of the misalignment or distortion of other parts of reality or of unrealities given substance by artists.[34]

Storr traces the grotesque throughout the history of Western civilization, citing Bernini, Baudelaire, Goya, and then moving on to the romantic, symbolist, and surrealist preoccupations with the unconscious best exemplified in Freud's writings about jokes, the displacements and condensations found in dreams, and the psychopathology of everyday life.

Storr's nuanced understanding of the grotesque, especially its alliance with historic surrealism, underlies Allora & Calzadilla's bewildering Kafkaesque *Track and Field*, and the notion is equally relevant to another sculpture, *Armed Freedom Lying on a Sunbed*, which sits inside the U.S. Pavilion's rotunda, greeting Biennale visitors [FIG. 8]. The space echoes, on a significantly smaller scale, the architectural form of the U.S. Capitol dome and rotunda, which is often considered to be the symbolic heart of America, and the location where presidents and dignitaries are laid in state in flag-draped caskets. Crowning the Capitol dome, roughly 300 feet above ground, is the 19 ½-foot original bronze *Statue of Freedom* (1857–62), also titled *Freedom Triumphant in War and Peace* [FIG. 9], which was installed in 1863. The original plaster model was exhibited in the Capitol until the mid-1960s, when it was put in storage. In 1993 it moved to the Russell Senate Office Building basement rotunda where it was displayed until 2008, when it was relocated to the center of Emancipation Hall [FIG. 10].[35]

The monumental *Statue of Freedom*, often called *Armed Freedom* or simply *Freedom*, was built by the neoclassical sculptor Thomas Crawford. It is an idealized representation of a woman wearing flowing robes that are joined by a medallion containing the letters *U.S.* Her headdress is encircled with stars and topped by a dramatic eagle's head, feathers, and talons.[36] In her left hand, she holds a laurel wreath and a shield containing thirteen stripes and stars that symbolize the original American colonies. Her right hand rests on the hilt of a sheathed sword, ready for action. There is an interesting tension between the notions of war and peace here. Interesting too is the symbolic representation of the relationship

34 Robert Storr, *Disparities & Deformations: Our Grotesque* (Santa Fe, N.M.: Site Santa Fe, 2004), 16.
35 See http://www.capitol.gov/html/VGN_201006147 8358.html.
36 See James M. Goode, *The Outdoor Sculpture of Washington, D.C.: A Comprehensive Historical Guide* (Washington, D.C.: Smithsonian Institution Press, 1974), 60.

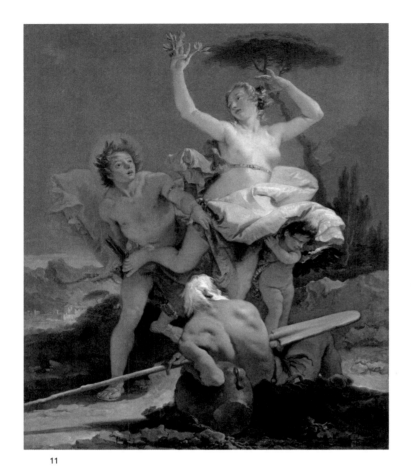

11

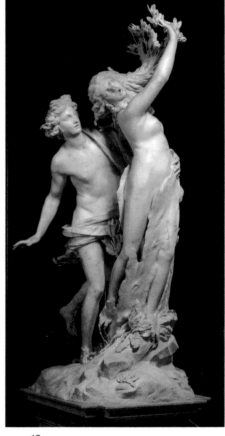

12

11. *Giovanni Battista Tiepolo* **Apollo and Daphne**, 1743–44; oil on canvas; 37 3/4 × 31 in. (96 × 79 cm); Louvre, Paris 12. *Gian Lorenzo Bernini* **Apollo and Daphne**, 1622–25; marble; front view, post-restoration; Galleria Borghese, Rome

between freedom and enslavement. It has been well documented that the statue itself was a source of controversy during its design. Not only was the statue cast by slaves, but it was meant to sport a different headdress, a Liberty Cap, worn by freed slaves (called *liberti*) upon manumission. Jefferson Davis, the leader of the Confederacy during the Civil War and the U.S. Secretary of War during the commission of the sculpture, rejected that design, however, because he viewed the headdress as a "Yankee protest against slavery."[37]

Allora & Calzadilla have incorporated a small replica of the bronze *Statue of Freedom* in their work *Armed Freedom Lying on a Sunbed*. They changed the statue's orientation from vertical to horizontal, an unexpected deviation from its original physical installation, and placed it inside an open Solaris 442 tanning bed that simulates a casket. The relationship is not just absurd and humorous, it is also awkward and profane. In this context, the rigid idealized and feminized representation of Freedom feels displaced and abnormal, even uncanny—familiar but strange and uncomfortable, nothing like an actual soft, responsive body of a person.

Allora & Calzadilla have written that their fascination with the surrealist "solar archetype/motif/subject/myth" inspired them to think about working with "a bronze sculpture lying on a 'sunbed.'"[38] They have cited numerous references to the sun by authors associated with historic surrealism and the avant-garde intellectuals who were part of the Parisian College of Sociology, including Georges Bataille, Aimé Césaire, and Roger Callois. One excerpt from Bataille's *Visions of Excess* seems especially relevant:

The sun, from the human point of view (in other words, as it is confused with the notion of noon) is the most elevated conception. It is also the most abstract object since it is impossible to look at it fixedly at that time of day. If we describe the notion of the sun in the mind of one whose weak eyes compel him to emasculate it, the sun must be said to have the poetic meaning of mathematical serenity and spiritual elevation. If on the other hand, one obstinately focuses on it, a certain madness is implied, and the notion changes meaning because it is no longer production that appears in light, but refuse or combustion, adequately expressed by the horror emanating from a brilliant arc lamp.[39]

Perhaps one of the earliest literary texts to address absurd transformation is Ovid's *Metamorphoses*, which tells the story of Apollo, the god of light and the sun, and Daphne, daughter of the river god Peneus. The famous myth introduces the victorious symbol of the laurel wreath, which artists have repeatedly represented throughout the history of art [FIGS. 11, 12].

37 Ibid.
38 Jennifer Allora and Guillermo Calzadilla, e-mail message to Carrie Lambert-Beatty; forwarded by the artists to the author on February 4, 2011.

39 Georges Bataille, *Visions of Excess*, ed. and trans. Allan Stoekl (Minneapolis: University of Minnesota Press, 1985), 57.

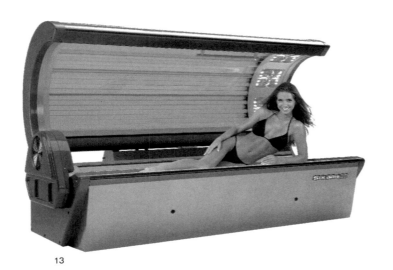

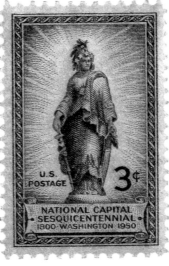

14

13

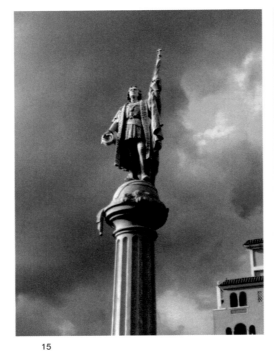

15

13. **Solaris 442 tanning bed promotional picture** 14. **Statue of Freedom three-cent stamp**,
1950; Smithsonian National Postal Museum 15. ***Allora & Calzadilla*** **Chalk Monuments**,
1998; chalk; 1/2 × 4 in. (1.3 × 10.2 cm) each; courtesy of the artists and Gladstone Gallery, New York

In the story, Apollo and Eros, the son of Aphrodite, fight over who should wield war-like weapons. Eros strikes Apollo with an arrow of gold meant to induce in him blind love, and he strikes Daphne with another arrow made of lead meant to repel love. As Apollo falls madly in love with Daphne, chasing after her through the woods, she tries to escape him, begging her father: "enclose me [in the earth] or change my form."[40] As Apollo watches, Daphne transforms from a beautiful woman into a laurel tree: her hair turns into leaves, her limbs into branches, her skin into bark, and her legs and feet into a trunk and roots. Apollo vows to love her always, exalting her memory by wearing a crown of laurel leaves. Henceforth the laurel crown would be awarded to the finest athletes and poets of antiquity.

The specific juxtaposition of the "sun bed" and the *Statue of Freedom* in the Rotunda playfully counterposes natural sunlight and bronzing—the latter as a physical material for traditional sculpture, a material used for modern sports medals, and as a cosmetic tanning practice meant to transform skin tones from lighter to darker. As the advertisement for the Solaris tanning bed suggests through its depiction of a thin, bikini-clad woman [FIG. 13], the device is tied to the American media's longstanding obsession with beauty and physical perfection. The advertisement also glorifies the practice of tanning, neglecting to acknowledge its proven health risks. The tanning bed, intentionally named a sunbed by the artists, radiates a blue artificial light meant to mimic the ultraviolet rays of the sun and introduces a remote reference to divine light. The correlation to a divine halo effect can be seen in one of many popular representations of the *Statue of Freedom* on U.S. postage stamps in the nineteenth and twentieth centuries. The three-cent stamp issued in 1950 for the National Capital Sesquicentennial, for instance, shows a frontal view of the statue with a glorious halo emanating from the figure, obviously meant to exaggerate the divine connotations of freedom [FIG. 14].[41]

The metaphoric connotations of transformation, monumentality, and light have fascinated Allora & Calzadilla throughout their career.[42] In San Juan in 1998, they worked with educators to develop the project *Chalk Monuments* [FIG. 15]. The artists recast in miniature scale the city's marble statue of Christopher Columbus, who initiated the Spanish colonization of the "New World," and the bronze statue of Juan Ponce de Leon, a Spanish explorer and first governor of Puerto Rico. Allora & Calzadilla not only shifted the scale of the large public monuments but transformed their respective permanent materiality

40 Thomas Bullfinch, "Chapter 3: Apollo and Daphne—Pyramus and Thisbe—Cephalus and Procris," http://www.greekmythology.com/Books/Bulfinch/B_Chapter_3/b_chapter_3.html.

41 It is interesting to note that the word *glory* is a lesser known synonym for a halo, defined as "a ring or spot of light" that appears around the shadow of an object. "Glory," www.merriam-webster.com/dictionary/glory.

42 An exhibition curated by Sofía Hernández Chong-Cuy, and organized by the Americas Society in New York in 2003, focused on this topic exclusively; see *Puerto Rican Light: Allora & Calzadilla* (New York: Americas Society, 2005).

16. *Allora & Calzadilla* **Puerto Rican Light (to Dan Flavin)**, 1998/2003; Dan Flavin's *Puerto Rican Light (to Jeanie Blake)*, 1965, battery bank containing solar panels, batteries, controller, and inverter; dimensions variable; installation at the Tate Modern, London; courtesy of the artists and Gladstone Gallery, New York

(marble and bronze) into small pieces of impermanent chalk, a material used in classroom instruction. They displaced the official function of a stable celebratory monument and turned it into a vehicle for discussion about the social, political, and cultural histories of Puerto Rico and colonialism.

In *Puerto Rican Light (to Dan Flavin)* (1998/2003) [FIG. 16], Allora & Calzadilla used appropriation more literally, this time borrowing Flavin's original 1965 sculpture *Puerto Rican Light (to Jeanie Blake)* and powering it with a battery bank that had been charged with solar panels in Puerto Rico, in a critique of American power and energy consumption. The nostalgic and romantic conception of Puerto Rican sunlight suggested in Flavin's work therefore is subverted by the literal importation of Puerto Rican solar energy.

For *Traffic Patterns* (2001–3), exhibited with *Puerto Rican Light (to Dan Flavin)* at the Americas Society in 2003, Allora & Calzadilla explored once again light as symbol, medium, and metaphor. They installed a dropped ceiling containing a lighting system that synchronized the light in the gallery space with a traffic light in San Juan; the gallery was illuminated for a few minutes with red, then yellow, and then green light. The lighting system was outfitted with a special relay device connected to a computer chip that was programmed with the time-code of the traffic light. Both of these projects drew a literal and metaphorical correlation between the appearance of light in the cities of New York and San Juan, and reversed the typical power relations associated with the United States and Puerto Rico.

One of the important historical interactions between the United States and Puerto Rico is revisited in *Half Mast\Full Mast* (2010), the third part of Allora & Calzadilla's series of short videos about the island of Vieques, a municipality off the coast of Puerto Rico that is best known as a former U.S. bombing range and testing ground.[43] The two-chanel video is structured as a sequence of paired images, one on top of the other, each depicting a different setting (see pages 82–83). Connecting them, though, is a cinematic framing of a flagpole that appears in the same area in each image, resulting in the illusion of a single flagpole that extends across the two screens, despite the images' otherwise obvious disjunctive backgrounds. Into one or the other of these frames, one male gymnast at a time enters and grabs onto the flagpole, pulling himself up perpendicular to it so that the body substitutes for a national or regional flag. Depending on whether the gymnast appears in the top or bottom screen, the "flag" seems to be flying at full mast or half-mast. Significantly, these "flagging" gestures occur in sites that symbolically mark moments of victory or setback in the island's struggle for peace, decontamination, ecological justice, and sustainable development.

43 A series of major protests against the U.S. Navy's use of the island of Vieques eventually led to the navy's departure in 2003. Today the former navy land is a national wildlife refuge, but it suffers from the environmental damage caused by the bombing and requires extensive remediation.

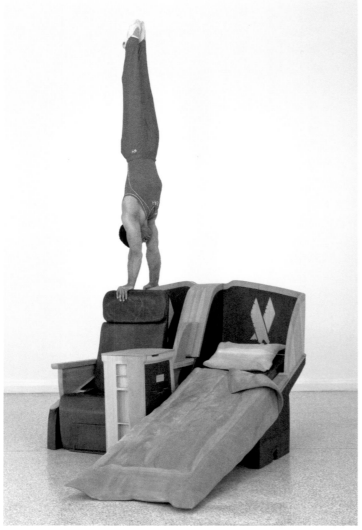

17

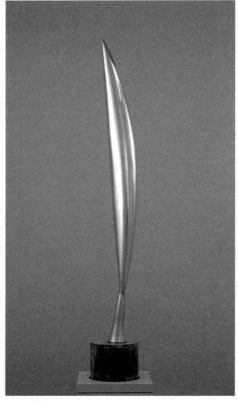

18

17. *Allora & Calzadilla* **Body in Flight (American)**, 2011; stained wood;
gymnasts; courtesy of the artists and Galerie Chantal Crousel, Paris
18. *Constantin Brancusi* **Bird in Space (L'Oiseau dans l'espace)**, 1932–40;
polished brass; 59 7/16 in. (150.8 cm) high, including base; The Solomon R.
Guggenheim Foundation, Peggy Guggenheim Collection, Venice, 1976, 76.2553.5

Asimilar metaphoric substitution of the body in place of a nationalist symbol recurs in *Body in Flight (Delta)* and *Body in Flight (American)* (both 2011). Turning to the commercial terrain of international flight, the artists have again appropriated forms from everyday life, this time Delta's and American Airlines' state-of-the-art elite business-class seats, which have been reproduced exactly in 1:1 scale in poplar and stained like polychromatic religious icons. Taken out of their original context in an airplane and remade in a new material, the seats appear as beautiful, well-crafted, and unusual abstract sculptures. Allora & Calzadilla's analogical interest in bodies, flight, and gravity led them to even greater extremes of unexpected juxtaposition when they invited gymnasts affiliated with U.S.A. Gymnastics to perform on top of the seats and throughout the gallery space [FIG.17]. In this project, the artists continue their manipulation of bodily orientation, which they first explored with *Armed Freedom*, and again emphasize the formal shift from vertical to horizontal that was taken up with a vengeance in *Half Mast\Full Mast*. In *Body in Flight*, the artists consider this relationship in terms of both the flexible seat design (its ability to "lie flat") and the gymnasts' bodies, which are in a continual state of movement in concert with the shape of the seats.

Allora & Calzadilla have described the airline seats "as symbols of commodity myths that are bound up with ideas of nationalism, competition, global commerce, travel, etc.," noting how their very designs "create and confirm narratives of progress, travel, comfort, business, leisure, class relations, and nationality." Furthermore, they chose to use the seats of two U.S.-based airlines as the models for their sculptures and to have gymnasts from the U.S. Olympic team perform in order "to further hyperbolize the nationalistic and competitive nature of the Biennial Pavilion structure (whose counterparts could easily be international sports competitions like the Olympics)."[44] The artists have acknowledged that *Body in Flight* "is a kind of perversion, contamination, or explosion" of Brancusi's *Bird in Space* (1932–40) [FIG. 18]. They are interested in how the object explores the essence of flight through an abstract sculptural object anchored by an "earthbound" support.[45] In *Body in Flight (Delta)*, Allora & Calzadilla's painted wooden replica of Delta's business-class seat becomes a balance beam for female gymnasts [FIG.19]. The women's routine, which lasts approximately seventeen minutes, emphasizes their extreme flexibility and fluidity. *Body in Flight (American)* loosely approximates a pommel horse and is used exclusively by male gymnasts who demonstrate quicker movements and sheer physical

44 E-mail message to choreographer Michael Clark, February 6, 2011; forwarded by the artists to the author on March 4, 2011.

45 Jennifer Allora and Guillermo Calzadilla, e-mail message to Carrie Lambert-Beatty; forwarded by the artists to the author on February 4, 2011.

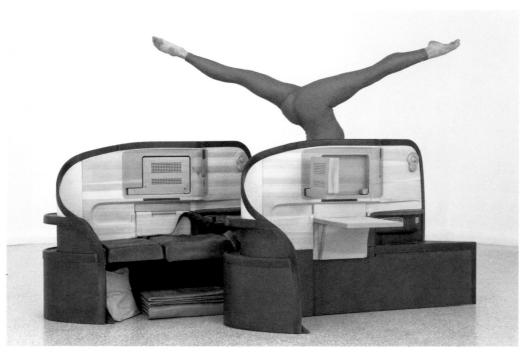

power over a twelve-minute period. The works appear in separate galleries, serving to isolate and contrast the gendered performances, which occur in the round so that visitors can encircle the gymnasts and watch the routines from different perspectives. The athletes physically engage their supports, leaving behind their dynamic bodily traces in chalky residues, sweat, and dirt.

Allora & Calzadilla did not want the athletes to perform typical one-minute gymnastic routines on the seats; instead they wanted to find a way to create unexpected juxtapositions that were "playful, intense, passionate, shocking, raw, [and] moving":

How can these "athletes" ...do completely different, yet extraordinary or surprising or unconventional things with their bodies (bodies which have been trained to execute a specific set of precise movements).... Since they are gymnasts and not (exclusively anyway) dancers, nor just regular people, how can we explore the untapped repository of possible expression that they alone could be capable of conveying?... We want a lot of things to happen—simple things, formally complex things, repetitive things, funny things, emotional things, terror-ific things, beautiful things, and so on.[46]

19. *Allora & Calzadilla* **Body in Flight (Delta)**, 2011; stained wood; gymnasts; courtesy of the artists and Gladstone Gallery, New York

The artists extended the usual duration of an actual gymnastics routine to last twelve to seventeen minutes because they wanted to estrange the nature of what is normally possible in the discipline of gymnastics. This intentional manipulation also acknowledges the compression of time and space that occurs during air travel itself. The artists explained: "We have always been curious about the paradox that the ultimate experience of flight on a jet plane going 600 mph and taking a person in a few hours from one part of the world to another is supposed to be felt by that person's body as a state of stasis, immobility, horizontality, etc.... Why has there not been any interest in having the body actually experience the sheer force/thrust/propulsion that is actually happening on the aircraft—in other words trying to heighten as opposed to hide the physical nature of flight?"[47] This same perplexing contradiction applies when the gymnasts perform on the sculpture. Seats that in their usual context are meant to connote comfort and rest instead support dynamic athletes who perform their challenging routines close enough that we can see their extreme concentration as their muscles quiver and they struggle to balance and hold their forms.

Allora & Calzadilla wanted to explore the paradoxical "gray space" between gymnastics and modern dance to create something completely new. After working for several months with U.S. all-around men's gymnastics champion Dave Durante, they invited New York-based modern dance choreographer Rebecca Davis to "break-down" or "mess up" the particular gymnastics movements associated with specific equipment. Through the rubric of dance, Allora & Calzadilla wanted the choreographer and the gymnast to create a gestural gymnastics vocabulary that did not yet exist.[48] Together, Durante and Davis worked with Allora & Calzadilla to develop a bodily language in which the gymnastics and dance elements "contaminate" each other (poetic glue again, but this time in real space and time, across disciplines). Davis explained: "We're working with possibilities located at opposite ends of the spectrum: pedestrian-like post-modernist movement on one end and highly skilled gymnastics on the other. The challenge is to move between the two without one style bleeding into the other, although that may very well become the aim at some point in the sequence!"[49] Durante commented on the transformational, innovative nature of the so-called contamination of specialties: "Coming from a straight gymnastics background, where everything is so structured and precise, it has been fascinating to see how Rebecca

46 Jennifer Allora and Guillermo Calzadilla, e-mail message to Michael Clark, February 6, 2011; forwarded by the artists to the author on March 4, 2011.

47 Ibid.
48 Conversation with the artists, March 4, 2011.
49 Rebecca Davis, e-mail message to the author, March 8, 2011.

and the performers have deconstructed certain gymnastic type movements into new unique and interesting shapes and positions that are now in a realm far from the gymnastics world."[50] In watching the rehearsals, one is struck by the simultaneous existence of paradox, impossibility, and resolution that occurs when the gymnasts interact with the decontextualized airline seats. They do in fact create a new kind of Convulsive Beauty containing compressed moments of "soul-dizzying" humor, elegance, and body-defying motions in a most unanticipated circumstance.

This contemporary unexpected coupling of gymnastics and modern dance choreography in relation to the form of a commercial airline seat owes a certain debt to neo-avant-garde experiments related to happenings and modern dance throughout the 1960s. Susan Sontag was one of the first critics to acknowledge the surrealist slant of happenings, arguing in her 1962 essay "Happenings: An Art of Radical Juxtaposition" that the formal logic of these spectacles related to a surrealist sensibility that privileged the aesthetics of dreams and the unconscious. The combination of performers' actions and the numerous radical juxtapositions of materials, movements, words, sounds, and lights was a paradoxical aesthetic that generated a kind of poetic shock that could be found throughout theater, painting, poetry, film, music, novels, and architecture in the twentieth century.[51]

Sontag's essay foreshadowed Annette Michelson's take on Yvonne Rainer's performance *The Mind Is a Muscle*, published in the 1966 issue of *Artforum* dedicated to surrealism. Rainer's dance practice in the late 1960s used the vocabulary of bodily form and gesture to emphasize a combination of stripped-down, minimal sounds and movements, making use especially of repetition and patterns. She interspersed classical dance moves with more common, everyday gestures and actions, looking at the body as a formal object without expression. Michelson, however, noted something beyond the minimalist form that so many critics at the time discussed. "Movement," she explained, "and the evocation or figuration of its absence tended to assume the nature and presence of objects. More urgently than any theoretical or speculative contexts, a work of this sort poses the question of surrealism's metaphor in a climate in which the notion of making replaces that of revealing or expressing." Michelson asked: "What finally is the place of Surrealism as

50 Dave Durante, e-mail message to the author, March 4, 2011.

51 Susan Sontag, "Happenings: An Art of Radical Juxtaposition," in *Against Interpretation* (New York: Noonday Press, 1967), 263-74.

Metaphor—and of its metaphors—in a time when Metaphor is stripped of cognitive value and exiled to the expressive peripheries of language?"[52] Allora & Calzadilla's *Body in Flight* (as well as many of their other recent performative sculptures such as *Clamor*, *Sediments, Sentiments...*, and *Stop, Repair, Prepare: Variations on "Ode to Joy" for a Prepared Piano*) offers one possible answer some forty-five years after Michelson first acknowledged surrealism's relevance to Rainer's practice. Surrealism's excessive metaphorical nature points to the endless unfixity of interpretation. In that same spirit Allora & Calzadilla create works that provoke viewers into a state, they say, of permanent questioning "about a particular subject, about preconceived notions of truth, about forms of representation, participation, identification."[53]

A rare instance in which viewers are privy to the artists' private ruminations about formal combination can be found on a double-page spread in *Etcetera* that depicts a pipe organ facing a picture of an automatic teller machine (ATM) [FIG. 20]—a combination realized in *Algorithm*, a towering, nearly 20-foot-tall sculpture in which a Diebold ATM sits inside a functioning pipe organ, replacing the typical organ keyboard, pedals, buttons, and knobs with various ATM parts: a card reader, keypad, speaker, display screen, receipt printer, and cash dispenser [FIG.21]. The project has mutated, in part according to the practical necessities of fabrication, scale, site, and budget. But there were many aesthetic decisions to be made by the artists as they worked with the organ maker, for every pipe organ is customized like a tailor-made suit. In this case, the alteration has been pushed to an extreme and the typical structure of the pipe organ has been manipulated, "contaminated" by the ATM that stands in for its console, producing a conflation of sacred and ordinary sounds that reveal the activity of global commerce through the medium of music. The final design of the pipe organ is more minimal in form, covered in wood and shaped geometrically like the letter V. The form is reminiscent of two pictures in *Etcetera*: a giant frontally oriented sculpture of a decapitated eagle [FIG.22] and a blurry image of a rising Phoenix [FIG. 23]. When asked about the coincidental formal similarities, Allora & Calzadilla replied that the resemblance "affirms a certain set of intuitive interests": "When we were looking at the different shapes of organs, having the U.S. Pavilion site in the backs of our minds, the eagle shape and the V shape resonated with us more than other shapes for the connotations they evoke."[54] (Perhaps not surprisingly, the male and female routines for *Body in Flight* also include this form, with the gymnasts' arms raised in the air.)

52 Michelson, "Breton's Surrealism," 72–77. Michelson's article appeared at the same time as Lucy Lippard's essay "Eccentric Abstraction," which attempted to accommodate both the major aesthetic characteristics of minimalism and the metaphoric basis of surrealism.

53 Guillermo Calzadilla in Jessica Morgan, "Jennifer Allora and Guillermo Calzadilla," in *Common Wealth* (London: Tate Modern, 2003), 89.

54 Jennifer Allora and Guillermo Calzadilla, e-mail message to the author, December 29, 2010.

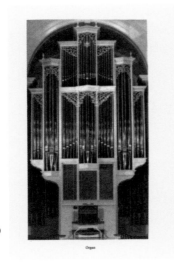

Organ

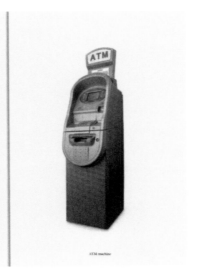

ATM machine

20

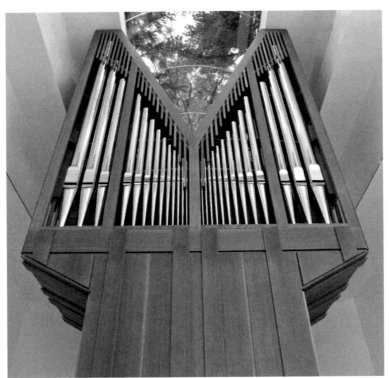

21

20. **Organ and ATM images from** *Allora & Calzadilla & Etcetera* 21. *Allora & Calzadilla*
Algorithm, 2011; ATM, pipe organ, and computer; 232 3/8 × 120 1/8 × 59 1/8 in.
(590.2 × 305.1 × 150.2 cm); courtesy of the artists and Gladstone Gallery, New York

Visitors do not encounter *Algorithm* head-on. Instead, they enter the gallery space and see the organ from behind, like a giant body with part of its skin torn off and the internal organs, musculature, and skeletal system partially exposed. One might hear the musical notes playing from other galleries and be lured to discover their origins. Or the beast might sleep, quietly, until woken up by a person needing to get a stack of Euros. Each financial transaction that someone conducts corresponds to a unique musical score file that produces randomized notes and chords at varying degrees of volume by driving pressurized air through pipes selected via the ATM keyboard.[55] The artists collaborated with composer Jonathan Bailey over the development of the project, initially giving him a set of musical reference points that ranged in style and concentrated mostly on the modern canon of organ music developed by composers such as György Ligeti, Olivier Messiaen, John Cage, Luciano Berio, and Steve Reich. At the outset Allora & Calzadilla gave Bailey a list of compositional goals for the music that would be generated by *Algorithm*:

1. Throughout the life cycle of the installation of this artwork, the music should not really ever exactly repeat.

2. That said, there should be an arc to the overall structure of the music that resolves—every hour or so.

3. The artwork should not produce any sound when it's not being used.

4. Each press of a button should result in immediate musical feedback.

5. There should be musical variety—at certain points, the organ should sound as though all keys are pressed down. At other points, only single note may play.

55 Jonathan Bailey explained the technological basis of the communication between the ATM and pipe organ: "The score files themselves consist solely of MIDI instructions, which the organ can respond to in the absence of a physical keyboard (called a 'manual' in the organ vernacular) or pedal, via an embedded computer interface. Whenever a user pushes one of the ATM's buttons or swipes their card, the corresponding musical file is instantly triggered to begin playing. The MIDI files vary in length and content, containing a wide variety of musical motifs that range from short individual notes to complex sequences of chords, melodies, as well as instructions to modify the tonality of the organ itself. In order to create a more musical structure, the full set of score files being generated for this piece will be organized into 'modes' or vignettes. Each mode will consist of a full set of score files that correspond to each input/output of the ATM, as described above. When the user begins a transaction with the ATM, the mode will change. This entire interaction is governed by a software system that relays ATM input to a musical module, which manages loading modes and playing back the MIDI files defined by those modes. We'll probably wind up with about 60 of these modes for the final piece, since the average ATM session appears to be about a minute long." Jonathan Bailey, e-mail message to Jennifer Allora and Guillermo Calzadilla, cited by the artists in an e-mail message to the author, December 29, 2010.

22

23

22. Headless eagle image from *Allora & Calzadilla & Etcetera*
23. Phoenix image from *Allora & Calzadilla & Etcetera*

Bailey described the compositional challenges that *Algorithm* presents:

At its most basic, the structure of music can be distilled down to two fundamental ingredients—pitch and time. By "time" in music, we refer to both onset time of pitches in relation to each other as well as their duration. One inherent compositional challenge in this project is that both the user and the environment have control over both of the time factors. We obviously do not know at the outset what the user's intention is when using the ATM. Will they simply withdraw cash? Check their balance? Transfer funds? A combination of these actions? How fast do they type on the pin-pad? Also, how much activity is there on the network—could this slow down or speed up the communications back to the banking server? We can control what happens once a user hits a single button, but in what order they hit what buttons and how quickly is largely outside of our control.[56]

The artists worked with the composer to create a collection of "curated ideas" that have evolved into the final piece, a combination of sounds that range from atonal material to more classically structured melodies, harmonies, and phrases. Allora & Calzadilla selected the title *Algorithm* because of the notion of "linking together algorithmic composition and algorithmic banking (and the assumptions/logic of this type of calculating a function—i.e., a set of rules that precisely define a sequence of operations)."[57]

The randomized notes—sound traces that mark and define the territory of the U.S. Pavilion in Venice in 2011—are an unavoidable abstract aural representation of international global commerce. Visitors who seek out the only ATM in the Giardini encounter a wholly unexpected machine that is at once absurd and incongruous, a physical and auditory disruption of the ordinary reminiscent of what they first experienced in front of the pavilion with *Track and Field*. But now the visitors are responsible for activating not a remote performer but this monstrous object. When they retrieve cash or make a deposit, they implicate themselves in the cycle of global commerce, forcing air through the organ's pipes and bringing life to Allora & Calzadilla's most recent sleeping beast: a grotesque physical, singing body that emits a contaminated array of surreal, minimal, spiritual, and profane sounds that physically reverberate on the bodies of visitors, transforming their respective orientations to the U.S. Pavilion, to the Giardini, and to the Biennale at large.

56 Ibid.
57 Jennifer Allora and Guillermo Calzadilla, e-mail message
to the author, December 29, 2010.

RECUPERATING PER-FORM-ANCE

Carrie Lambert-Beatty

IN THE ART OF JENNIFER ALLORA AND GUILLERMO CALZADILLA, TRAINED BODIES DO THEIR THING.

Pianists play pianos. Fishermen pilot boats. Opera singers sing. Dancers dance. In the U.S. Pavilion at the 54th International Art Exhibition — La Biennale di Venezia runners run; gymnasts practice muscular, gravity-defying routines; and you, the Biennale visitor, go through a maneuver in which *you* have been well-schooled: plugging into global economic networks with a swipe and some taps at an ATM. While Allora & Calzadilla are known for the complex constellations of historical research, art historical reference, and free-form wordplay that surround their works, there is an equally distinctive though less-remarked upon aspect of their art: their use of performance by others.

THE READIEST associations with the term "performance" are works in which artists use their own person as material or medium: Chris Burden wiggling nude over broken glass, Joseph Beuys caged with a coyote, Karen Finley covering herself in chocolate. But there is a much broader history of art conceived as an action to be performed by someone else. This is generally the case, of course, in conventional choreography or musical composition, but it also characterizes certain developments in twentieth-century avant-garde production, such as Fluxus ("The audience is invited to dance a tango" is the full score of a 1964 piece by Ben Vautier). More recently, the activities of attendants became elements of installation art, as in Ann Hamilton's composed environments. In fact, the last two decades have seen a widespread tendency toward what Claire Bishop identifies as outsourced or delegated performance, as when Santiago Sierra hires day laborers to act as human columns beneath a sculpture, for instance, or when Vanessa Beecroft puts fashion models on display. At stake in much delegated art, Bishop suggests, are "the aesthetics and politics of employing other people to do the work of the performer."[1]

1 Claire Bishop, quoted in Cherie Federico, "Double Agent: Exploring Ethics, Performance, and Authenticity," *Aesthetica* (April–May 2008): 27.

ALLORA & CALZADILLA could be considered delegators—they hire performers to enact particular activities while they themselves remain behind the scenes—but they couldn't be more different from the artists in whose works, Bishop points out, "we are always looking at people who have been paid to perform some aspect of themselves (rather than a skill or talent): gender, sexuality, ethnicity, economic status, disability, etc."[2] For it is precisely a "skill or talent" that Allora & Calzadilla ask the gymnasts, runners, singers, pianists, and dancers in their works to demonstrate. More significantly, the artists ultimately ask the performers to reinvent these skills or talents themselves.

VARIATIONS

Allora & Calzadilla practice an aesthetics of inversion. An upturned table, a supine statue, behind-the-back drumming, and an upside-down tank are just a few examples of reorientation in their art. So, even though their 2008 work *Stop, Repair, Prepare: Variations on "Ode to Joy" for a Prepared Piano* is generally described as a punctured piano in which a pianist stands, it seems more useful to think of it inversely, as a pianist with a piano around her [FIG.1]. In any case, it is an artwork in which a skilled musician's normal relationship with the instrument is turned inside out. For this piece, Allora & Calzadilla commissioned several pianists to create a twenty-five-minute version of the fourth movement of Beethoven's Ninth Symphony (the "Ode to Joy") for a Bechstein on wheels, which had been cored like an apple. With this, the artists found a path between the playfulness of John Cage's prepared pianos and the legacy of avant-gardists who have reduced the instruments to splinters. And though Allora & Calzadilla's prepared piano can never be un-prepared, it is not destroyed. It can—and must—be played.

THE PIANIST threads herself through the hole so that the piano extends around her, an absurdist hoop skirt. She bends forward to reach the keys, on which she plays the notoriously difficult composition upside down and backward, while at the same time pushing the huge instrument through the gallery along a predetermined path. It's not a graceful image. The artists take the dignified, frontal encounter between maestro and instrument and give us a hunchbacked, scuttling hybrid. The performer curls over the keyboard in a posture that recalls vomiting or being punched in the gut, and because of the way she must throw her weight into the piano to move it, her feet half grip, half drag along the ground. The masterly pianist is made over as a baby in a giant walker—or better, perhaps, a physical therapy patient being supported as the process of walking is relearned.

2 Claire Bishop in Julie Austin, interview with Claire Bishop, "Trauma, Antagonism and the Bodies of Others: A Dialogue on Delegated Performance," *Performance Paradigm* 5, no. 1 (May 2009), http://www.performance-paradigm.net/category/journal/issue-5.1.

NEUROLOGISTS HAVE learned that the brain of someone who has suffered a neurological injury can often develop ways around the signal-blocking damage, not only compensating for lost function but actually shifting the pathways for that function to different parts of the brain. The music in *Stop, Repair, Prepare* demonstrates a similar kind of compensatory creativity. The instrument is missing the whole center section of its strings, and so the music — already denatured by the transposition from full orchestra and choir to single piano — limps along, with passages displaced into the high and low reaches of the keyboard or reduced from melody to percussive tapping. The analogy to neurological recuperation is more than metaphorical. These work-arounds are unique to each player, who must be a veteran musician, with mind and muscle honed by untold hours and years of practice, but at the same time an experimenter willing to recondition radically his or her body and brain. Imagining this process of relearning makes *Stop, Repair, Prepare* seem less about a carefully prepared piano than about a laboriously prepared piano player. "Oh god," says pianist Amir Khosrowpour, of learning to play backward and upside down for *Stop, Repair, Prepare*. "It was terrible. Panic attacks. Extreme frustration. Wondering why the hell I agreed to take on this project." It took months of practice "before things started to click, before my brain began to figure out which way was up and which way was down."[3]

REHABILITATING WARRIORS

The wars in Iraq and Afghanistan have generated a peculiar, bloodless genre of war photography. In such images, we see soldiers engaged with specialized equipment in the half-athletic, half-clinical environment of stateside physical therapy rooms [FIG. 2].[4] Their wounds are healed over but their bodies are often terribly transformed — limbs missing, a skull scooped out, or a face burned partially away. They walk between handrails or on treadmills, or work with the flashcards and adapted writing tools that visualize recovery from brain injury. Politically undecidable, these images can be interpreted in terms of determination, heroism, and resilience — qualities that make the wars seem recoverable — or as damning depictions of what foreign policy wreaks at the level of individual bodies and lives. In either case, each pictured body is haunted by unseen others: by fallen comrades who did not survive, by those still fighting, and by the thousands and thousands of Iraqi and Afghani victims of these wars who are unlikely to have access to the technology and expertise such images showcase. Meanwhile, neither martyred nor triumphant — or perhaps both — the recuperating soldiers embody the grueling mental-physical work of relearning.

3 Amir Khosrowpour, e-mail interview with the author, February 11, 2011.

4 Such imagery is extensive among representations of the current wars. See Tyler Hicks's "The Wounded," photo-essay accompanying the story "A New Kind of Care in a New Era of Casualties" by Erik Eckholm in the *New York Times* online, January 31, 2006, and Ruth Fremson's "After Surviving, Learning to Live," accompanying Lizette Alvarez's "Spirit Intact, Soldier Reclaims His Life," *New York Times* online, July 2, 2010.

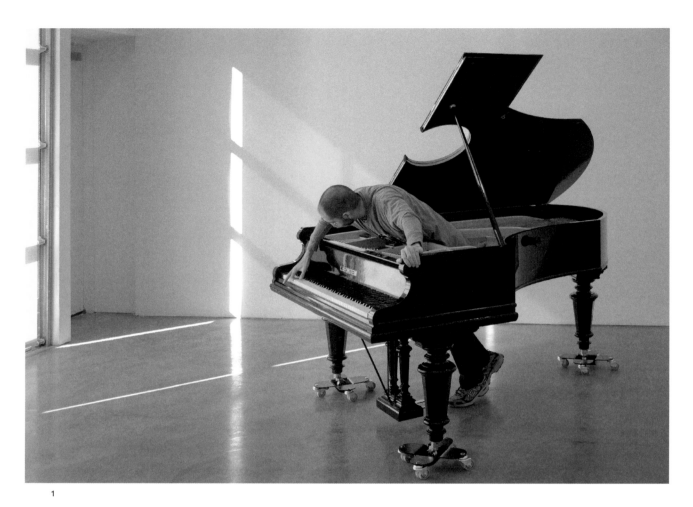

1

2

1. *Allora & Calzadilla* **Stop, Repair, Prepare: Variations on "Ode to Joy" for a Prepared Piano,** 2008; prepared Bechstein piano, pianist (Amir Khosrowpour shown); 40 × 67 × 84 in. (101.6 × 170.2 × 213.4 cm); installation view, Gladstone Gallery, New York, 2009 2. **A NASA-developed "anti-gravity" treadmill,** V.A. Medical Center, Palo Alto, California

IN SPITE of the formal rhyme of the contraption-supported body and the shared conceptual ground in the idea of retraining, it might seem gratuitous to compare such imagery with an artwork about, of all things, piano practice. But Allora & Calzadilla's *Stop, Repair, Prepare* is in fact, like much of their work, a meditation on the way war and militarism suffuse and even drive culture, particularly music. At the heart of the "Ode to Joy" is a Turkish military march, reflecting the vogue for the music of Ottoman army bands in early nineteenth-century Europe. Ironically, given the long struggle over the accession of Turkey to the European Union, the Ode is the official music of that body. It has also been, among other things, the national anthem of Ian Smith's apartheid Rhodesia, the one Western musical composition accepted in China during the Cultural Revolution, and the piece chosen to celebrate Adolf Hitler's birthday. The Haus der Kunst in Munich where Allora & Calzadilla first presented *Stop, Repair, Prepare* was built by the Nazis, and the "Ode to Joy" was played at the building's official opening. The artists chose a Bechstein because a photograph they found in the Haus der Kunst's archive shows the interior furnished with that make of piano—unsurprisingly, since the Bechstein family were dedicated supporters of Hitler.

IT WAS as a refugee of World War II that Walter Benjamin wrote his theses on the philosophy of history, including the famous aphorism: "There is no document of civilization that is not also a document of barbarism."[5] He calls on the historian to "brush history against the grain" to uncover the darker side of cultural treasure. But what is to be done once the barbaric has been brought to light? So-called revisionist histories of artworks are sometimes understood to be pure condemnations, as if the revisionist's aim was to put out of circulation art tainted by the uses to which it has been put. But even as they ask us to stop, repair, and prepare, Allora & Calzadilla nowhere ask us to label, reduce, or abandon. This is why the performance element of their work matters. Attending to the skilled performance at the center of their meditation on the "Ode to Joy" suggests a different attitude toward the histories borne in and by works of art, insofar as *Stop, Repair, Prepare* becomes an image of radical relearning. Relearning is never the same as learning—the new knowledge will always be ghosted by the having-known—but a limping transformation is transformation just the same. In effect, the piece treats "Ode to Joy" itself as a kind of convalescent, rewiring pathways around its historical scars.

5 Walter Benjamin, "Theses on the Philosophy of History," in *Illuminations: Essays and Reflections*, ed. Hannah Arendt (New York: Knopf Doubleday, 1968), 256.

LISTENING TO DANCE

Skill has been artistically suspect for several decades. In the 1960s the de-skilling impulse was made especially clear in dance, as artists such as Yvonne Rainer became fascinated by the movement of performers who had no previous dance training. In her works of the mid-1960s highly skilled, professional dancers might perform alongside people working well outside their artistic comfort zone (including painter Robert Rauschenberg and sculptor Robert Morris). Rainer experimented with teaching complicated choreography to beginning dancers — not, à la *Dancing with the Stars*, to bring them toward a normative ideal, but to generate a raw quality of movement in dance, something almost impossible for trained bodies to replicate. She conversely made work that consists solely of ordinary movement. Her brilliant *We Shall Run* (1963) might be difficult to remember and tiring to perform, but the only kind of movement it requires is an easy jog [FIG. 3]. Even when Rainer worked with highly trained dancers, one of her goals was to develop what she called a "tasklike" quality of movement. The aim was to interrupt the circuits of narcissism and desire, exhibitionism and admiration that constitute the conventional relationship between performer and viewer. She wanted to bring the superhuman performer down to earth.

ALLORA & CALZADILLA were inspired in part by this era of dance history when developing *Compass* (2009), in which the usual relationship between dancer and audience is upturned [FIGS. 4–5].[6] In this piece, the viewer sees only a large, empty room with light filtering in along the edges of a dropped ceiling that bisects what would otherwise be a soaring space. A dancer performing an hour-long solo occupies the room's top half. His floor is the viewer's ceiling. There is a carefully gauged gap of only a few inches between the walls and the hanging ceiling, which ensures that the room's two zones communicate audibly, but not visually. Conventional dance—with its raking stages, skintight costumes, and mirrored walls before which dancers train — is oriented to vision. Allora & Calzadilla developed dance to be heard.

LIKE GYMNASTICS, sports, opera, and even the military, forms of dance could well be added to Italian philosopher Giorgio Agamben's list of what he calls, after Foucault, apparatuses:

Not only… prisons, madhouses, the panopticon, schools, confession, factories, disciplines, juridical measures, and so forth (whose connection with power is in a certain sense evident), but also the pen, writing, literature, philosophy, agriculture, cigarettes, navigation, computers, cellular telephones and — why not — language itself, which is perhaps the most ancient of apparatuses — one in which thousands and thousands of years ago a primate inadvertently let himself be captured, probably without realizing the consequences that he was about to face. [7]

6 Thanks to Jose Kuri and Monica Manzutto for the opportunity to experience *Compass* installed in Mexico City, and to Tom Levin for his insights.

7 Giorgio Agamben, "What Is an Apparatus?" in *What Is an Apparatus? and Other Essays*, trans. David Kishik and Stefan Pedatella (Stanford, Calif.: Stanford University Press, 2009), 14.

Used to shape, train, and orient human beings, apparatuses are the cultural mechanisms that make a living being into a subject, to the extent that anyone's personal identity can be said to be the product of many of these "subjectifying" mechanisms. But not all apparatuses are equal: Whereas a church apparatus can produce a Christian, or a factory can subjectify you as a laborer, contemporary apparatuses seem to Agamben to desubjectify instead. According to him, in contemporary life we encounter ever more apparatuses (every gadget, every trend), and they are more superficial in their subjectifying work, so that rather than providing an identity, they leave us reduced, he says: to a phone number, a statistic, a couch potato. [8]

AGAMBEN'S APPARATUS describes the work done on us when we work with a given tool or system. And this operation is what Allora & Calzadilla's use of performance pinpoints. Perhaps it is only a coincidence that the pommel horses, uneven bars, and other equipment used in competitive gymnastics are referred to as "apparatuses," but the expert performers in Allora & Calzadilla's art have literally been shaped by mechanisms such as opera, gymnastics, or the piano. The work of the apparatus is made audible in their voices or visible in their gestures; it is manifest in musculature and posture. However, the manner in which the artists work with these performers also puts into question some aspects of Agamben's essay, which is marked by a dichotomy between the authentic subjectivizing of the past and the artificial, superficial version in the present, and by a highly schematic view of contemporary media. In particular, Agamben objects to the argument that says that any tool can be used for good or evil, insisting that in terms of its subjectifying function, there is only one way to use an apparatus, or rather to be used by it. That may be, Allora & Calzadilla seem to say. But what if we turn the apparatus upside down?

MIND AS MUSCLE

Neuroplasticity is the name — or buzzword — for discoveries in neuroscience over the last forty years that together have changed the scientific understanding of the human brain and nervous system: from a finely tuned machine to a flexible and adaptive organism. As one popularizer of the term puts it, researchers have been demonstrating "that children are not always stuck with the mental abilities they are born with; that the damaged brain can often reorganize itself so that when one part fails, another can often substitute; that if brain cells die, they can at times be replaced; that many 'circuits' and even basic reflexes that we think are hardwired are not." [9] Among humanists, neuroscience is often perceived as a threat, reducing the complexities of emotion,

8 Ibid., 20–21.

9 Norman Doidge, *The Brain That Changes Itself: Stories of Personal Triumph from the Frontiers of Brain Science* (New York: Viking, 2007), xix.

3. *Yvonne Rainer* **We Shall Run**, performance at the Wadsworth Atheneum, Hartford, Connecticut,
March 7, 1965; Photo by Peter Moore, © Estate of Peter Moore/VAGA, New York, NY

perception, thought, and personality to chemical reactions and genetic predispositions. But the discourse of neuroplasticity suggests the opposite: that conditioning, practice, experience, and even thinking itself actually alter mental matter. Brains are changed and shaped by training — by processes of subjectification — as much as bodies are. Or, as Yvonne Rainer put it back in 1966, "the mind is a muscle."

WHEN KHOSROWPOUR discusses the process of learning to read music anew in order to complete the task Allora & Calzadilla set for him, he describes becoming a beginner, again, in terms of recoordinating his senses. "When learning a new piece, I [normally] look at the music and directly translate what I read to my fingers. Sight to muscle. It took some time to realize that I had to read the music, *hear* what it sounds like, and *then* translate to my fingers."[10] Likewise, to participate in *Compass*, dancers, conditioned to fine-tune the way their bodies look to an audience, had to instead consider the way they sound to one.[11] I am reminded of the cases that pepper the neuroplastic discourse, of patients whose brains rewire damaged senses, using the tickle of an electrode on their tongue rather than their inner ear to balance, being able to "see" images tactilely projected on the skin, or regaining use of a paralyzed arm by putting the *good* arm in a restraint. The neuroplastic analogy helps envision the radicality of those Allora & Calzadilla works in which an apparatus is turned over, displaced, reversed. When they ask performers to work under these new conditions, they ask them to unlearn and relearn — and so perhaps to resubjectify, at least a little. By contrast, what Agamben describes is an inflexible system: each apparatus corresponds to a particular subjectification, no matter how you use it.

THE KEY thing about the discourse of neuroplasticity is that it highlights two capacities: to be shaped and disciplined, and to recover or change. While the idea has taken hold as another marketable fountain of youth — avoid Alzheimer's! Do Sudoku! — our neuroplasticity should be sobering as well as hope-inspiring. Yes, the brain is malleable matter … but, the brain is malleable matter. This bittersweet discourse suits the work of Allora & Calzadilla, I think, as it simultaneously suggests the possibility for real transformation and the odds against it.

WHEN ALLORA & Calzadilla upturn a military tank and reimagine it as an exercise machine they produce new meanings. (Is it sword into plowshare, or plowshare into sword?) But they also produce new *processes*. And while they let us observe those processes in the reinvented skills of the performers, we are also, of course, enacting them. Under the suspended floor of *Compass*, viewers are given a new, almost synesthetic sensory task: listen to dance. The artists draw you into the assignment

10 Amir Khosrowpour, e-mail interview with the author, February 11, 2011.

11 In the first installation of *Compass*, at the Temporäre Kunsthalle, Berlin, the dancers were trained tap dancers — one of the few forms of theatrical dance that does attend to the sound as well as to the look of the dancing body. In Mexico City, where *Compass* was subsequently installed, trained tap dancers were not used, although to increase audibility, the performers, who came from a range of dance backgrounds, all danced in tap shoes.

4

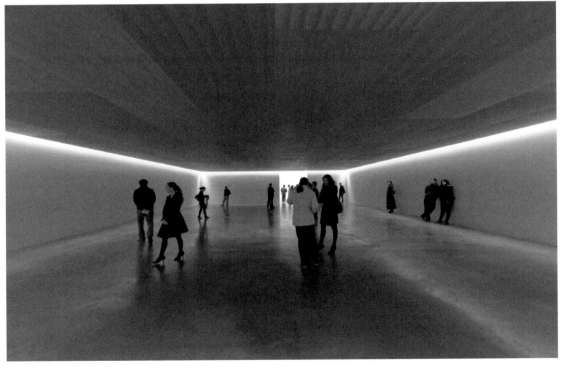

5

4-5. *Allora & Calzadilla* **Compass,** 2009; suspended wooden drop ceilings, dancers; dimensions variable; installation view, Kurimanzutto, Mexico City, 2010

by creating, in collaboration with each performer, dances whose choreography describes very precise shapes in space and over time. These patterns are kept entirely invisible; yet in time, they become perceptible. The work your eyes usually do to track changes in a dancer's position and location can instead be done by your ears, it turns out — if you are willing to do the work of being transformed by a transformed apparatus.

PERHAPS THE same is true of *Algorithm*, commissioned for the 2011 Venice Biennale and consisting of an automatic banking machine crossed with a pipe organ, and here the political consequences of such relearning start to become apparent. What might happen if we could learn to hear our money moving? If our every tap at the machinery of global capital resonated around us like the voice of God? Rewiring an ATM or modifying a musical instrument makes the apparatus newly strange, and the usual way to understand the politics of such a move is through the sense of surprise Brecht called the *Verfremdungseffekt*: in this "alienation effect" a new distance, a space for critical consciousness is supposed to open up between the viewer and the object. But in an innovation-hungry mass-media economy, such effects are fleeting, and in the mid-twentieth century, Frankfurt School thinkers mobilized the word "recuperation" to describe the culture industry's easy absorption of radical artistic innovations. Under different conditions, Allora & Calzadilla invite a rethinking of recuperation in relation to art, insofar as their works offer themselves up as machines for relearning: apparatuses for what might be called, paradoxically, a physical therapy of culture.

VENICE \ VIEQUES: MARKED SITES \ DIVIDED HORIZONS

Yates McKee

Dedicated to Ahmed Basiony (1976–2011)[1]

U.S. representation at this global event ensures that the excellence, vitality, and diversity of the arts in the United States are effectively showcased abroad and provides an opportunity to engage foreign audiences to increase mutual understanding.

U.S. State Department, "Allora and Calzadilla to Represent the U.S. at the Venice Biennale"

The "infinite horizon"... is no longer a line that is drawn, or a line that will be drawn, which orients and gathers the meaning of a course of progress or navigation. It is the opening or distancing of horizon itself, and in the opening: *us*. We happen as the opening itself, the dangerous fault line of a rupture.

Jean-Luc Nancy, Being Singular Plural

IN "HALF MAST\FULL MAST," WHICH PREMIERES

at the 54th International Art Exhibition — La Biennale di Venezia, Jennifer Allora and Guillermo Calzadilla present us with a wall-sized video projection split along a horizontal axis into two simultaneously visible rectangular frames, one situated above the other, and each bracketing a discrete, stationary view. The twenty-one-minute video is divided into a sequence of nineteen parts, all of which share the same logic of doubled frames and coupled views, each with a roughly equal duration of between one and two minutes. Screened as a continuous loop, there is no apparent hierarchy between the parts in spatial or temporal terms, and indeed in approaching the installation the viewer will enter the sequence in a chancelike fashion, at some point encountering the "beginning" of the loop depending on the length of time he or she spends in front of the projection. The video itself is silent, but the viewer's ambient encounter with it in the pavilion site is acoustically marked by the aleatory composition of musical events emanating from Allora & Calzadilla's hybrid organ/ATM, *Algorithm*, installed elsewhere in the building.[2]

1 Ahmed Basiony, the Egyptian representative to the 2011 Venice Biennale, was shot by snipers from the Egyptian Police Forces in Tahrir Square, Cairo, on January 25, 2011, while filming a video about the nonviolent popular demonstrations against the U.S.-backed authoritarian government of Hosni Mubarak. He died three days later. Basiony was killed by weapons supplied to the Mubarak regime by the United States government; the memory of his art and his person will be overtly honored by the postrevolutionary Egyptian Pavilion, but it will also haunt the U.S. Pavilion, which Allora & Calzadilla have laudably transformed into a platform for critically considering the role of the United States relative to the rest of the world.

2 The spatial, temporal, and acoustic experience of the "looped" video installation has become so ubiquitous in contemporary art as to often escape notice. Yet it marks a major departure from the conventions of the movie theater or even the video screening, in which spectators are expected to remain fixed in one contained spot for a finite duration, rather than coming in and out of an installation environment at a whim. While this is not necessarily a development to be lamented, it is important to explicitly highlight it, given that it significantly influences the embodied reception process of works of art, and indeed in some cases the actual design of artworks themselves. See Alexander Alberro, "The Gap Between Film and Installation Art," in Tanya Leighton, ed., *Art and the Moving Image: A Critical Reader* (London: Tate, 2008), 423–29.

AS THE VIDEO OPENS, WE SEE IN THE TOP FRAME

the curvature of an apparently undeveloped coastline, which stands out against an otherwise verdant topography marked on its upper edge by a slim horizontal band of open sky [FIG. 1]. The scene is still, with the exception of an almost indiscernible disturbance of leaves by the wind and the lapping of the sea in the distance. In the bottom frame, we see the dank interior of an abandoned building, illuminated by a row of windows — faintly evocative of a filmstrip — that transforms the exterior landscape into a series of abstract, luminous frames. The top segment of the split screen thus seems to evoke the timeless rhythm of "natural" elements (earth, water, sky), while the bottom speaks to a bounded "cultural" matrix (architecture, photography, and film). Yet the separation between these two domains is itself interceded by a metal pole that cuts vertically through the far left area of each frame, bringing the two segments of the screen into what at first appears to be a seamless alignment. In other words, even though there are two different poles, each enclosed in a discrete frame, together, by virtue of being placed one on top of the other, they form a single, continuous alignment on the surface of the screen. In the bottom segment, the pole extends from bottom to top, bisecting the lower frame completely and seeming to extend vertically "into" the top frame. There, the pole extends only about three-quarters of the way up, leaving a gap between the top of the pole and the upper edge of the frame, thus rendering incomplete the vertical division of the field. The series of axes created by the pole(s) minimally evokes the logic of what Rosalind Krauss once called "the cruciform of all pictoriality," which she described as "the most primitive sign of an object in space: the vertical of the figure projected against the horizon-line of an implicit background." [3] Yet rather than providing a sense of perceptual stability, the figure-ground dynamic generated by the interposition of the pole vis-à-vis the landscape is highly ambivalent, at once separating and joining, dividing and connecting, partitioning and linking the multiple regions of the field. In other words, while the internally split, off-center pole(s) create a kind of figurative projection against the receding expanse of the environmental background, at the same time they contribute to a sense of the screen as a flattened composition suggestive of an asymmetrical grid-structure. This undecideable compositional movement calls to mind Yve-Alain Bois's description of the "aporetic braiding" of Mondrian's late canvases such as *New York City* (1942), which involves the "destruction" of the elementary terms of pictoriality that had subsisted throughout his oeuvre from the early landscapes, to the eventual abstraction of the latter into fields of plus-minus cruciform elements, and ultimately to the decentralized "equilibrium" of line and plane in his works of the early 1930s. [4]

3 Rosalind Krauss, *Passages in Modern Sculpture* (Cambridge, Mass.: MIT Press, 1977), 264.

4 Yve-Alain Bois, "Piet Mondrian: *New York City*," in *Painting as Model* (Cambridge, Mass.: MIT Press, 1994), 162. See also Rosalind Krauss's discussion of Mondrian's *Pier and Ocean (Sea and Starry Sky)* (1915) in *The Optical Unconscious* (Cambridge, Mass.: MIT Press, 1993), 15. See also Jaleh Mansoor's reading of these texts relative to the conjugation of modernist abstraction and postcolonial discourse by Mona Hatoum in "A Spectral Universality: Mona Hatoum's Biopolitics of Abstraction," *October* 133 (Summer 2010): 49–74.

5 I describe the sections of the video as "partitions" because of the rich polyvalence of the word, which shares an etymological root with other words such as part, participate, and party. All of these words denote a simultaneous division and sharing of something common that is necessarily differentiated from within and without, implying a kind of ambivalence, if not violence, as regards the organization of space. Indeed, partition can refer at once to an architectural element that delimits one room from another, to the geopolitical dividing-up of a territory, and to the play between part and whole in the compositional logic of an artwork. In using this term I also intend to echo Jacques Rancière's notion of the *partage du sensible*, or "partition of the sensible," which "establishes at one and

JUST AS THE SPECTATOR BEGINS TO

perceptually map the oscillating spatial terms at work in *Half Mast\Full Mast*, yet another element joins the scene that pushes the existing tensions into even greater instability. From off-camera, a young dark-skinned man in jeans and a T-shirt purposefully approaches the pole in the top frame. With both arms, he grabs the pole at top and bottom and uses it as a lever to raise his entire body from a vertical position standing on the ground parallel to the pole to a horizontal position suspended in mid-air. His body thus forms an imperfect perpendicular appendage to the pole, doubling not only the horizon line of the background topography in that frame, but also the horizontal line separating the two sectors of the overall screen and even the series of horizontals that structure the perforated architectural space pictured in the lower segment. In a remarkable feat of athleticism, the man holds this position for some twenty seconds, subjecting the otherwise rigid rectilinearity of the pole to a slight bending—and thus disalignment from its counterpoint in the lower sector—before his muscular endurance gives way to gravity and he lets himself down to exit the scene. With the withdrawal of the figure and the realignment of the pole, the overall scene appears to return to its original status: visually, it looks the same as it did at the beginning. The enigmatic event, however, leaves a mnemonic trace. Both the landscape appearing in the top sector and the overall screen itself are invisibly marked in our memory by the now-absent body and the cleaving of the unity of the pole(s).

OVER THE COURSE OF ALLORA & CALZADILLA'S VIDEO THE SAME ACT

is performed by twenty-three different men. These acts transpire in a sequence of nineteen "partitions," as I will henceforth call them, that make up the structure of the video.[5] Each partition is itself vertically divided at the exact same location in the overall screen by the pole (the one constant element), but with a different coupling of topographical and architectural sites, many of which are seen in a state of ruin. In the spacing of these partitions, the performer sometimes undertakes this task in the upper segment of the frame, sometimes in the bottom segment, sometimes in both consecutively, and in one case, not at all.[6]

WHAT EXACTLY DO WE WITNESS IN THE

coming-to-pass of these bodily tasks relative to the pole they use for leverage, the sites at which they occur, the compositional network of the video framing the sites in

the same time something common that is shared and exclusive parts. This apportionment of parts and positions is based on a distribution of spaces, times, and forms of activity that determines the very manner in which something in common lends itself to participation and in what way various individuals have a part in this distribution." Jacques Rancière, *The Politics of Aesthetics: The Distribution of the Sensible*, trans. Gabriel Rockhill (London and New York: Continuum, 2006), 12. Rancière's terms resonate closely with the formal, spatial, temporal, and compositional logic of *Half Mast\Full Mast*, as well as with the questions concerning the politics of appearance and disappearance in the landscape of Vieques, the topical *locus* of the video.

6 This process of ephemeral remarking involves yet another dimension that we have yet to comment on, but which involves a visual and metaphorical echoing between the typographic arrangement of the title and the structure of the screen. Treating the title as a kind of word-sculpture in a manner that recalls Robert Smithson's 1966 drawing *A Heap of Language*, the first half of the title is stacked "above" the second half, and, like the screen, it is bisected horizontally. This in turn echoes the horizontal dash separating the two halves of each part of the title, which is then played off of the verticality of the letters themselves. Combining and dividing, joining and separating, the title and the video themselves become bound up in a translocational process of "spacing" relative to each other.

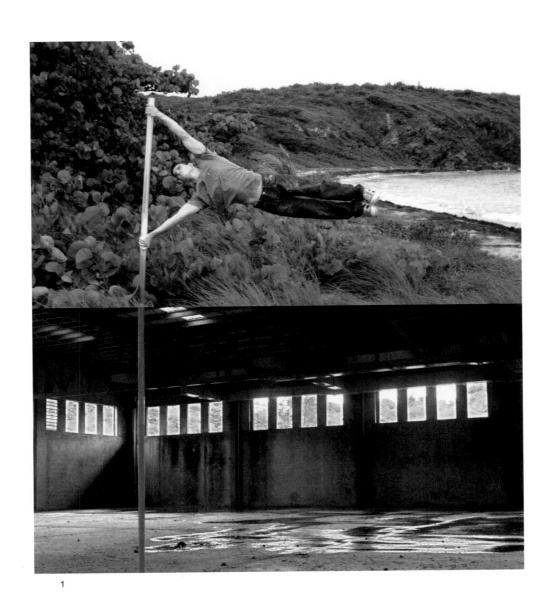

1. **Allora & Calzadilla** **Half Mast\Full Mast**, 2010; high-definition two-channel video, color, silent; 21:11 min.; courtesy of the artists and Lisson Gallery, London; Gladstone Gallery, New York; Galerie Chantal Crousel, Paris; Kurimanzutto Gallery, Mexico City

question, and ultimately the site of the screening-wall itself? An athletic exercise? A dance performance? A sculptural procedure? All of these terms are relevant, but none exhaust the complex articulation of mediums at work in this site-specific, or, as I will call it, *translocational* video installation. In using the word translocational, I mean to suggest that the video stages a relationship of contiguity between apparently distant, unconnected sites, including the actual circumstanes in which the video will be received over time, starting in Venice.

ALTHOUGH THE SITES FEATURED IN THE VIDEO

are irreducibly singular in their ecological, geographical, and architectural texture and could not be mistaken for the stereotypical "nonsites" that some critics have associated with globalization, they are not immediately granted by the video itself any determinate locational identity; they thus retain a certain enigmatic anonymity relative to the majority of Venice spectators. The video in principle has an internal formal logic that works without any overt explication of the sites. Yet, it is important in the discursive context of this catalogue to note that the sites in question pertain to the island of Vieques, an inhabited island off the coast of Puerto Rico. In 1941 the United States Navy purchased two-thirds of the island (the western and eastern ends) from corporate sugar plantations, in the process evicting thousands of caneworkers and their families from the land on which they worked and lived. The land in question was remade as a weapons-testing range and munitions dump, the activities of which had highly deleterious environmental, economic, and health effects for the population that persisted on the remaining one-third of the island under civilian jurisdiction over the course of the past half century. In the 1970s, local fishermen initiated a nonviolent civil disobedience movement against the U.S. Navy, a campaign that involved creative maritime tactics to debilitate navy warships; such protests were both coercively suppressed and hegemonically pacified by federal and Puerto Rican authorities over the following decades. In 1999, however, the inadvertent killing of a Vieques citizen by an errant naval explosive that fell into the civilian part of the island sparked a new protest movement informed by a half century of political and ecological grievances on the part of the population. Thanks to pressure exerted by transnational environmental advocacy networks spanning Vieques, Puerto Rico, and the United States — and global media coverage thereof — in 2003 the navy evacuated the island. The former military areas, however, were transferred not to the civic municipality of Vieques, but rather to the Department of the Interior (DOI), which ironically designated the areas in question as a "wildlife refuge"; the designation has served to exclude the descendents of the former residents of the areas in question from having a say in how such regions

will be developed and managed in the future. Having marked the highly degraded but potentially generative site as purely "natural," the DOI has since worked largely to exculpate the military from its obligations to fully remediate its former testing grounds. In a series of photographs, videos, sculptures, and research publications made in the mid-2000s and grouped under the titular rubric of *Land Mark*, Allora & Calzadilla framed Vieques as a "transitional geography" positioned precariously between the social and ecological wounds of the occupation, on the one hand, and a future-oriented project of survival remediation and sustainable development on the other.[7]

BEFORE DISCUSSING IN GREATER DETAIL

the ways in which the multifarious partitioning and spacing at work in *Half Mast\Full Mast* stage a translocational reframing of the specific sites in Vieques, I wish to address an important question implicitly posed by the physical setting of the installation in which the video will make its first appearance: *What does it mean for an artist to "represent" the United States at the Venice Biennale?* In the most general sense, the artist in this institutional setting is meant to stand in as a particular exemplification of the creative capacities of the nation as a whole relative to the artistic representatives of other nation-states (or at least those with a pavilion at the Biennale). Though not of course under an obligation to put forward anything specifically "about" the United States—such a requirement would indeed contradict the principle of free creativity informing the mandate of the pavilion—the reception of any work presented in the architectural context of the pavilion is overdetermined by this national-representative function. The U.S. Pavilion is necessarily marked by some minimal assertion of the *Americanness* of the work presented therein, and thus connected in some way to the experience, identity, and aspirations of the popular "we," or what Benedict Anderson famously called the "imagined community" of the nation.[8]

WITH THIS NATIONAL-REPRESENTATIVE BAGGAGE, THE U.S.

Pavilion and its counterparts in Venice appear as something of an anachronism from the vantage of the contemporary artistic field. Over the past decade, this field has become increasingly globalized in economic, geographical, institutional, and discursive terms, rendering suspect the very idea that one would assess the practice of an artist in terms of his or her nationality.[9] Certainly, artists still pragmatically interact with nation-based institutions—and often take nationalist ideologies as material for

7 For an extended analysis of this long-term, multifaceted project, see Yates McKee, "Wake, Vestige, Survival: Sustainability and the Politics of the Trace in Allora/Calzadilla's *Land Mark*," *October* 133 (Summer 2010): 20–48.

8 See Benedict Anderson, *Imagined Communities: Reflections on the Origin and Spread of Nationalism* (London and New York: Verso, 1991). For a groundbreaking collection on the various relationships between national frameworks, urban sites, and global exhibitions, including but not limited to the hegemonic (though increasingly relativized) model of Venice, see *The Biennial Reader: An Anthology on Large-Scale Perennial Exhibitions of Contemporary Art*, ed. Elena Filipovic, Marieke van Hal, and Solveig Øvstebø (Ostfildern: Hatje Cantz, 2010). Of particular

relevance is Caroline Jones's "Biennial Culture: A Longer History," 66–87, and Rafal Niemojewski's "Venice or Havana: A Polemic on the Genesis of the Contemporary Biennial," 88–103.

9 On the globalization of the contemporary artistic field, see "Questionnaire on the Contemporary," *October* 130 (Fall 2009); Terry Smith, Okwui Enwezor, and Nancy Condee, eds., *Antinomies of Art and Culture: Modernity, Postmodernity, and Contemporaneity* (Durham, N.C.: Duke University Press, 2008); and *The Biennial Reader* in its entirety. Of special relevance in the latter volume are Charlotte Bydler, "The Global Art World, Inc.: On the Globalization of Contemporary Art," 378–405, and Okwui Enwezor, "Mega-Exhibitions and the Antinomies of a Transnational Global Form," 426–45.

investigation — but many of the most prominent practitioners in the contemporary field are resolutely cosmopolitan, perpetually moving across the globe, "one place after the other," happily escaping any national label or affiliation.[10]

IN MANY WAYS, NO ARTISTS BETTER EXEMPLIFY THE ITINERANCY

and cosmopolitanism of the contemporary field than do Allora & Calzadilla, a culturally hybrid couple whose art historical influences, theoretical research, and working sites span the globe. It is difficult to imagine them "representing" any nation-state, the United States least of all. Does their participation in the Biennale, then, signify merely a good opportunity for a pair of global artists to present their equally global work in a high-profile platform? By the time one has walked through the pavilion building to arrive at the screening-wall of *Half Mast\Full Mast* — starting with *Track and Field*, a sculptural *détournement* of a decommissioned tank that greets spectators at the entrance to the building — the answer will be resolutely "no." Allora & Calzadilla have approached the pavilion and its historical mandate of national representation as sites of institutional critique.[11] Echoing the important precedent set by pavilion-specific projects such as Hans Haacke's *Germania* (1993) and Santiago Sierra's untitled project for the Spanish Pavilion (2003), the artists occupy the U.S. Pavilion in both physical and discursive terms, staging a series of probing challenges to the way it represents and addresses its putative national basis both to its "own" people and to the rest of the world.[12]

IN DELIBERATELY APPROACHING THE INSTITUTION

as a site of critique, the artists telescope several historical strands in the evolution of site-specificity as conceptualized by Miwon Kwon in her book *One Place After Another: Site-Specific Art and Locational Identity*. According to Kwon, site-specificity originally was understood as involving a grounded relation between artwork and site. Rather than existing as a portable, self-contained object, the site-specific work was understood to be welded to a physical location, as in the case of what Krauss called "marked sites," such as Michael Heizer's *Double Negative*.[13] This "physical" sense of site would then be extended to encompass the social and institutional determinations involved in the space of the museum or gallery, which itself became the object of critical interrogation, as in the work of artists such as Daniel Buren or Hans Haacke. Eventually, by the 1990s, according to Kwon, site became entirely unhinged from its determination by physical location, defined now in terms of topical discursive

10 See Miwon Kwon, *One Place After Another: Site-Specific Art and Locational Identity* (Cambridge, Mass.: MIT Press, 2002). Of course, many significant artists have indeed taken up questions of nationalism as a "discursive site" of their work, which is a rather different matter from "representing" a particular nationality. Especially subtle in this regard is Gabriel Orozco, as discussed by Benjamin H. D. Buchloh in "Refuse and Refuge" (1993), in Yve-Alain Bois, ed., *Gabriel Orozco* (Cambridge, Mass.: MIT Press, 2009), 1–15.

11 For the authoritative collection of documents pertaining to this strand of contemporary art over the past three decades, see Alexander Alberro and Blake Stimson, eds., *Institutional Critique: An Anthology of Artists' Writings* (Cambridge, Mass.: MIT Press, 2009).

12 In *Germania*, Haacke physically broke up the tiled floor of the Nazi-era German national pavilion, transforming the interior into a pile of rubble that made the typically smooth experience of spectatorial ambulation into a precarious navigation of ruins. In Sierra's project, he worked with the ambiguous status of the Venice pavilions as portions of terrain under the sovereign jurisdiction of the nations in question; he arranged for a Spanish customs officer to stand guard at the entryway to the pavilion, requiring that visitors present Spanish passports to be allowed entry. Upon entering the pavilion, the "authorized" viewers found that the exhibition consisted of nothing more than an empty, untreated gallery space — exactly as it was left after the exhibition held two years earlier.

13 Rosalind Krauss, "Sculpture in the Expanded Field," *October* 8 (Spring 1979): 30–44.

2

3

2. *Allora & Calzadilla* **Returning a Sound**, 2004; video, color, sound;
5:42 min.; courtesy of the artists and Gladstone Gallery, New York
3. *Allora & Calzadilla* **Under Discussion**, 2005; video, color, sound;
6:14 min.; courtesy of the artists and Gladstone Gallery, New York

concerns. The resurgence of interest over the past decade in questions of land, space, and territory has reshuffled Kwon's (admittedly provisional) narrative of "phases" and retroactively thrown into relief the fact that from its very inception, site-specificity was never simply about the fixity of place. Exemplified by Robert Smithson's dialectic of site/non-site, questions of mobility, traversal, and circulation were essential, as were those concerning the historical and social marking of even the most apparently remote or "natural" environments. In other words, site-specificity was always a matter of the relation *between* locations — including between a site and "itself" as a mediatic trace.[14] "Marked sites" were always bound up with what Krauss, in her original theorization of site-specific works, called "the photographic experience of marking," including that of the film or video camera.[15]

IN BOTH ITS PHYSICAL INSTALLATION

and its internal operations *Half Mast\Full Mast* weaves together all of these mutating art historical strands to create a translocational video, which means, to use Kwon's concluding injunction, "addressing the uneven conditions of adjacencies and distances between one thing, one person, one place, one thought, one fragment next to another, rather than invoking equivalences via one thing after another."[16] In particular, Allora & Calzadilla's video constructs an "adjacency" between the mandate of the Biennale site — representing the "excellence, vitality, and diversity and of the arts in the United States" — and the artists' long-term research concerning the "transitional geography" of Vieques.

BY HIGHLIGHTING VIEQUES IN THIS CONTRIBUTION

to the Biennale, Allora & Calzadilla put additional pressure on the already significant decision by the pavilion committee to destabilize at some level the taken-for-granted status of "U.S. artist" by selecting what the State Department press release calls a "Spanish-speaking team living and working in the U.S. territory of Puerto Rico."[17] Though Allora & Calzadilla were undoubtedly selected on the excellence of their work relative to the global artistic field, the choice of artists living and working in Puerto Rico also entails an inadvertent acknowledgment of the history of hemispheric expansion on the part of the United States.[18] Though subject to U.S. law and possessing citizenship, residents of Puerto Rico nonetheless have an ambivalent political relationship

14 See Yates McKee, "Land Art in Parallax: Media, Violence, Political Ecology," in Kelly Baum, ed., *Nobody's Property: Art, Land, Space* (New Haven: Yale University Press, 2010).

15 Krauss, "Sculpture in the Expanded Field," 41.

16 Kwon, *One Place After Another*, 166.

17 The decision to make Allora & Calzadilla the U.S. national representatives for 2011 was made by the U.S. Department of State after consultation with the Federal Advisory Committee on International Exhibitions (FACIE), a committee convened by the National Endowment for the Arts.

18 It is important to note that Allora & Calzadilla are not the first artists to represent the United States at Venice associated with cultural, regional, or racial "otherness" vis-à-vis the white, male-dominated history of postwar U.S. art. In recent decades Robert Colescott, Felix Gonzalez-Torres, and Fred Wilson have all been selected, and, with varying degrees of explicitness, have interrogated the national-representative function assigned to them

by this honorific institution. And yet, the geopolitical status of Puerto Rico as an "unrepresented" quasi-colonial supplement to United States makes the selection of Allora & Calzadilla unique in the history of the U.S. Pavilion. That said, it is important to make the further point that Allora & Calzadilla do not identify as "Puerto Rican artists" in any identitarian or nationalist manner, despite having produced a number of works that take Puerto Rico and its history as sites of concern. In fact, neither artist is "from" Puerto Rico in any original sense. Allora is of Italian-American heritage from New Jersey, and Calzadilla is originally from Cuba but relocated to Puerto Rico in his youth. Their decision to live, work, and teach in Puerto Rico — and to embrace the island as their geographic base in the U.S. Pavilion publicity materials — is thus a politically contingent form of regional identification rather than any culturally essential affinity.

to the United States given that the territory has long been governed as a quasi-colonial possession.[19] Lacking statehood, legislative representation in Congress, and the right of its residents to vote for president, Puerto Rico is thus a kind of second-class supplement to the United States, an additional member that does not quite belong but has played a constitutive, economic, and geopolitical role for the United States for more than a century. The island of Vieques is, by turn, on the margins of the already marginalized territory of Puerto Rico. If the selection of Allora & Calzadilla was, among other things, a laudable affirmation of the diversity of the United States, then the artists push that gesture of national inclusion to its limit by drawing attention to a doubly marginalized site that suffered from the environmental fallout of that nation's worldwide military-industrial complex.

"HALF MAST\FULL MAST" IS THE THIRD IN A SERIES

of videos by Allora & Calzadilla concerning Vieques in which objects and bodies are brought together in quasi-sculptural performative assemblages.[20] In the first video, *Returning a Sound* (2004), a young man on a motorbike that has been retrofitted with a trumpet on its muffler rides around the formerly restricted areas of the island, creating a sort of aleatory soundtrack that the artists have described as an "anthem" for Vieques [FIG. 2]. In *Under Discussion* (2005), another young man retrofits an upturned conference table with an outboard motor, transforming it into a watercraft that he then pilots around the coastline of Vieques [FIG. 3]. In both cases, the vehicle/performer assemblage enacts a kind of retracing of the island's contours, highlighting ecologically degraded areas. This retracing is performed in such a way as to simultaneously celebrate the victory of local residents over the military occupation and draw attention to the ongoing indifference of the U.S. government to the economic and ecological living conditions on the island in the aftermath of the military evacuation.

"HALF MAST\FULL MAST" EXTENDS THE ARTISTS' CONCERN WITH

Vieques elaborated in the *Land Mark* videos, although here the artists deploy not an automotive vehicle but rather the deceptively simple sculptural device of a pole, which is staked at various locations across the island. Though unremarkable as a physical object, the peripatetic pole becomes a "site-marker" that, in collaboration with the framing function of the camera, fractures the apparent unity of the landscape in which it is situated by setting into motion the "aporetic braiding" between figure and ground described earlier.[21] Informed by a concern with the contextually contingent nature of aesthetic meaning that dates back to Duchamp, precedents for such an approach to object-placement can be found in twentieth-century European versions of institutional critique, especially the "poles" of André Cadere and the stripes of Daniel Buren.

19 See Jose Trias Monge, *Puerto Rico: The Oldest Colony* (New Haven: Yale University Press, 1997). Monge's book is a highly informative history of the second-class treatment afforded to Puerto Rico and its residents by the United States; the book, however, ultimately takes a proindependence stance, advocating for Puerto Rico to become a sovereign nation-state. Whatever one thinks of such a position, it is important to note that it is very

controversial in Puerto Rico itself, and competes with others advocating the integration of Puerto Rico into the United States as the fifty-first state.

20 See McKee, "Wake, Vestige, Survival," and Hannah Feldman, "Sound Tracks: The Art of Jennifer Allora and Guillermo Calzadilla," *Artforum*, March 2007, 336–41, 396.

21 Though I derive the term "site-markers" from Krauss's discussion of "marked sites" (see above), it also echoes

Rather than adhering to what Krauss called the "placeless" portability of modernist sculpture—the presentation of objects whose significance in principle remains continuous regardless of context due to the elevating function of the pedestal—such practices deployed objects as differential markers relative to otherwise familiar or taken-for-granted environments. A more precise art historical debt, however, is owed to Smithson's coupling of site/non-site, exemplified by his *Yucatan Mirror-Displacements* (1969), in which he temporarily installed a collection of square mirrors in various configurations at selected sites in the Yucatán in order to both reframe and "displace" the environment in question—a process he then displaced further through photographic documentation and print-circulation in the pages of *Artforum* [FIGS. 4-6]. Recalling Smithson's technique, *Half Mast\Full Mast* decenters and multiplies the landscape, partitioning it in a kind of *mise en abyme*.[22]

"HALF MAST\FULL MAST" ADOPTS A MORE

somber and meditative tone compared to the earlier videos. Instead of a mobile camera following the trajectory of a playfully absurd vehicle, here each partition is given over to an intensive, almost structural-cinematic stillness that is in turn broken by the minimal bodily act of the performers as they leverage their own weight with the site-marker. If in the two earlier videos we witness the mobile energy of a "victory lap" inscribed in the wake of the watercraft or the indexical score of the motorbike as it accelerates across the terrain, the inscription process at work in *Half Mast\Full Mast* occurs as the performers deploy their bodies as compositional elements that are set off against landscape views already framed and organized as a series of vertical and horizontal axes by the stationary camera. These asymmetrical, gridlike compositional structures tremble with tension, which is brought out further by the actual trembling of the performers' bodies as they struggle to retain their grip on the site-marker before succumbing to the force of gravity. Allora & Calzadilla's pole/body assemblage thus forms a kind of tensional process-sculpture in the vein of Richard Serra's early prop pieces of the late 1960s [FIG. 7] or, more proximately, Dennis Oppenheim's *Parallel Stress* (1970), in which the artist photographed his body horizontally suspended like a precarious "bridge" between two cinderblock walls, echoing the structure of an actual metropolitan bridge in the background of the photograph [FIG. 8]. In *Half Mast\Full Mast*, the performer's body allows a kind of inscriptive or drawing process to take place, whereby the landscape is provisionally stricken-through by the line created by the precariously outstretched body. The landscape is, as it were, put *sous rature* ("under erasure")—cancelled out while still remaining visible.[23] Recalling the ephemeral—though photographically preserved—landscape markings of Ana Mendieta, the body leaves a mnemonic trace after it has disappeared from the scene, calling the self-evidence of the site into question.

the landscape/camera dialectic developed by Nancy Holt throughout the 1970s, especially in her Locators series, which involved the staking-out of pole-bound viewfinders at specific sites; see Alena Williams, "Concrete Traces: Nancy Holt's Speaking Media," in Williams, ed., *Nancy Holt: Sightlines* (Los Angeles and Berkeley: University of California Press, 2011), 183–201.

22 Robert Smithson, "Incidents of Mirror-Travel in the Yucatan" (1969), in *Robert Smithson: The Collected Writings*, ed. Jack Flam (Berkeley and Los Angeles: University of California Press, 1996), 119–33.

23 "Translator's Introduction," in Jacques Derrida, *Of Grammatology*, trans. Gayatri Chakravorty Spivak (Baltimore: Johns Hopkins, 1976), xvii.

5

4

6

4–6. *Robert Smithson* Yucatan Mirror Displacements (1–9), 1969; three from
a series of nine cibachrome prints from chromogenic 35mm slides; Solomon R.
Guggenheim Museum, New York; © Estate of Robert Smithson/Licensed by VAGA,
New York, NY; images courtesy of James Cohan Gallery, New York/Shanghai

INDEED, FOR MOST VIEWERS OF THE VIDEO

in the context of the U.S. Pavilion, the locational identity of the sites depicted will be far from self-evident. As the nineteen partitions of the video come to pass, we see a number of architectural structures in various states of evacuation, ruin, and decrepitude. No overt explanation is provided as to what "we" as a national or international public of spectators are looking at; even if one studies all the topographical and architectural singularity of detail the video offers forth, it remains cryptic, enigmatic, and haunting in its anonymity for the untrained eye.

"HALF MAST\FULL MAST" IS THUS, IN A CERTAIN WAY, ADDRESSED TO AN

audience that is structurally and geopolitically absent from Venice as a site of spectatorship. To the residents of the tiny island of Vieques (population 10,000), almost every frame in *Half Mast\Full Mast* would present a recognizable site of political and ecological conflict. Architectural ruins pertaining to the military occupation, the civil disobedience movement, and various development initiatives appear throughout, often coupled with apparently untouched natural settings that in fact bear the invisible traces of violence. But in each case, the site in question has been marked by the artists with the framing device of the pole, in turn used as a propping device for the performers. The appearance and subsequent disappearance of the body relative to the sites give the process a mnemonic dimension that speaks to the politics of remembrance and obliteration embedded in the Vieques landscape.

THE ABSTRACT COMPOSITIONAL LOGIC OF SPACING

at work in *Half Mast\Full Mast* is articulated with reference to the cultural-semiotic convention announced in the title, namely, the flying of a flag at half-mast to mark a period of national mourning or distress. The practice originates in maritime culture, and was meant to make a space at the top of the ship's mast for the "invisible flag of death" to be flown.[24] In other words, it is an elementary semiotic code that involves seeing what is not there, or at least visually marking the limit or place of absence that cannot in and of itself be represented. In the United States and its territories, flying the national or state flag at half-mast can be done only with an executive mandate; in other words, an official decision must be made as to whether the death or distress in question is worthy of official recognition in the form of a flag-lowering. In Judith Butler's words, the lowering of a flag involves a framing and regulation of the "grievability of lives"—which is a condition for their viability or survivability in the first place.[25] The "normal" condition of a flag is of course that it be flown at full mast,

24 Julian Franklyn, *Shield and Crest: An Account of the Art and Science of Heraldry* (London: MacGibbon & Kee, 1961), 176.

25 Judith Butler, "Survivability, Vulnerability, Affect," in *Frames of War: When Is Life Grievable?* (London: Verso, 2009), 33–62.

functioning as a positive indicator of state authority and collective identification. But this "normal" condition is perpetually haunted by the "invisible flag of death" whose place it takes and by the vanished "others" who are not given the privilege of having their absence be marked.

THE POLITICS OF IDENTIFICATION, GRIEVABILITY, AND SURVIVABILITY

involved in the apparently simple protocols of flag-lowering informs Allora & Calzadilla's decision to give the performers in the video the task of transforming their bodies into temporary, unofficial "flags" hoisted from the minimal prop staked out by the artists at sites across the island. These bodily flags, however, are not tethered to the pole and held aloft by wind currents; rather, the relation between performer and prop is one of intense physical exertion and psychological determination. Recalling to various degrees the minimal task-performances undertaken by dancers such as Yvonne Rainer and the experiments with corporeal endurance and discipline by artists such as Vito Acconci, Chris Burden, and Oppenheim, the extended, horizontalized body we see here acts to resist gravity until the very moment its own singular capacity to hold itself up has been exhausted. Though dignified and concentrated, the performers are nonetheless engaged in a kind of struggle to hold on to, to hold up, their position as flags relative to the sites in question, which is to say, to *sustain* an appearance that is otherwise precarious.[26]

THE TEMPORAL DURATION OF EACH PERFORMANCE

is thus a kind of index of that singular body's ratio of weight and muscular strength, a fact that compounds the already complex relationship between the individual body and the collective entity that flags are typically supposed to represent. In other words, in "becoming" a flag, in however absurd a manner, the performers exacerbate the metonymic logic of representation, which is to say, the reciprocal standing-in for one another of parts and wholes. As a cultural form concerned with interpellating the "we" of the nation-state, the flag is meant to psychically bind citizens to an abstract formal design that, as famously demonstrated by Jasper Johns's *Flag* (1954–55), is simultaneously an optical surface, a material object, and a readymade symbolic sign.[27] Citizens project their own particular body and mind onto the surface/object/sign of the flag, making it coterminous with the imagined collective entity of the nation. Yet in *Half Mast\Full Mast*, the particular body of the performer "literally" stands in for the flag, attaching itself to the pole in such a way as to contaminate the official place signifying the general unity of the people.[28]

26 I place the word sustain in italics here to mark its etymological derivation from the Latin verb *sustinere*, "to hold up, endure," which itself derives from *tenere*, "to hold." On the politics of sustainability as an ecological concept as deployed in art and design, see Yates McKee, "Haunted Housing: Eviction, Ecocriticism, and the Biopolitics of Sustainability in New Orleans," *Grey Room* 30 (2008), 84–113, and McKee, "Wake, Vestige, Survival."

27 On the formal and semiotic logic of Johns's flags, targets, and maps, see Fred Orton, *Figuring Jasper Johns*

(Cambridge, Mass.: Harvard University Press, 1994). Ann Wagner supplements Orton's approach with a politically charged discussion of the formal logic of hegemonic representation relative to Johns's *Flag* in "According to What?" *Artforum*, November 2006, 272–77.

28 On the ambivalent relation between part and whole in political representation, see Ernesto Laclau, "Populism, Representation, and Democracy," in *On Populist Reason* (London: Verso, 2005), 157–73. Also see Carrie Lambert-Beatty's discussion of Yvonne Rainer's

OBVIOUSLY, THE ABSURD LITERALIZATION

of the function of the flagpole and the raising or lowering of its bodily attachment have no proper authorization, no commanding power, no identificatory compulsion; even though the performative ritual of "flying" is undertaken, it is not done by the right person in the right time, at the right place, with the right materials. It is something more akin to the "infelicitous performative" identified by J. L. Austin in his discussion of the proper context and conditions for a speech-act to take effect.[29] Austin famously dismisses the example of the unauthorized "low-type" who bursts onto the scene to make a declaration of marriage or to christen a ship; lacking the "proper" conditions, such a speech-act is moot, and not really an act at all. Having failed to meet the predetermined criteria, the performance does not do what a ritual is supposed to do: reproduce the status quo of the given social order and the definite distribution of roles upon which the latter depends. Yet, as Thomas Keenan has posed, what if something else *does* happen when those who are unauthorized to do so nevertheless simulate an official ritual and make "themselves into something else by rewriting ... the context."[30]

SUCH A PERFORMATIVE "REWRITING" WAS ALREADY OPERATIVE

in the two earlier videos in Allora & Calzadilla's Vieques series: in *Under Discussion*, the figure of the conference table is appropriated and taken for a countertouristic excursion around the island; in *Returning a Sound*, the trumpet/bike issues a noise that is at once an emergency siren and a celebratory anthem echoing across the terrain. Similarly, the pole/body assemblage of *Half Mast\Full Mast* functions to reframe sites across the island variously in terms of raising (a celebratory gesture associated in military terms with success, victory, or conquest) and lowering (an indicator of mourning, distress, or crisis). Over the course of the nineteen partitions of the video and the internal divisions thereof, however, any simple separation between "half" and "full" is impossible to secure. When the body is raised in the top frame of a given partition, it lends to the overall composition a sense of a "raising"; when it is undertaken in the bottom frame, the overall composition reads as "lowered." But are the sites in the upper frame necessarily ones of affirmative development and those in the bottom ones of negligence or crisis? And what about the frames in which only the pole is shown and no body makes an appearance? The difficulty we have in determining any clear-cut meaning for these apparently semiotic cues suggests the uneven and faltering temporality of "progress" in the postmilitary reconstruction of the island.

remarkable conjugation of the politics of the flag as both a sign and a material object with her tasklike minimalist dance scores in *Trio A with Flags*, performed as part of the *People's Flag Show* at the Judson Memorial Church in 1970. Carrie Lambert-Beatty, *Being Watched: Yvonne Rainer and the 1960s* (Cambridge, Mass.: MIT Press, 2008), 210-13.

29 J. L. Austin, "Performative Utterances," in *Philosophical Papers*, 3rd ed. (London: Oxford University Press, 1962), 239-40.

30 Thomas Keenan, "Drift: Politics and the Simulation of Real Life," *Grey Room* 21 (Fall 2005): 105. Also see Carrie Lambert-Beatty's reference to Austin's "infelicitous performative" in her discussion of the "parafictional" tendency in contemporary art and activism as exemplified by groups such as the Yes Men and 0100101110101101, "Make-Believe: Parafiction and Plausibility," *October* 129 (Summer 2009): 61.

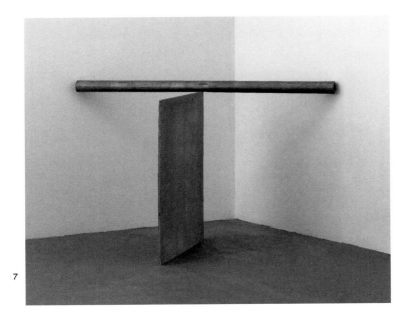

7

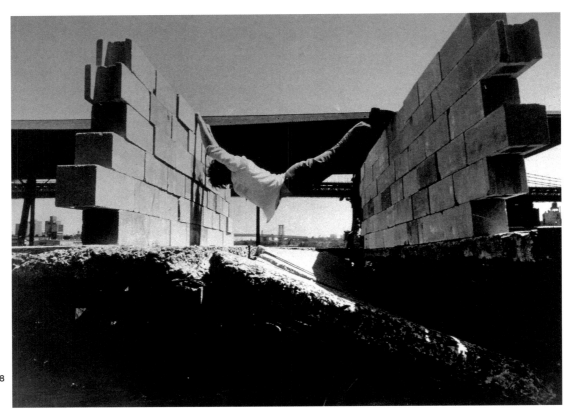

8

7. *Richard Serra* **Equal (Corner Prop Piece)**, 1969–70; lead plate and lead tube rolled around steel core; overall dimensions: approx. 52 × 84 1/4 × 92 in. (132.1 × 214 × 233.7 cm); The Museum of Modern Art, New York, Gilman Foundation Fund (728.1976.a-b) 8. *Dennis Oppenheim* **Parallel Stress – a ten minute performance piece – May 1970. Photo taken at greatest stress position prior to collapse. Location: Masonry block wall and collapsed concrete pier between Brooklyn and Manhattan bridges** (detail); courtesy of the Dennis Oppenheim Estate

IN LIGHT OF THE GENERAL SENSE OF PRECARIOUSNESS

telegraphed by the video, it is significant in ecological, or better yet, *biopolitical* terms that the semiotically ambivalent ritual of the flag-raising is undertaken in front of the camera by *living bodies*.[31] Biopower was understood by Michel Foucault as the ensemble of techniques deployed by the modern state to manage the interrelation among populations, territories, and resources—in short, the totality of life-support systems necessary for the functioning of a capitalist economy and the reproduction of a living workforce. Rather than being administered exclusively from above, however, biopower for Foucault entails the emergence of demands on the part of populations concerning the negligence or abuse of life-support systems (health, food, water, air, housing, education, infrastructure) by the very state aiming or claiming to optimally manage that population.[32] As Butler argues in her discussion of grievability cited above, among the necessary "sustained and sustaining conditions of life" in the biopolitical sense is access on the part of particular lives to the realm of appearance, a realm whose frames or borders must be constantly challenged and remade in order for the lives in question to register as worthy of being sustained.[33]

THE SITES REFRAMED BY THE ARTISTS

and their performers in *Half Mast\Full Mast* should thus be viewed biopolitically in Butler's sense, which encompasses both the material and the mediatic conditions required for sustaining life. Through the meticulous compositional weave of horizontal and vertical axes in each frame—further exacerbated by the raising and lowering of the performers' bodies—Allora & Calzadilla complicate any stable figure-ground relationship that would secure our relation as viewers to the sites in question. As noted above, the artists conjure an absent counterpublic for these sites: the people of Vieques itself and their capacity to read the landscape in terms of the often invisible histories inscribed therein. Spaces and objects that appear as merely empty or incidental environmental backdrops to the minimal activity of the performer are in many cases highly charged locations. Take, for instance, the first coupling of frames described at the beginning of this essay. The apparently undeveloped coastline in the top segment was a central site in the former bombing range and remains massively contaminated. The lower segment, featuring the strangely cinematic architectural interior, is the ruin of a never-completed sports complex that was begun by the Puerto Rican government in the 1970s as part of a development package aimed at pacifying the population in the aftermath of the first generation of civil disobedience activism against the U.S. Navy.

31 Citing Judith Butler's *Precarious Life: Powers of Mourning and Violence* (New York and London: Verso, 2004), Hal Foster has suggested that "precarity" is the exemplary trope in both political and formal terms for the best artworks of the past decade, including those of Paul Chan, Thomas Hirschhorn, and Isa Genzken. Foster, "Precarious," *Artforum*, December 2009. Pamela Lee draws on Foucault's notion of biopower in her discussion of the entwining of living bodies and media systems in 1970s performance and video art in "Bare Lives," in Leighton, *Art and the Moving Image*, 140–57.

32 Michel Foucault, *The History of Sexuality, Part 1*, trans. Robert Hurley (New York: Vintage, 1976).

33 Butler, *Frames of War*, 52.

IN ANOTHER COUPLING OF SITES, WE SEE A WEATHER-

beaten fortresslike structure on top of a hill, and in the lower segment a covered, open-air patio filled with empty benches and vertically punctuated by a series of cement columns [FIG. 9]. Banal in and of themselves, these images are photographically framed and sculpturally supplemented (by the pole) in such a way as to train our attention on them, and Viequenses would recognize both sites. The structure in the top segment is Monte Carmelo, and the lower segment shows the ruins of a ferry terminal on the western edge of the island. When hundreds of families were evicted in the 1940s to make way for the bombing range on the eastern side of the island and the ammunition dump on the western side, many of the evictees resettled, without official permission, on land between the designated military and civilian areas of the island. Among these families was that of Carmelo Felix and his wife, Maria Velásquez, who erected a homestead on top of a hill in this "buffer zone," replete with animals, gardens, and an apiary. After years of de facto residency there, however, the family was accused of trespassing on military land; federal marshals were sent in to evict them. Refusing to be forced out, and with the support of fellow Viequenses, the family engaged in civil disobedience (including allowing the marshals to unwittingly disturb the bee boxes, the inhabitants of which swarmed the officers, according to local memories). The family's resistance eventually created such a logistical difficulty for the marshals that they aborted the effort, implicitly acquiescing to the family's right to remain in the home. Monte Carmelo thus became a kind of unofficial historical landmark for island residents. The acts of civil disobedience there prefigured the success, a decade later, of protesters in tactically challenging and wearing down the resolve of the military to remain on the island at all.

THE RUINS SEEN IN THE LOWER

segment of the screen pertain to a remarkably recent infrastructure project that was never actually completed. The ferry terminal would have connected Vieques much more efficiently to mainland Puerto Rico, facilitating the nascent — and internally contested — ecotourism industry on the island. Suspended in mid-construction in 2004 due to budgetary limitations, the evacuated and overgrown ferry terminal site is what Smithson would call a "ruin in reverse," speaking not to the faded glory of a monumental past but to the faltering of "progress" in the present.[34]

34 Robert Smithson, "A Tour of the Monuments of Passaic, New Jersey" (1967), in Flam, *Robert Smithson*, 72. Smithson also took an interest in the "terminal" as both an allegorical figure and an infrastructural object; indeed, an early version of *Spiral Jetty* was designed for a never-realized air-terminal complex at the Dallas–Fort Worth airport. See "Towards the Development of an Air Terminal Site," in Flam, *Robert Smithson*, 52–60.

THE COUPLING OF MONTE CARMELO AND

the unbuilt ferry terminal in this partition *Half Mast\Full Mast* is exemplary for the video as a whole insofar as it draws out a relationship between the histories of violence and resistance in the past and the conundrums of tourism and sustainable development in the postmilitary transitional period.

IN THE TOP SEGMENT OF ANOTHER OF THE NINETEEN PARTITIONS WE

see nothing but an open, forested terrain that expands infinitely to the horizon line, which bisects the frame into one band of land and another of sky [FIG. 10]. Aside from the temporary site-marker of the pole, the landscape appears pristine—there is no sign whatsoever of the fact that less than a decade ago this field was strewn with used munitions, leaving the soil and water dangerously contaminated. In the lower segment of the partition, we see a similar horizon, but it is shot from a greater distance so as to include a flat, leveled dirt road in the foreground. In the background, parallel to the road and partially overgrown by vegetation is a white concrete barrier. On its surface the viewer can just make out the spray-painted name "David Sanes Rodríguez," the faded words bookended by Christian crosses. The name itself is crossed through by the site-marking pole installed at the scene by the artists closer to the camera. Vertically bisecting the horizontal white barrier, the pole creates a cruciform structure, and does so repeatedly with the other horizontal elements of the landscape as they ascend above the barrier: a chain-link fence, the horizon line of the background terrain, a band of clouds, and finally a telephone wire that cuts across the entire frame at the very top. Standing directly in front of the barrier several feet to the right—and also crossing out a letter of the name—is another pole, this one apparently permanent, which echoes the series of cruciform intersections made by the site-marker. Farther to the right, and situated behind the barrier, is the strong vertical of a telephone pole that creates cruciforms with the background landscape, eventually leading up to an actual wooden cross at the place where the telephone wires are supported. In this partition, Allora & Calzadilla stage a remarkable multiplication of formal and metaphorical echoes, with "cross" functioning both as a kind of forensic marker—"X marks the spot"—and as a cultural-religious sign symbolizing suffering and martyrdom. These senses come together at the site in question: the spot on the outer edge of what was formerly the civilian zone of the island where Sanes, a private security guard, was killed by an errant bomb in 1999. His death was the immediate catalyst for the reactivation of grievances on the part of the Vieques population spanning several generations, and it led to the three-year civil disobedience campaign against the military that ultimately succeeded in forcing

the latter to evacuate. A site of collective mourning and political self-assertion for Viequenses that is otherwise barely marked as such, in *Half Mast\Full Mast* it is reframed as a countermemorial split between the actuality of the site in question and its videographic recording. The physical instantiation of this memorial is the ephemeral bodily task of the performer, hoisting himself at "half-mast" in the lower frame containing the inscription of Sanes's name. As in other partitions of the video, the "climax" of the performance is the bending of the pole by the body's weight in such a way that it creates a momentary cleavage in the otherwise continuous, though decentered, sense of visual orientation. The performance is thus displaced, preserved, and recontextualized as a mediatic trace to which the audience in Venice now bears witness.

THE LEGACY OF THE CIVIL DISOBEDIENCE

movement is evoked in another of the partitions with reference to the coastal waters off the island, where in the 1970s fishermen initiated guerrilla tactics against U.S. Naval vessels performing weapon-testing exercises in what had been customary fishing zones. In the lower frame, the site-marker bisects dramatically with the horizon line of the sea to form an off-center X, which is echoed a few feet to the right by the convergence of a torn grid of wired fence overlaid almost perfectly with a jetty in the background to create yet another cruciform intersection [FIG. 11]. The fence in question was, during the period of civil disobedience, a crucial threshold between demonstrators and the military—cutting through it was part of a risky act of trespassing onto the live bombing range as a means of forcing a cessation of the military exercises and drawing media attention to the grievances of protestors. It now stands as a decrepit and all-but-forgotten remnant of the territorial authority of the military. In the upper frame of this partition, the site-marker cuts the same jetty-structure that appears from a distance in the lower frame, though the latter is now shown from a head-on angle. From this new angle, the jetty extends from the foreground of the camera's view into the distance in a sort of readymade, off-center study in linear-point perspective. Constructed as a narrow grid of beams pointing toward an island in the distance, the jetty is affixed with a radar tower for facilitating communication among fishermen at sea, who now, since the evacuation of the military in 2003, have free range over the still-contaminated coastal waters of Vieques. Hoisting himself up on the site-marker, the performer creates an imperfect correspondence with the island in the distance, as well as with the horizontal axes of the jetty's grid.

ANOTHER CONTEMPORARY ECHO OF THE HISTORY OF POLITICAL ACTIVISM

in Vieques is evident in a subsequent partition whose bottom frame features a site-marker placed in front of a small, nondescript building partially ensconced behind tropical foliage [FIG. 12]. In the top frame, the site-marker has been planted in an office space (presumably the interior of the building shown below) that includes a desk with microphones, a gridded file cabinet, and a wall decorated with a photograph, a framed document, and Vieques flag (consisting of blue horizontal bands and the insignia of a colonial fortress), none of which are fully legible in the video. Unlike the relatively open sites of the other performances, this space is small and claustrophobic, but certainly not abandoned — it looks to be a place of ongoing work, and also of public address and media appearance of some kind, given the microphones. The site in question is the office of the Committee for the Rescue and Development of Vieques (CRDV), a non-governmental advocacy organization that evolved out of the civil disobedience movement. Headed by local public intellectual Robert Rabin, CRDV has been a key actor in pressing the federal government to ecologically remediate Vieques in its entirety; it is also an important model in its concerns with sustainable and equitable development of the island in the aftermath of the navy's departure. Among other things, this has involved a critique — though not a simple rejection — of the emergent status of Vieques as a site of tourism-based development.

SEVERAL EXPLICIT SIGNS OF THIS DEVELOPMENT

appear in *Half Mast\Full Mast*, most conspicuously in the form of the W Hotel logo that appears in the lower frame of another of the partitions [FIG. 13]. In that example, the top frame shows a picturesque seascape, with the colorful if slightly ramshackle array of rooftops in a seaside town standing out against the verdant hills as they extend toward the coast. In the bottom frame we see what appears to be a freshly construct-ed road that leads up to the prominently branded entrance of the W property. As the performer undertakes his "half-mast" reframing of this site, we witness several service trucks entering the compound, there to provide an optimal luxury experience for the elite Northern tourists staying inside.

THERE ARE RISKS IN MAKING LUXURY TOURISM THE PRIMARY

development engine of Vieques. Job creation in such low-wage service sectors involves very few possibilities for social mobility and furthermore is dependent upon the seasonal whims of Northern tourists. Among the initiatives undertaken by the CRDV to explore alternative sustainable development models for the island is a computer literacy and microcredit training center set up by Milda Rabin (the spouse of Robert

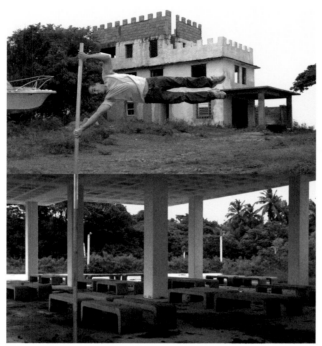
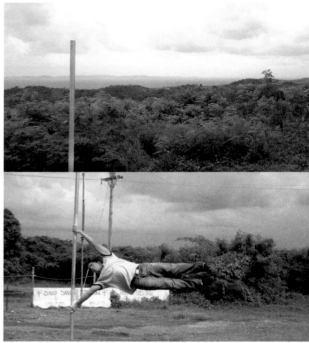
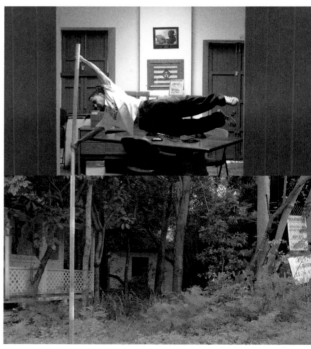

12

9-14. *Allora & Calzadilla* **Half Mast\Full Mast**, 2010; high-definition two-channel video,
color, silent; 21:11 min.; courtesy of the artists and Lisson Gallery, London; Gladstone Gallery,
New York; Galerie Chantal Crousel, Paris; Kurimanzutto Gallery, Mexico City

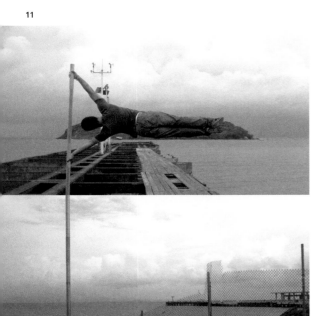

14

Rabin) for high school and college students interested in eventually developing their own professional careers and commercial enterprises in Vieques (including, for instance, the cultivation of green-collar industries at the microlevel of the island). Significantly, the only partition of *Half Mast\Full Mast* to feature other people beyond the performer is one that involves the placement of the site-marker inside the CRDV training center, which appears in the upper frame above a landscape view marked in the distance by a military ruin [FIG. 14]. As a female professor lectures to students at work at their computer stations in a classroom decorated with landscape photographs of the island, the performer enters the scene to undertake the same bodily action that has occurred in all of the other partitions. As it is staged in the upper frame of the partition, the performer's act makes the overall partition into a "full mast," a salute to the efforts of the training center and the young people in whose potentiality it is investing.

APPEARING NEAR THE END OF THE VIDEO, THIS

is the sole "populated" partition of *Half Mast\Full Mast*, and it brings out a metaphorical valence of the bodily performances in terms of biopolitical *training*.[35] In order to develop their impressive capacity for endurance and concentration, the performers have evidently undergone athletic training, a theme taken up by Allora & Calzadilla throughout their overall Venice exhibition in order to highlight the historical resonance between the Biennale and the modern Olympic games. These two events were founded within a year of each other in the mid-1890s as complementary ways, in the words of Caroline E. Jones, to "sublimate military desires." Jones writes, "Like the Biennial, international competition was imagined as a way of both sharpening national skills and neutralizing the risk that national mettle would be tested in war."[36] At an institutional and geographical remove from both the Olympics and the Biennale, Vieques was a site for the sharpening of a different set of "national skills"—the training of soldiers to use large-scale technologies of ballistic destruction. With the military now evacuated, what will a new training, or perhaps countertraining, involve for the population of Vieques, which continues to suffer from the aftermath of the military exercises undertaken there for half a century? The simultaneous endurance and resistance displayed by the performers are perhaps transposable, the video seems to suggest, to the realm of the biopolitical.

35 Though in his famous analyses of biopower in the spaces of the military, the prison, the school, and the workplace Foucault would appear to treat "training" as primarily a figure of disciplinary normalization to be resisted, it would be a mistake to read him as advocating a model of subjectivity that would somehow ever exist purely outside such institutions. For a theoretically subtle discussion of "training for life" in both its psychological and its material dimensions in the context of the massive social, economic, and environmental project of post-slavery Reconstruction and its aftermath, see W. E. B. DuBois, "On the Training of Black Men," in *The Souls of Black Folk* [1903] (New York: Dover 2004), 55–67. For materials pertaining to youth leadership training in Vieques related to questions of sustainable development, tourism, and global warming, see the "Vieques Youth Leadership Initiative 2020 Report," available at http://www.vyli.com.

THE FIGURES OF TRAINING, SKILL, AND EXERCISE EVOKED

by Allora & Calzadilla in *Half Mast\Full Mast* thus create a kind of historical and geographical constellation between official state institutions (ranging from the military to the Biennale) and what Homi K. Bhahba would call the "incubatory moment" of postmilitary Vieques. Citing W. D. Winnicott, Bhahba describes such transitional conditions in terms of a "'third space' of psychic and social 'variability' whose agency and creativity lie in experiences that constellate or 'link the past, present, and future.' It is the contiguity of these space-time frames that constitute the 'cultural' as a practice that can both signify and survive the turning points of history and its transitional subjects and objects."[37]

BHABHA DEVELOPS THIS FORMULATION

concerning "transitional subjects and objects"—an echo of Allora & Calzadilla's description of Vieques as a "transitional geography"—in a discussion of how to rethink democracy as something more than an already established set of institutions. Bhabha suggests that democracy is reinvented when those who have been excluded from its purview take up its universalizing terms in light of their particular histories of marginalization, suffering, and survival, giving rise to what he calls a "double horizon" of democracy.[38] This double horizon is concerned simultaneously with actually existing laws, policies, and institutions (such as those currently governing the redevelopment of Vieques, for instance), and with the making of new rights-claims on the part of subaltern groups whose voices have hitherto not registered in the constituted process of democratic deliberation.

BHABHA'S DOUBLING OF THE FIGURE OF "HORIZON" IS HIGHLY RELEVANT

to *Half Mast\Full Mast* in both poetic and political terms. Derived from the Greek word *horos* (boundary-marker), horizon has several inflections, each of which involves the drawing of a finite, stable line in relation to which other things become visible or meaningful; we speak, for instance, of the horizon of a landscape to describe the visual division between the sky and the earth as seen from a specific physical situation or point of view. The philosopher Hans-Georg Gadamer uses the language of landscape in describing his phenomenological conception of horizon as "the range of vision that includes everything that can be seen from a particular vantage point." For Gadamer, we only ever encounter the world from within some situated horizon, a "standpoint that limits the possibility of vision"—which is itself formed by what he calls "tradition."[39]

36 Jones, "Biennial Culture," 77.

37 Homi K. Bhabha, "Democracy De-Realized," in Ute Meta Bauer, Mark Nash, Okwui Enwezor, and Octavio Zaya, eds., *Democracy Unrealized: Documenta 11, Platform 1* (Ostfildern: Hatje Cantz, 2002), 355.

38 Ibid.

39 Hans-Georg Gadamer, *Truth and Method* [1960], trans. Joel Weinsheiner and Donald G. Marshall (London: Continuum, 2004), 301.

Insisting that our being situated in a horizon of tradition is an inescapable condition of subjectivity, Gadamer raises the ethical question of how we might relate to the horizons of others outside of our own—those, for instance, at work in a literary or artistic text from a different historical period. He suggests that we must "transpose" ourselves into the place of the other, putting "ourselves into someone else's shoes" in such a way that the two horizons in question are "fused" and overcome their particularity. This fusing is thus also an expansion, enabling us to see beyond the necessarily limited and narrow boundaries of our own culturally given lifeworld. Gadamer's "fusion of horizons" can itself be considered a horizon in yet a third sense of the word, namely, a future-oriented expectation or aspiration, as in a defining goal beyond the present toward which one strives in ethical terms.

IN ITS REFUSAL TO IDENTIFY OR NARRATE

the sites that appear in the partitions, *Half Mast\Full Mast* challenges Gadamer's ideal of fusion. Through its silence, the video negatively evokes the local landscape knowledge of a phantom counterpublic—the population of Vieques—that is absent from the site of reception.[40] The video does not claim to offer to the Venice-based audience any experience of what the hermeneutic anthropologist Clifford Geertz once called "seeing from the native's point of view."[41] The translocational adjacency created by the video, however, cannot be reduced to a simple split between an unknowing Venice audience and some authentic, rooted experience on the part of Viequenses.

ALTHOUGH UNEVEN POSTCOLONIAL DEVELOPMENT IS

at the heart of the disunity of the audience for this video, it does not necessarily dictate that a spectator in Venice be incapable of reading the general problems of violence, landscape, and memory staged by the video, or of noting the few locational clues scattered across the nineteen partitions; nor does it suppose that a Vieques resident would transparently recognize the sites in question, as if they were self-evident in their meaning. Indeed, through the very sculptural, performative, and videographic techniques adopted by the artists and their collaborators, even the sites most "familiar" to a Vieques resident become estranged, abstracted, and displaced, demanding in principle as much critical acumen on the part of "natives" as it does of visitors to the island and witnesses-at-a-distance such as those in Venice and future sites of the video's reception.

40 On the figure of the "phantom public," see Bruce Robbins, ed., *The Phantom Public Sphere* (Minneapolis: University of Minnesota Press, 1993), and Michael Warner, *Publics and Counterpublics* (New York: Zone Books, 2002).

41 Clifford Geertz, "From the Native's Point of View: Notes on Anthropological Understanding," in *Local Knowledge: Further Essays on Interpretative Anthropology* (New York: Basic Books, 1983), 55–70. Geertz's essay in fact involved a debunking of the idea that cultural horizons could be "fused" in some transcendent synthesis; Geertz paved the way for postmodernist and postcolonial anthropologists who would dismantle the idea that anyone ever simply occupies a single, continuous cultural tradition in the first place, framing "culture" as an unstable network of hybrid and contested signifying practices rather than a bounded "lifeworld" in the Gadamerian sense.

"HALF MAST\FULL MAST" ACCOMPLISHES THIS UNSETTLING

of the Vieques landscape through formal strategies of dividing, disorienting, and disadjusting our sense of horizon.[42] Horizon functions here not as a fixed boundary against which we might orient and stabilize our relation to the world, but rather as a distant echo of what Bois identified in Mondrian's late work as an "aporetic braiding" in which the oppositions between horizontal and vertical, line and plane, ground and figure come undone. Extending this formal logic to the relationship between society and environment in Vieques and beyond, Allora & Calzadilla's video weaves these terms into a precarious biopolitical network concerning "the conditions that render life sustainable."[43] Further, through its conjuring of a phantom counterpublic, the video defines its already divided horizons as doubled in Bhabha's sense of the term. This doubling foregrounds the irreconcilable but inescapably entwined histories of the exhibition platform and the local disaster zone of Vieques, posing the following question to the ideal of "mutual understanding" informing the mandate of the U.S. Pavilion as a "global event": "Who gives voice to the silence or absence that marks the place where the horizons intersect and intermediate living begins?"[44]

WITH BHABHA'S QUESTION AS A CODA, IT IS PERHAPS RELEVANT TO

conclude this discussion of *Half Mast\Full Mast* with reference to anthropogenic climate change, which involves the dissolution of any predictable boundaries between sea, land, and sky. The unintentional carbon footprint of two centuries of fossil fuel–driven capitalism, based primarily in the Global North, has always been bound up with the military footprint of the United States. Having suffered the local environmental fallout of weapons destined to be deployed in the securing of foreign energy resources for half a century, Vieques now finds itself, along with other already-vulnerable post-colonial locations in the Caribbean and across the world, at the forefront of global warming. Climate change haunts the environment of the island, requiring, for instance, that we re-read the rustling of the leaves and the lapping of the waves that appear in the inaugural partition of *Half Mast\Full Mast* as themselves historically marked in a certain way. As every square inch of the planet and its atmosphere become entangled in climate change, we realize that the latter involves the dissolution of a key "horizon" of human history itself: the dividing line between what has hitherto been considered nonhuman natural systems—weather patterns, sea levels—and the world of social, economic, and political practices.[45] Though focused on Vieques, the translocational approach to site undertaken in *Half Mast\Full Mast* provides conceptual and aesthetic terms for thinking about the increasingly undecideable relationship between human and nonhuman histories at a planetary scale, tracing the divisions that continue to mark the "we" of humanity as it puts its own survival at risk.

42 For an important recent discussion of "horizon" as a classical formal device of spectatorial orientation that has been increasingly destabilized by global media technologies, see Hito Steyerl, "In Free Fall: A Thought Experiment on Vertical Perspective," *E-Flux Journal* (March 2011), http://www.e-flux.com/journal/view/222.

43 Butler, *Frames of War*, 33.

44 Bhabha, "Democracy De-Realized," 358.

45 On the massive ramifications of climate change for our sense of the "horizons" of human world history, see Dipesh Chakrabarty, "The Climates of History: Four Theses," *Critical Inquiry* (Winter 2009): 197–222. Significantly, Chakrabarty engages with Gadamer's *Truth and Method* in this text.

TRACK AND FIELD

ARMED FREEDOM LYING ON A SUNBED

ALGORITHM

HALF MAST\FULL MAST

BODY IN FLIGHT (DELTA)

BODY IN FLIGHT (AMERICAN)

TRACK AND FIELD

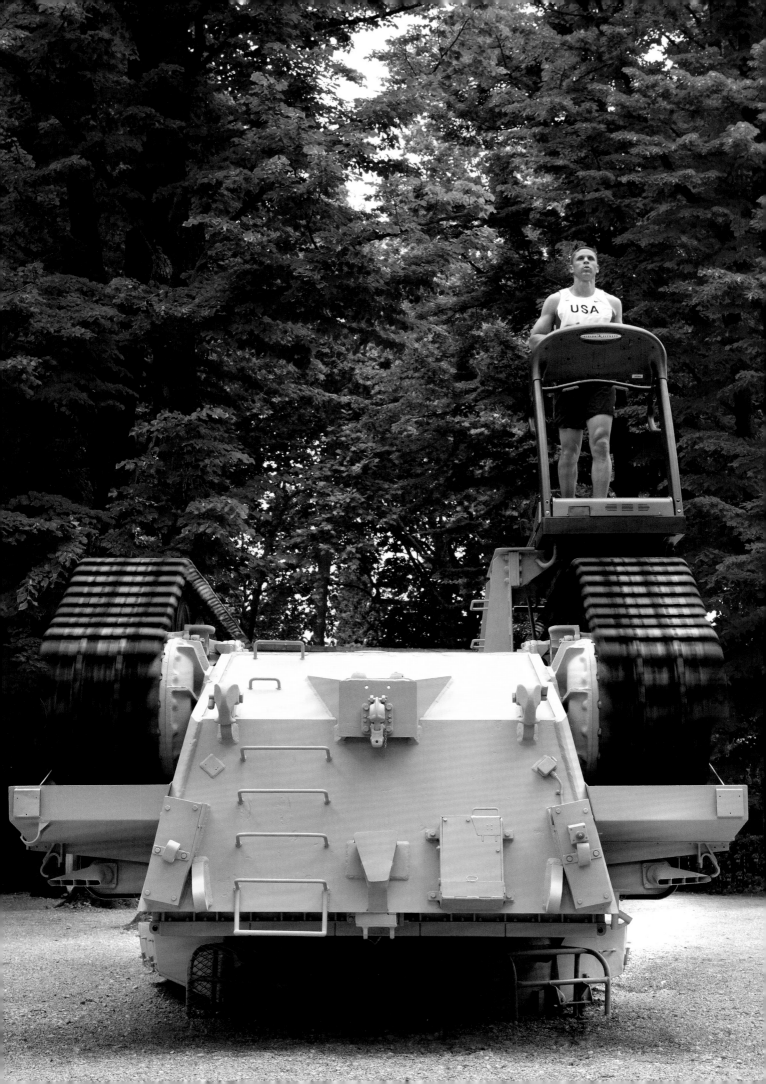

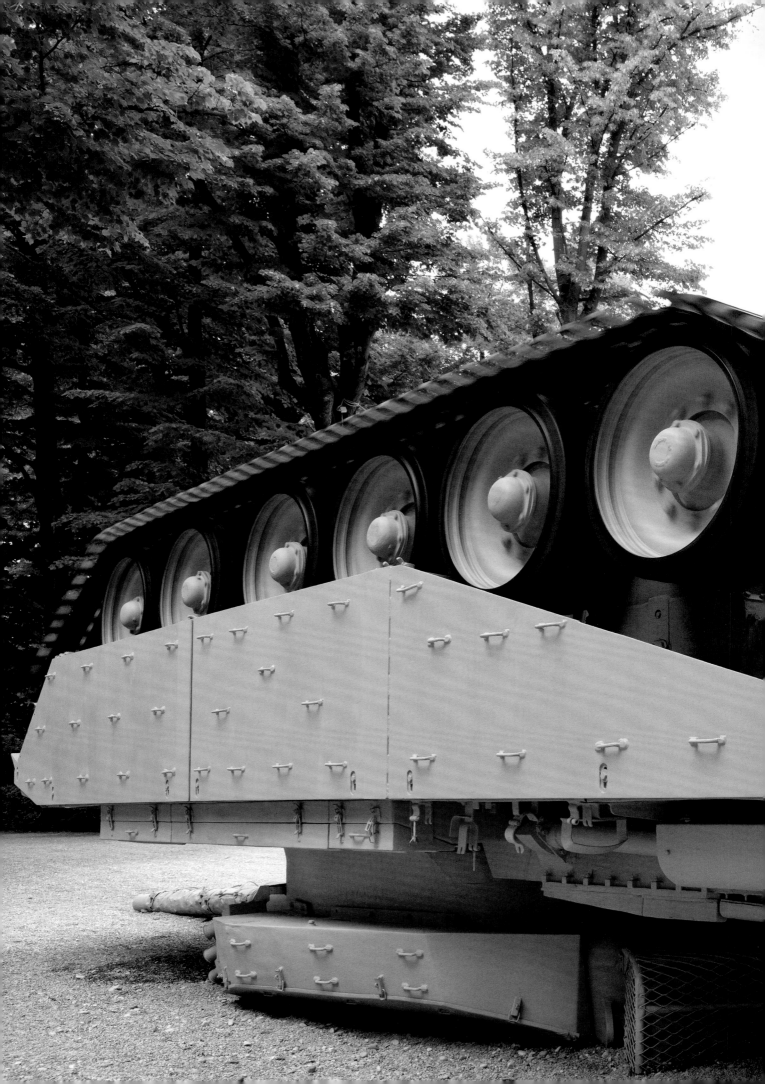

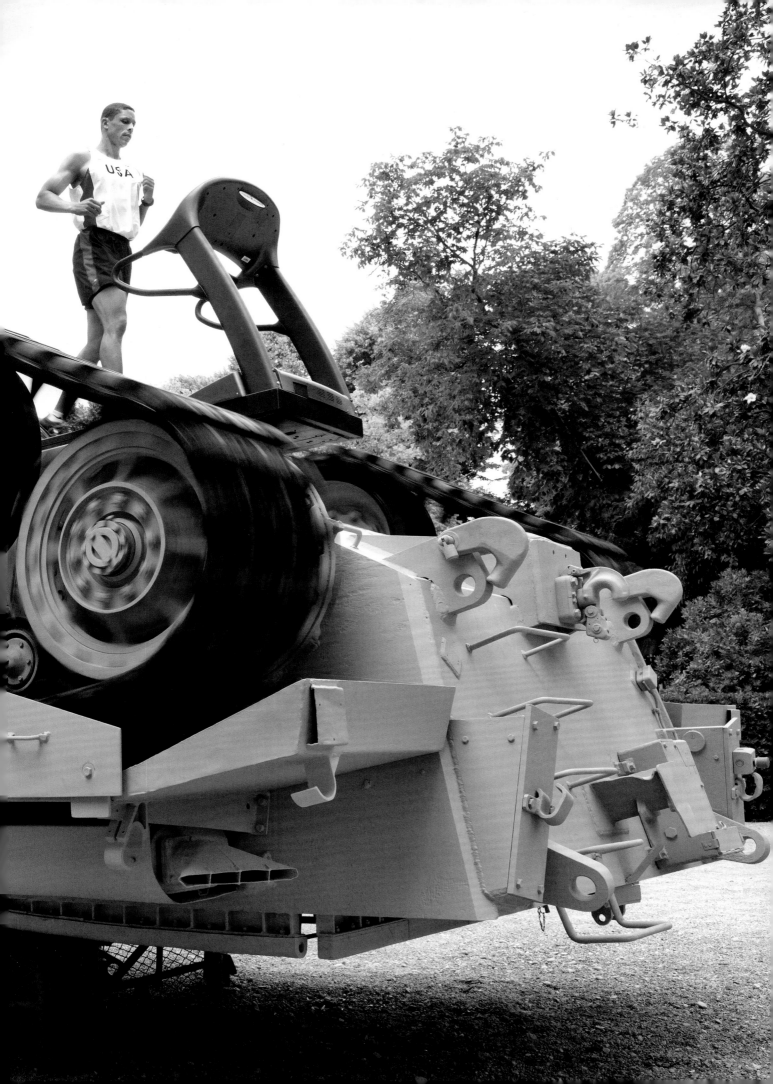

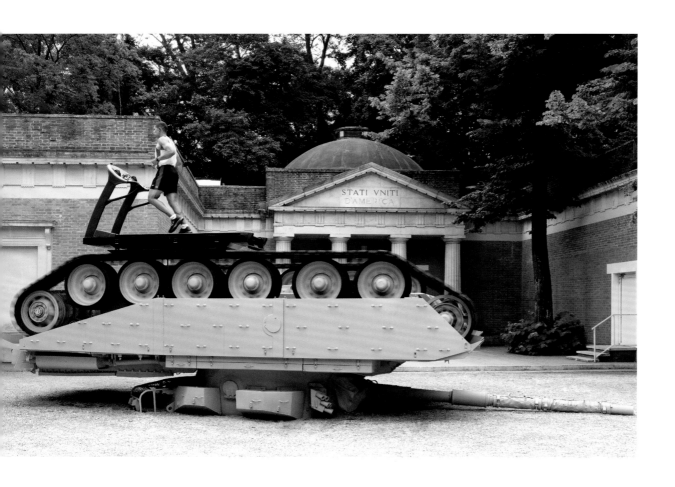

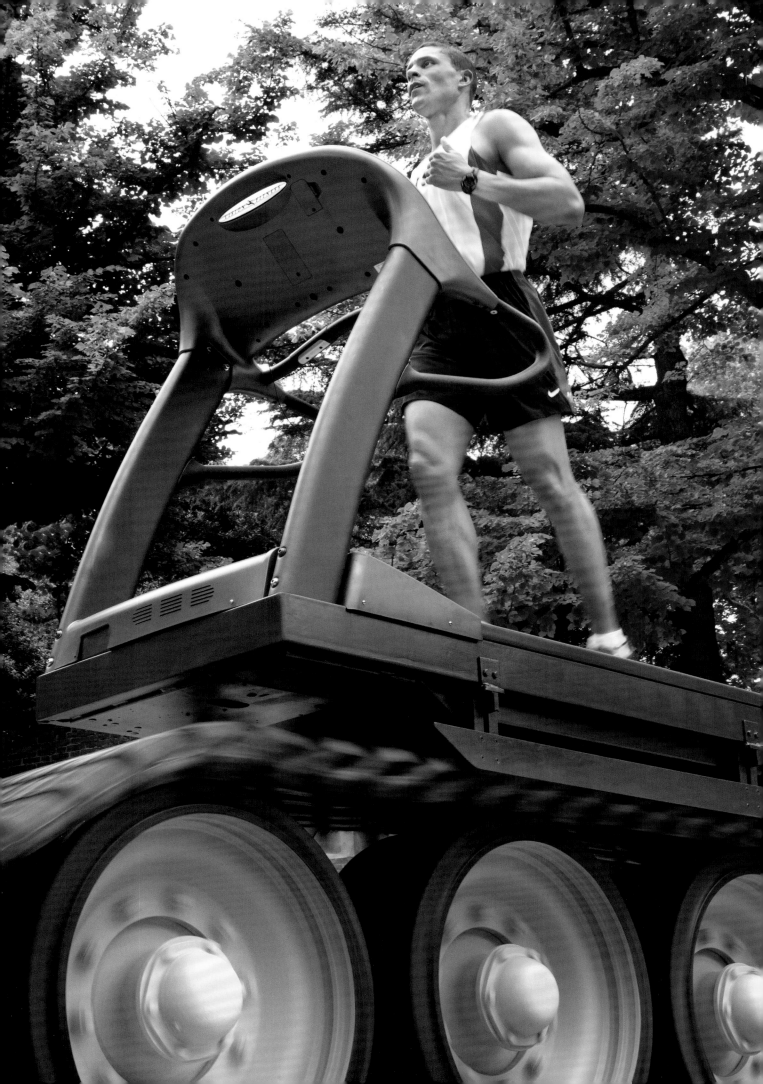

ARMED FREEDOM LYING ON A SUNBED

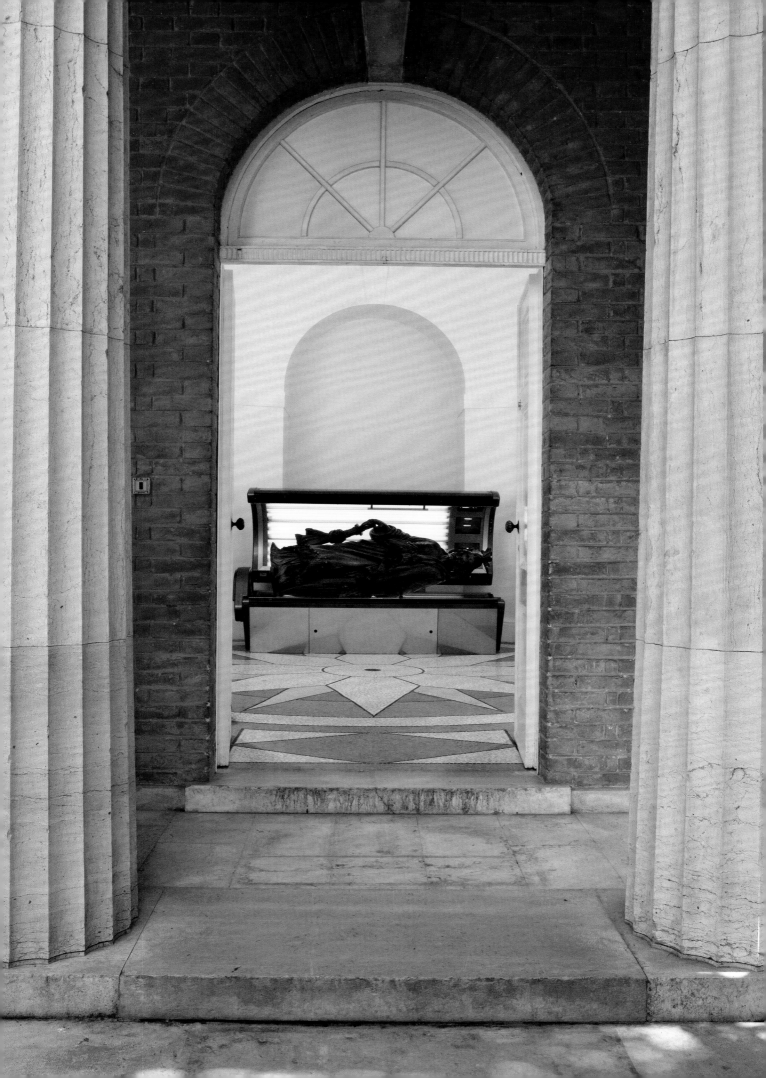

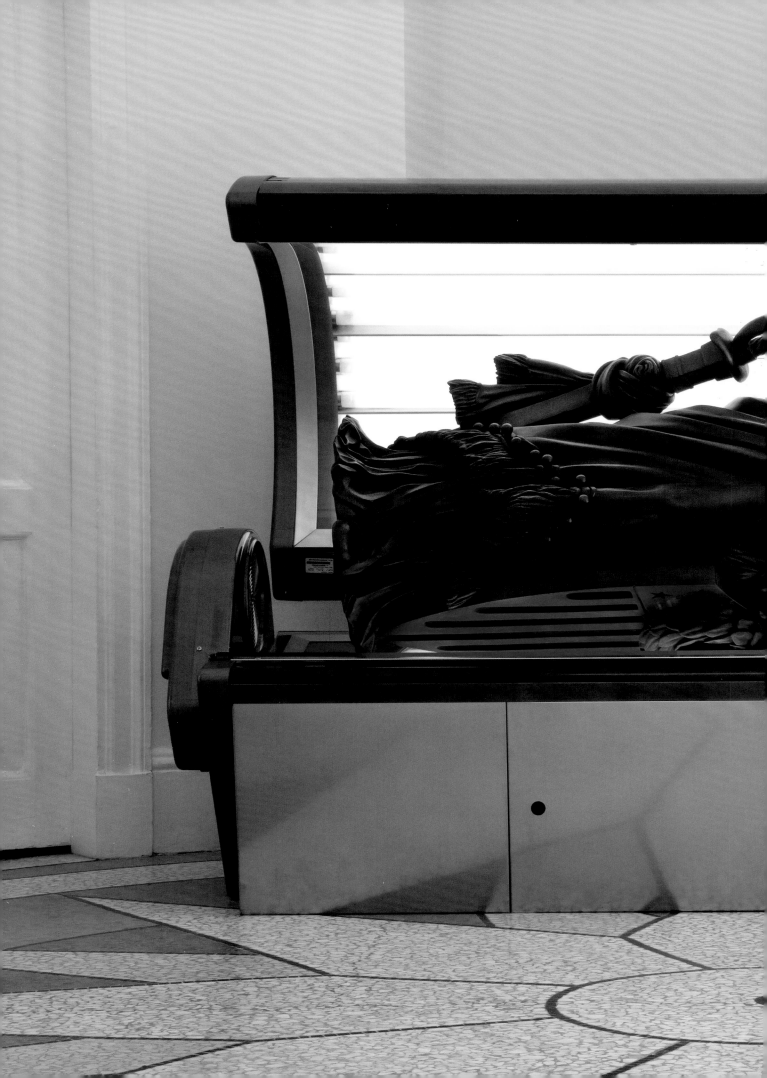

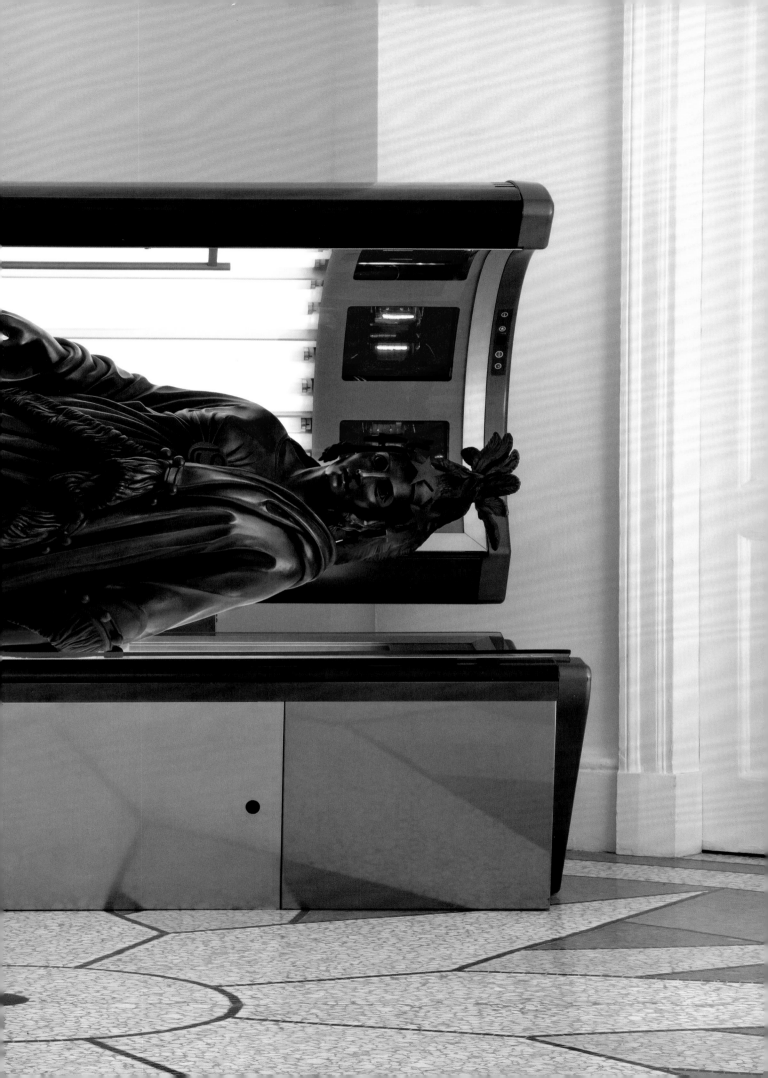

ALGORITHM

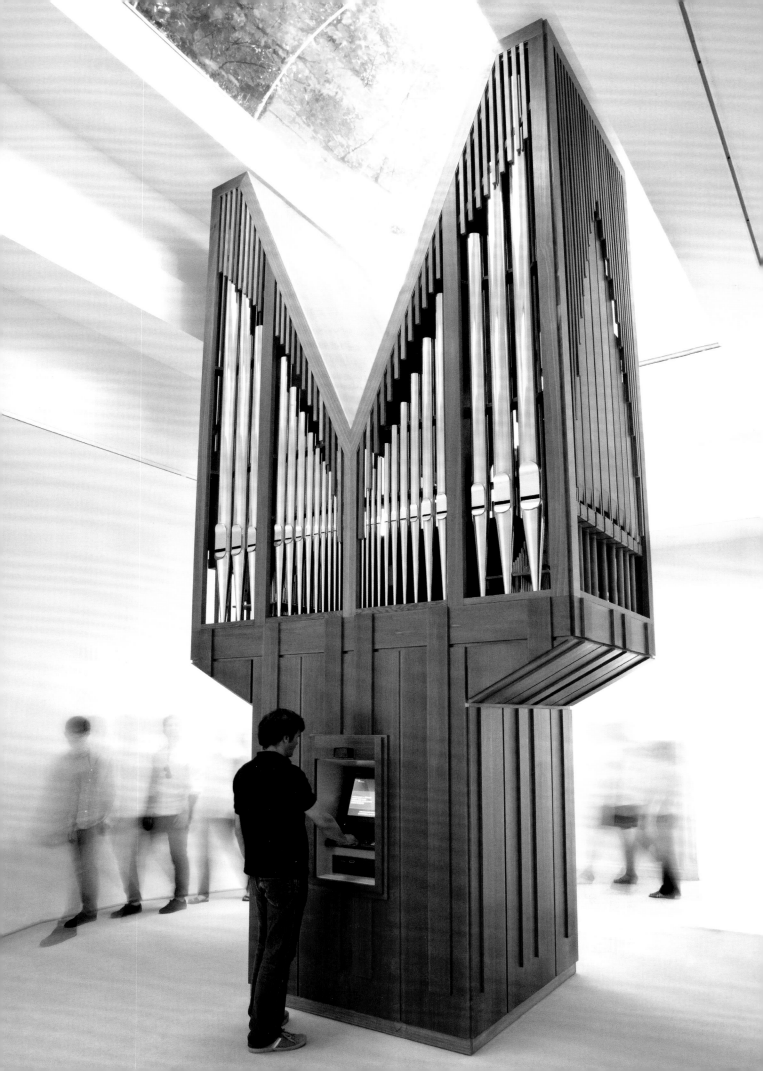

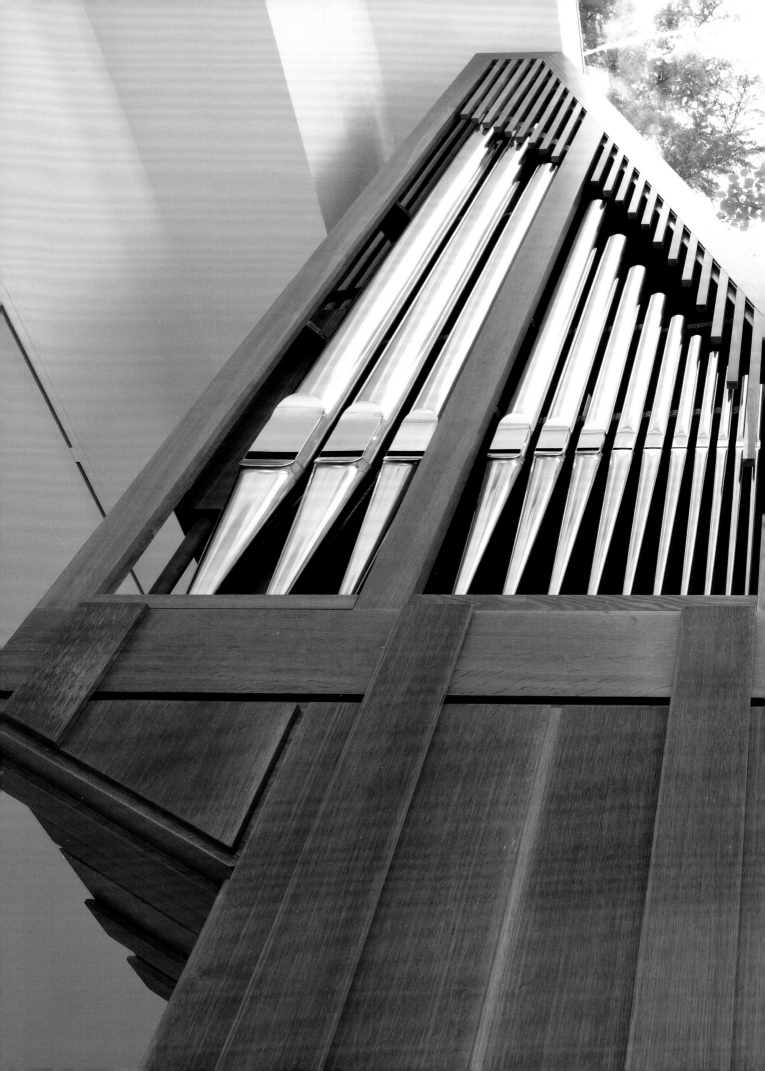

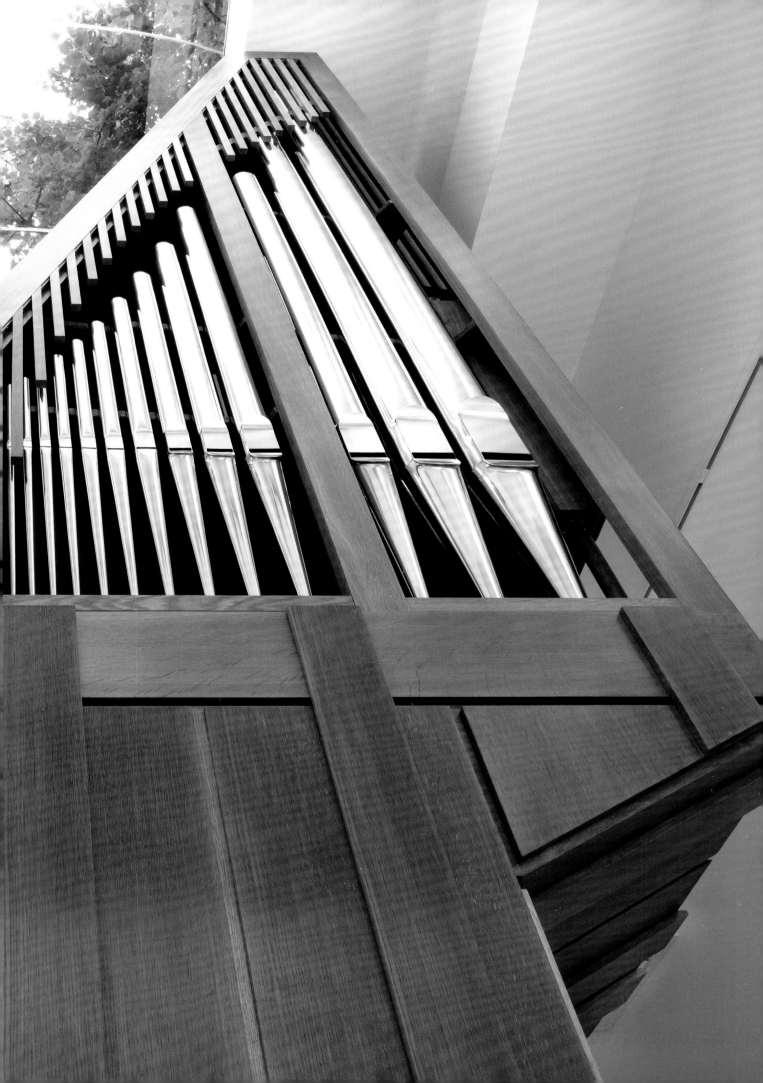

HALF MAST\FULL MAST

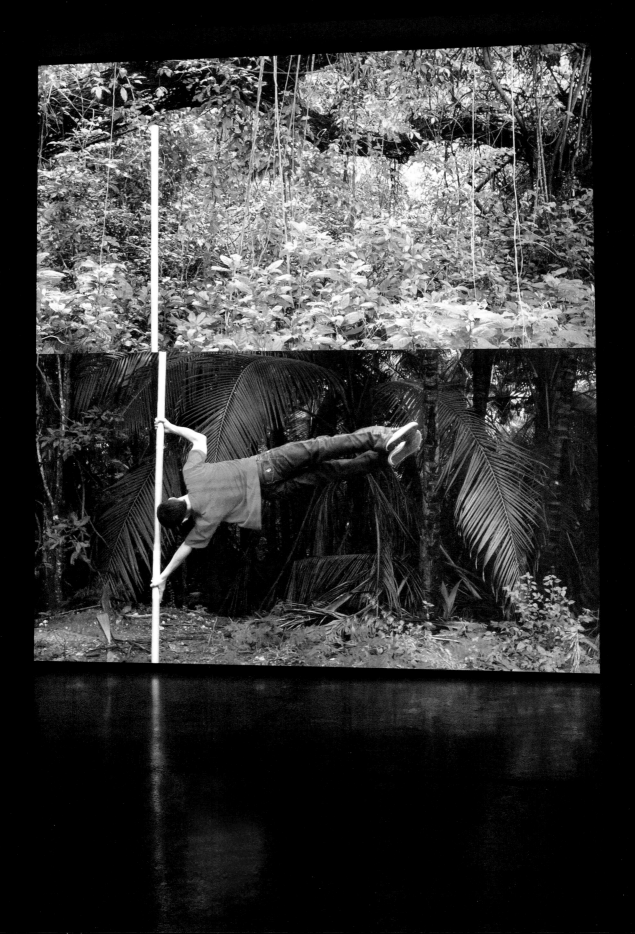

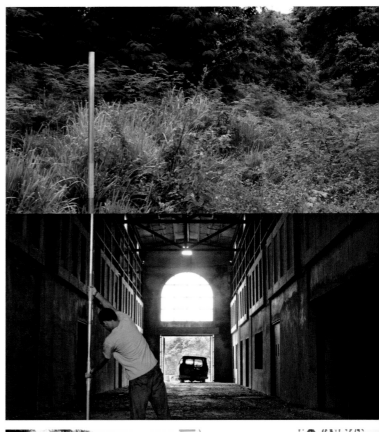

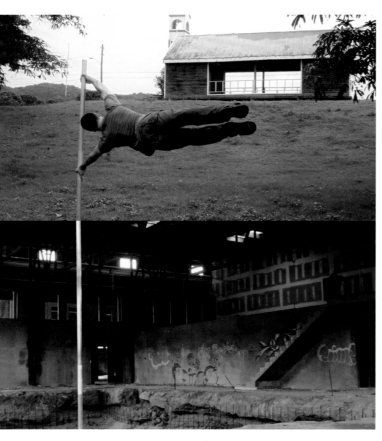

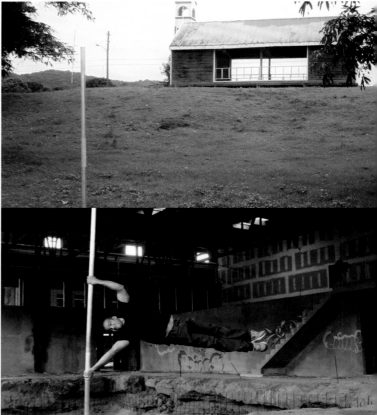

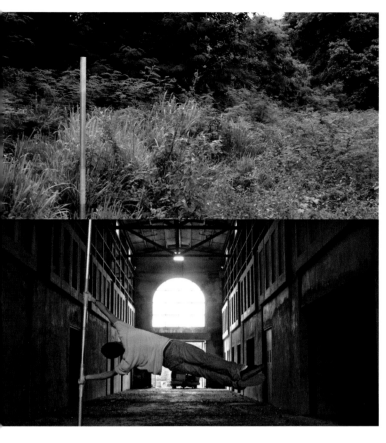
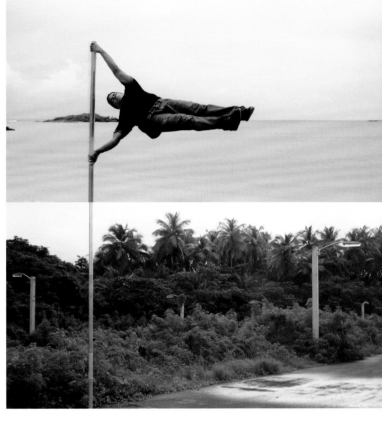

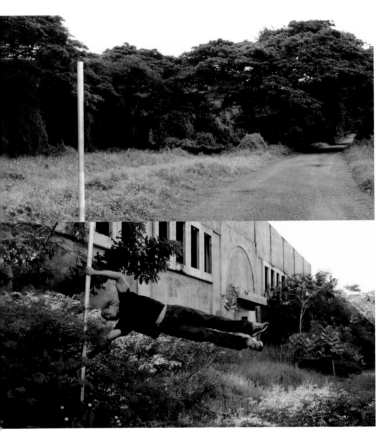

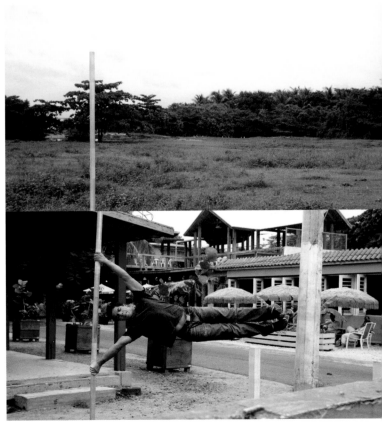

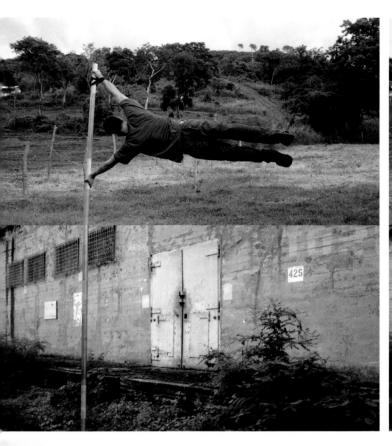

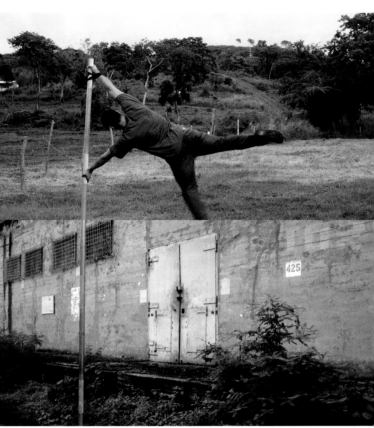

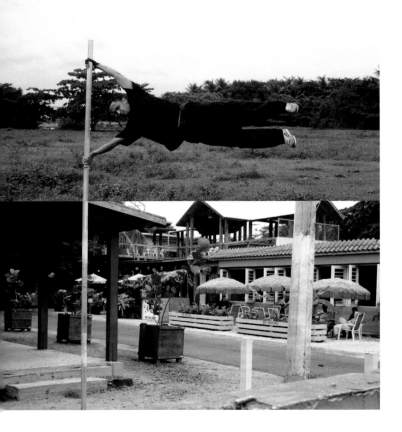

BODY IN FLIGHT (DELTA)

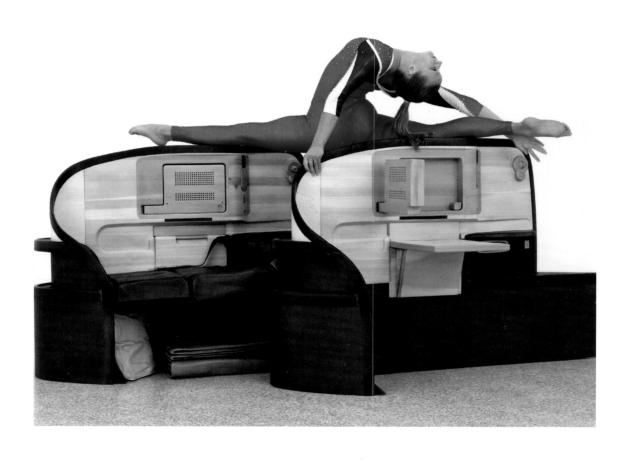

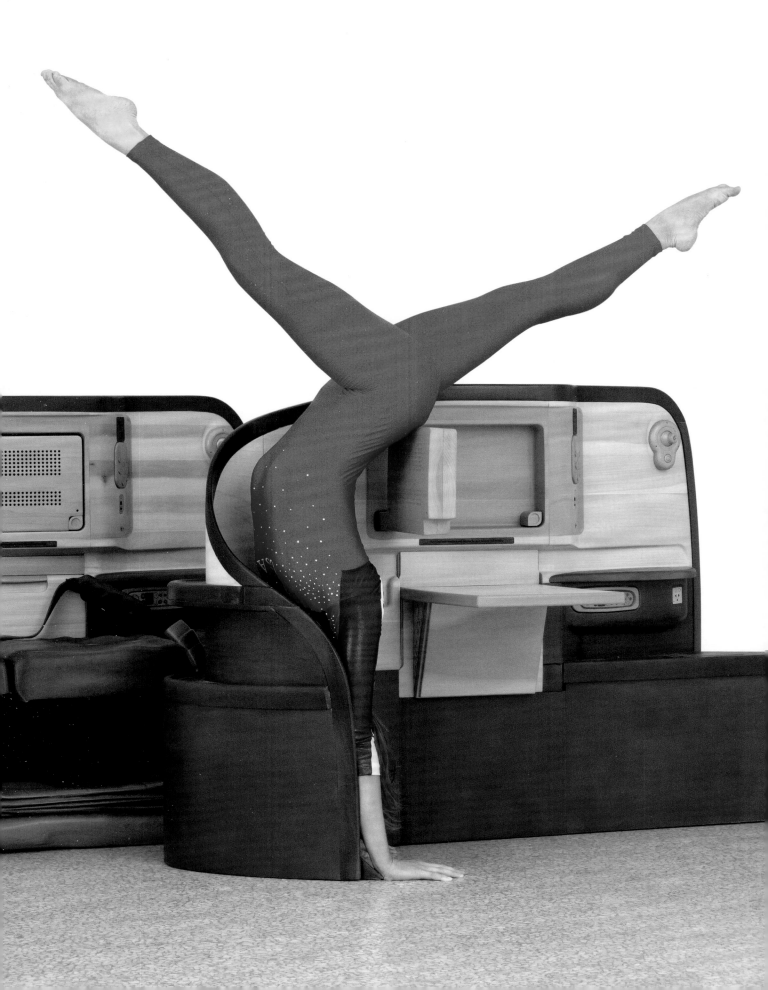

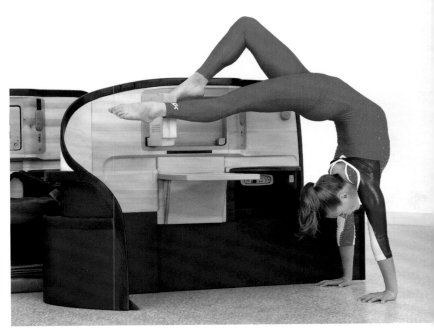

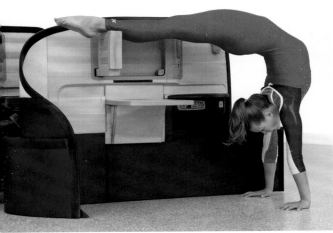

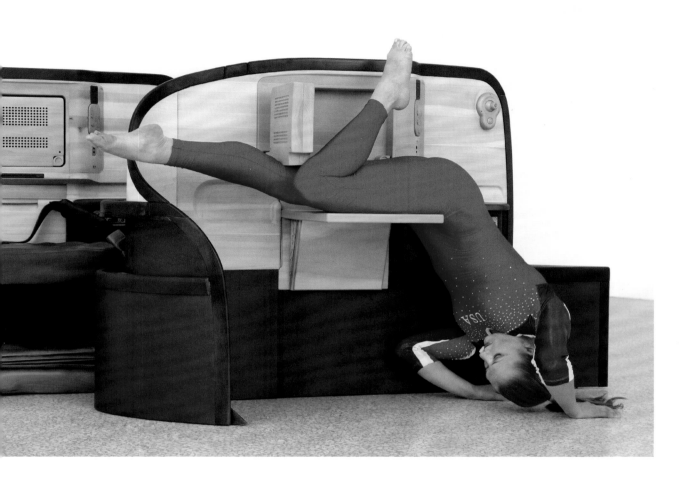

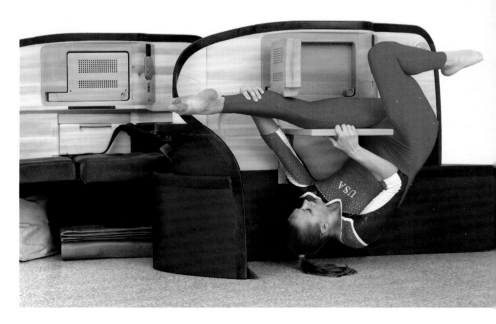

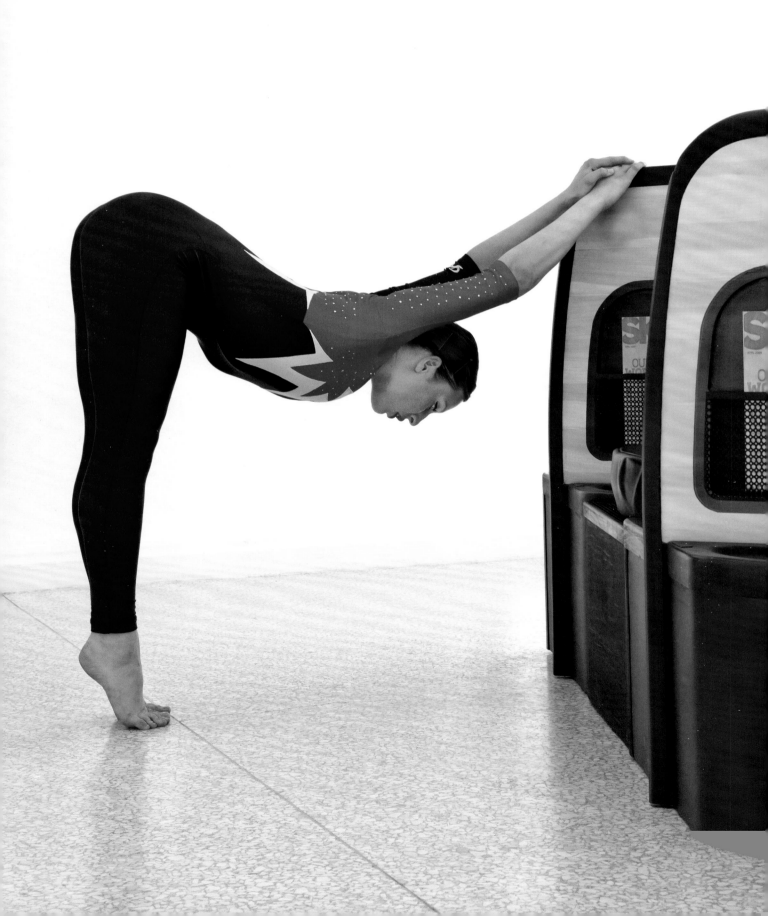

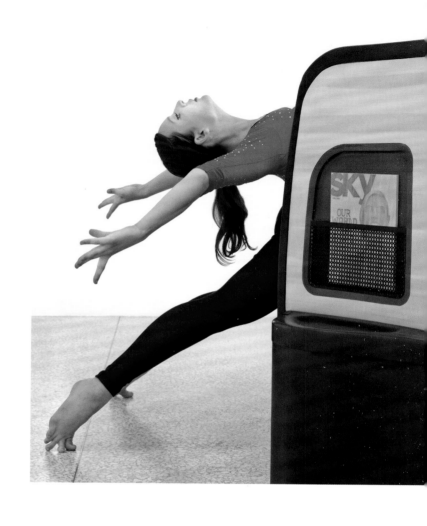

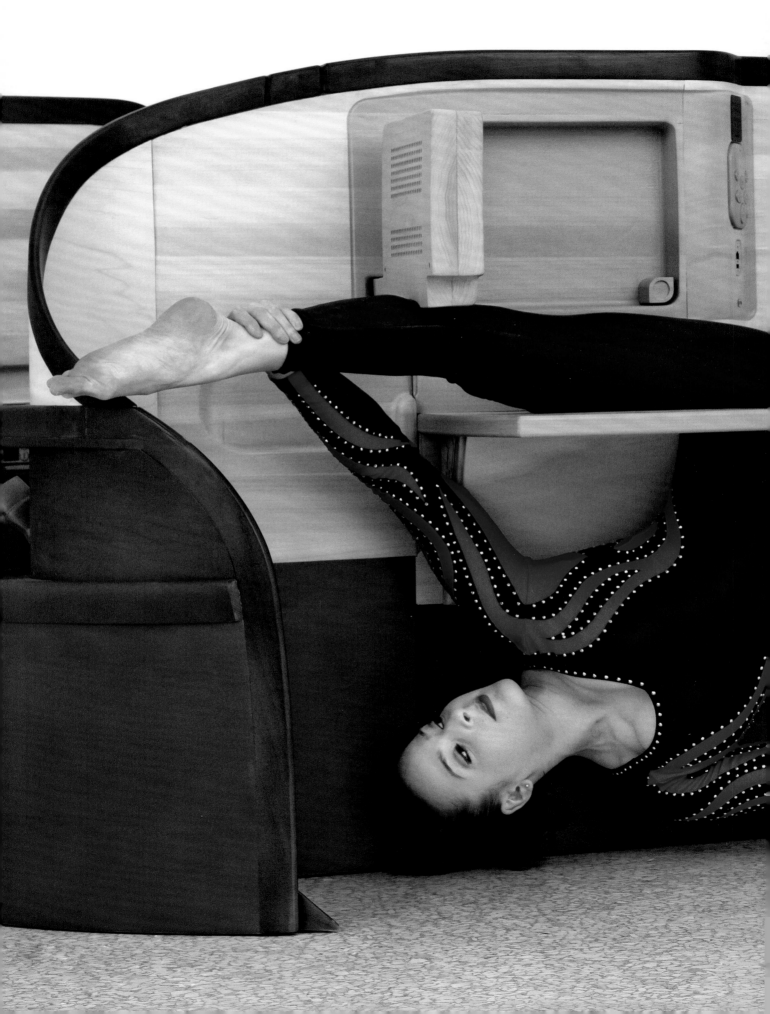

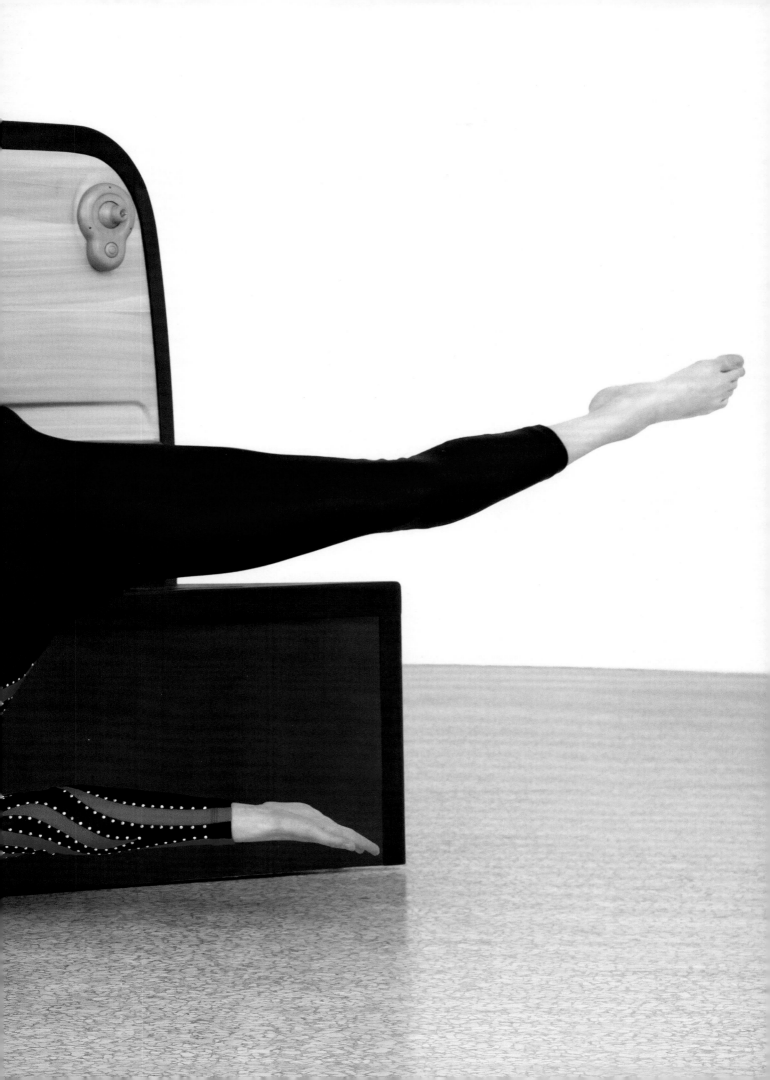

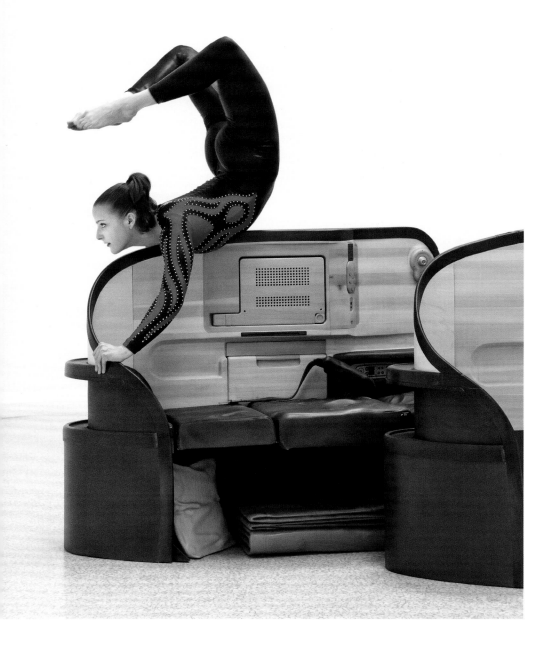

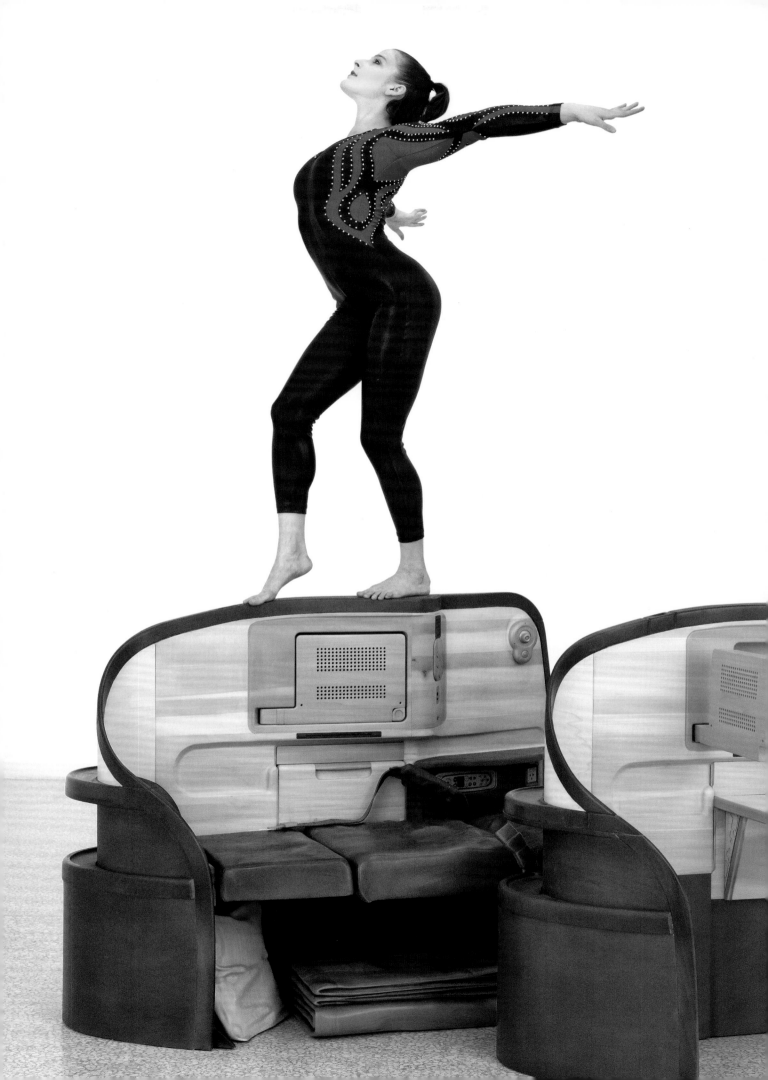

BODY IN FLIGHT (AMERICAN)

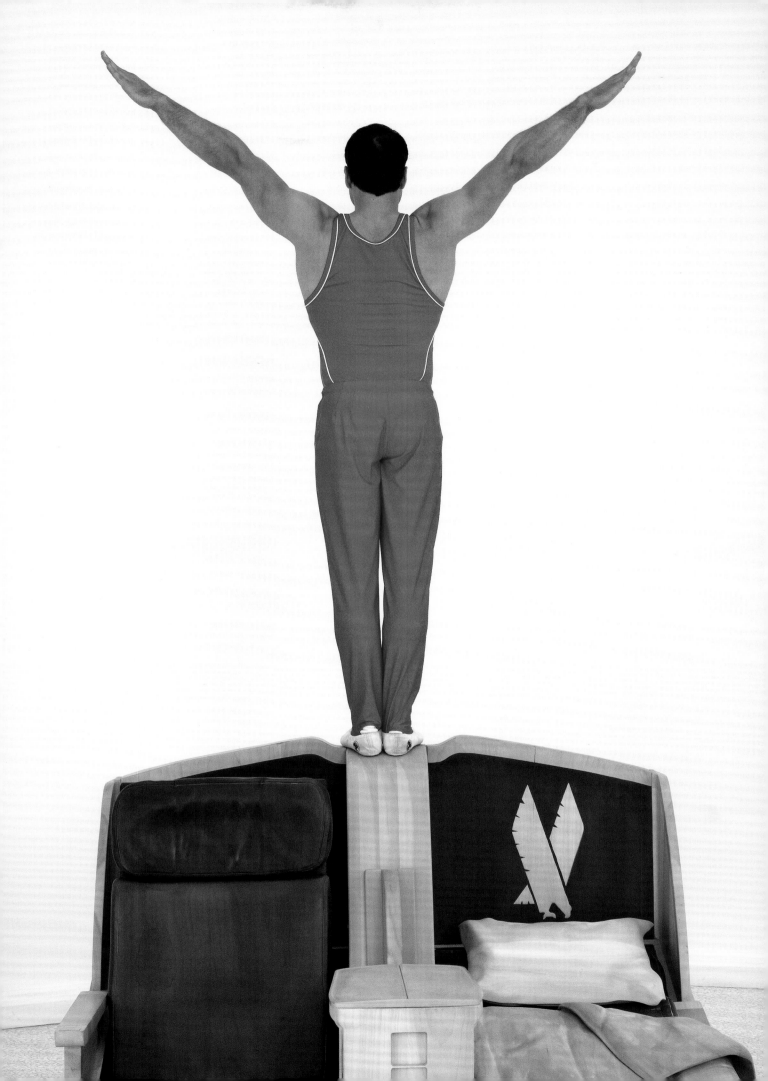

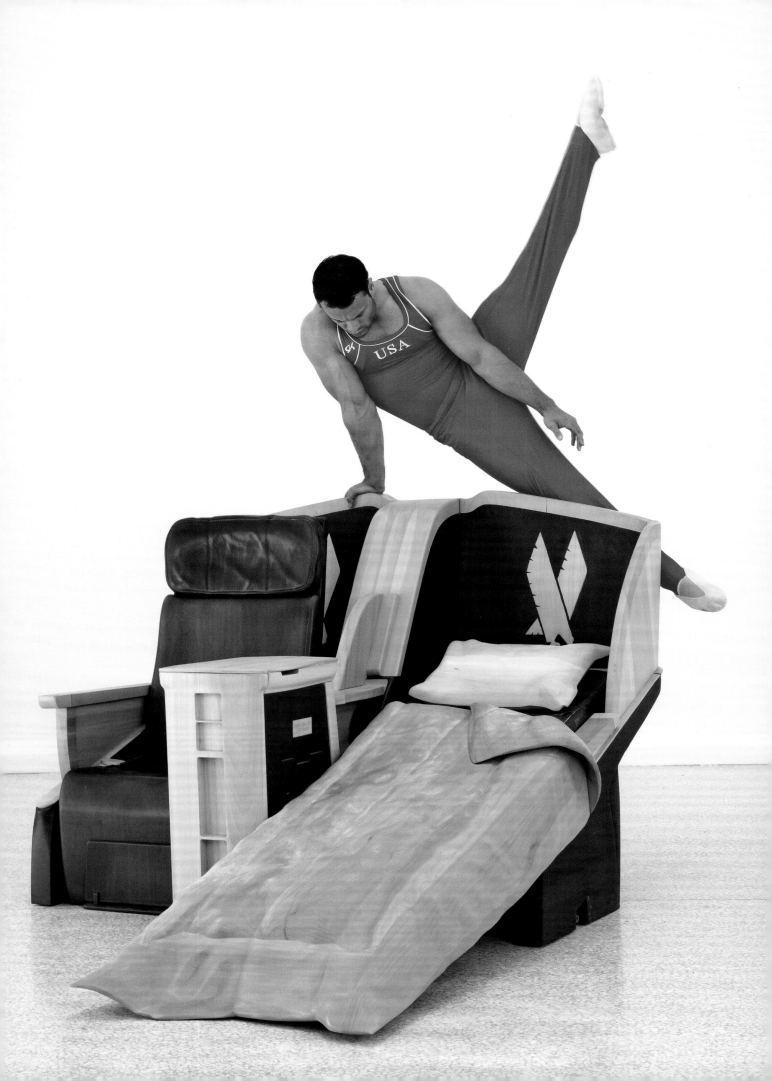

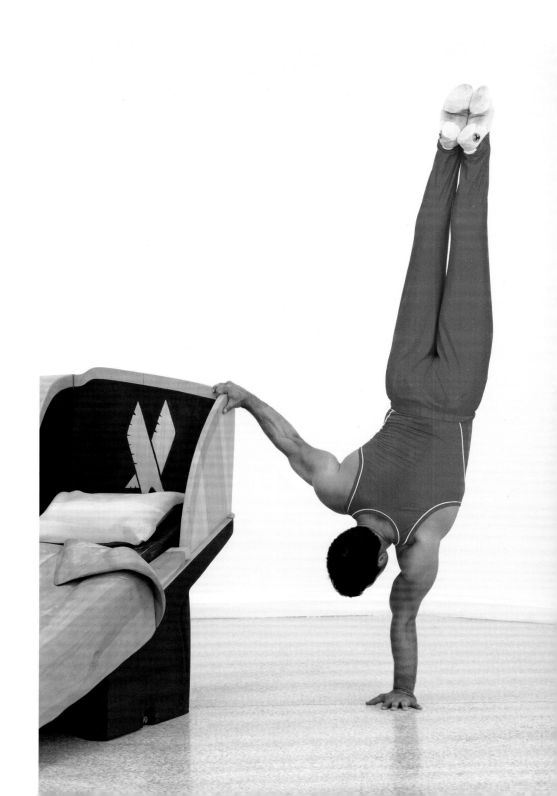

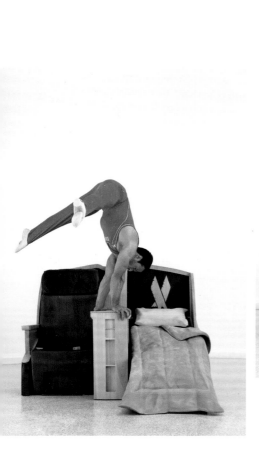

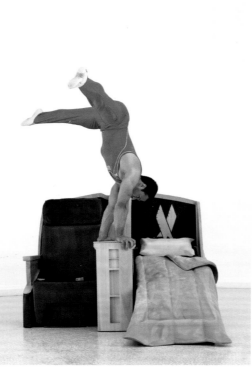

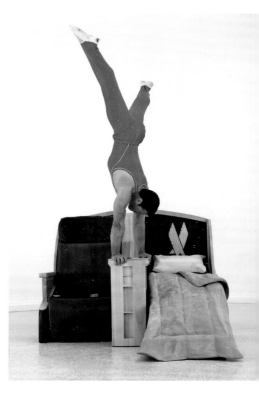

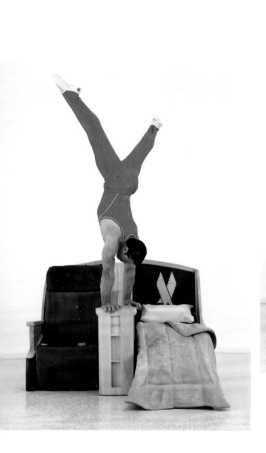
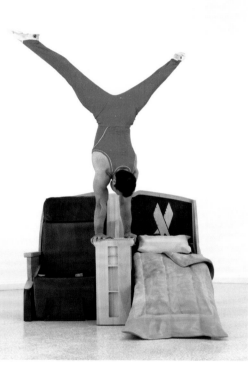
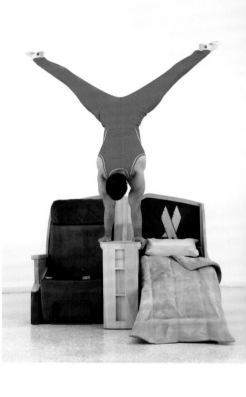

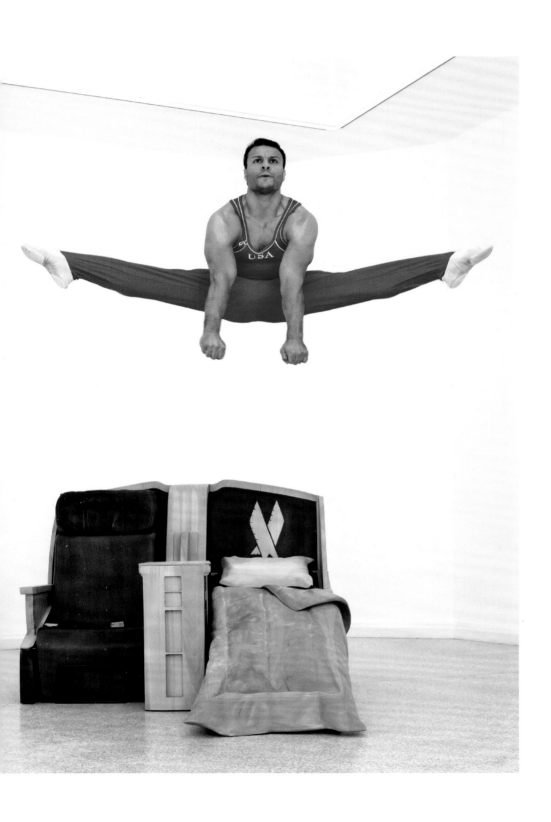

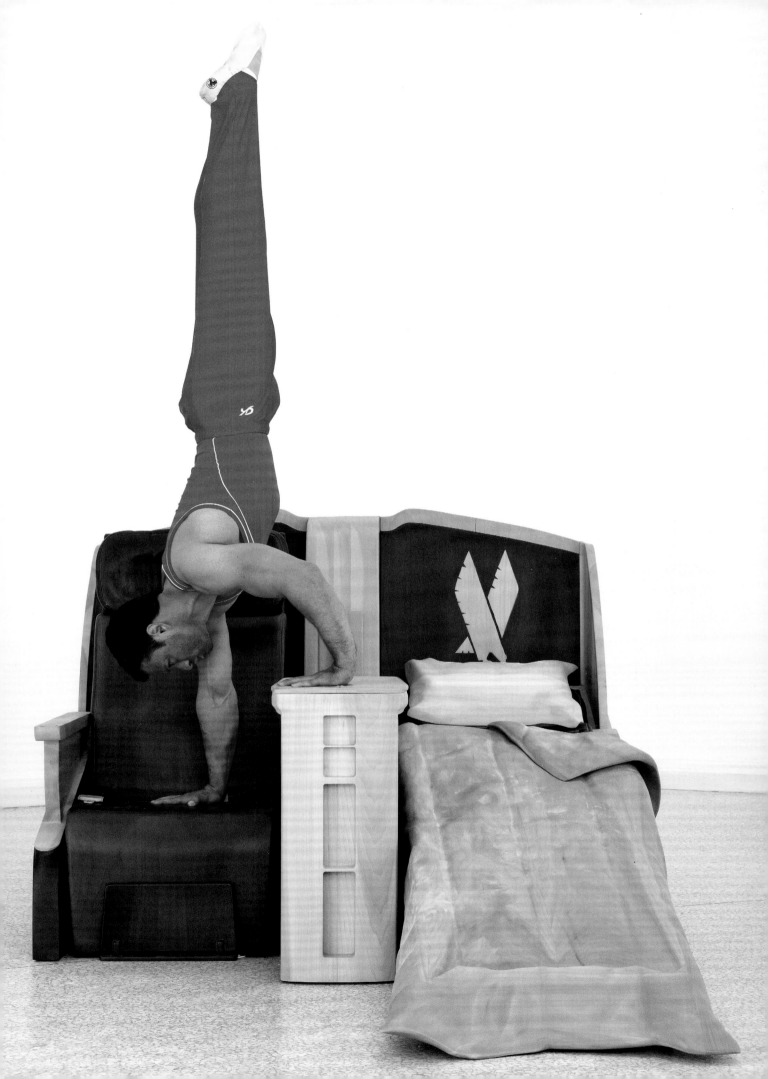

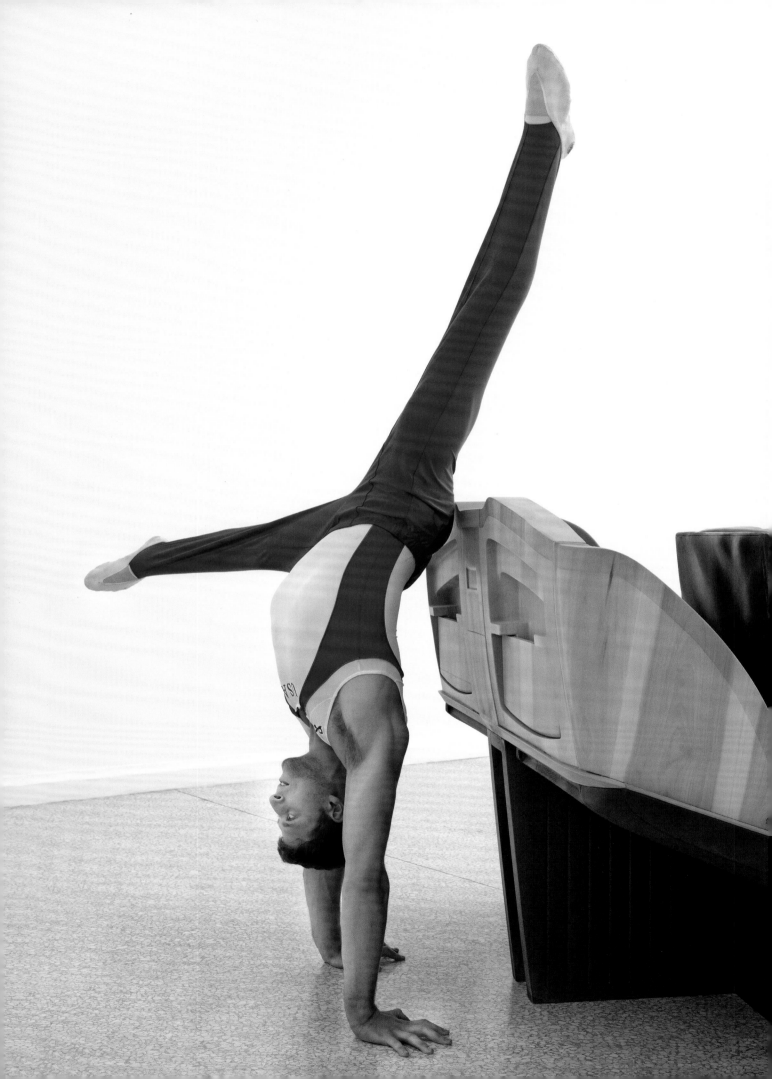

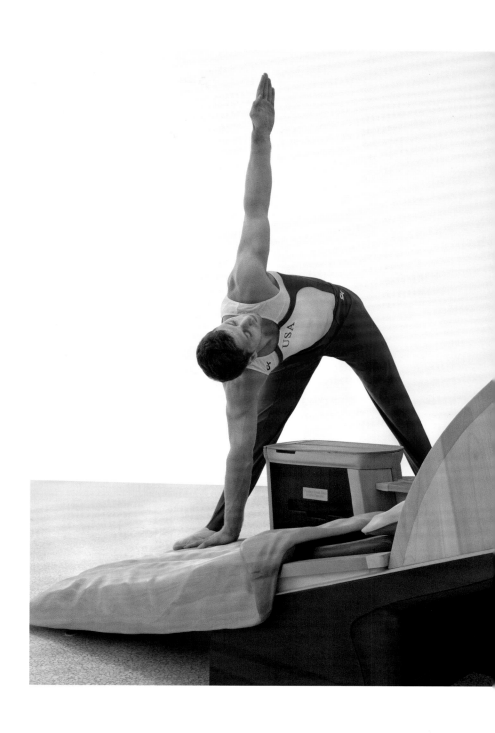

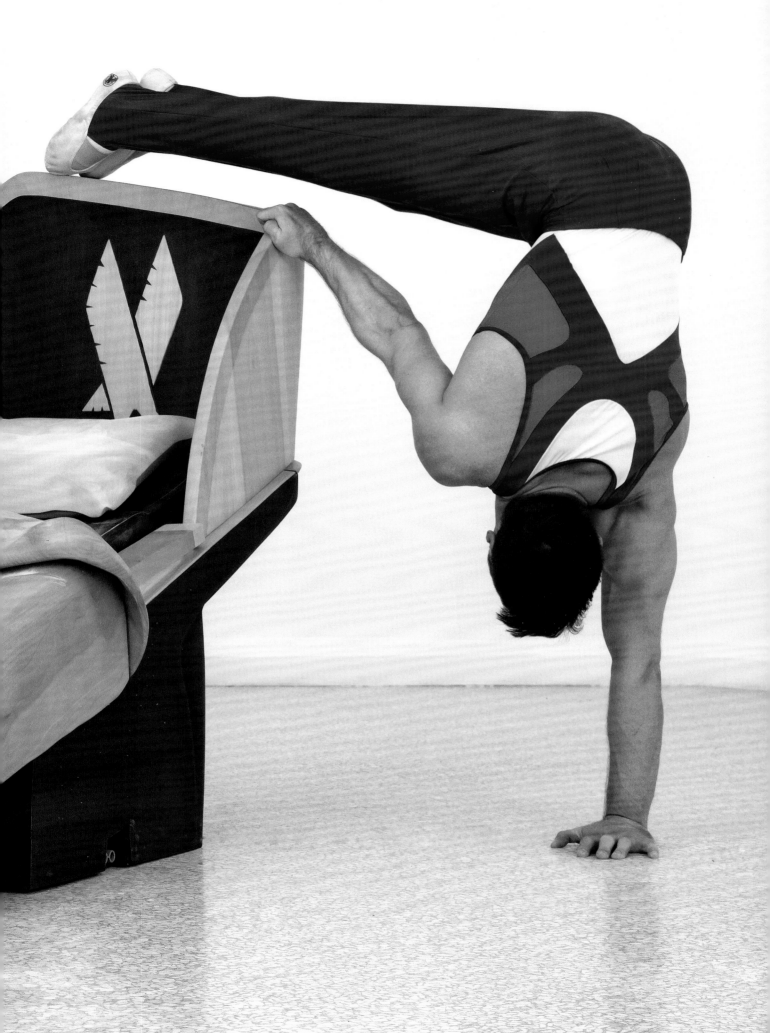

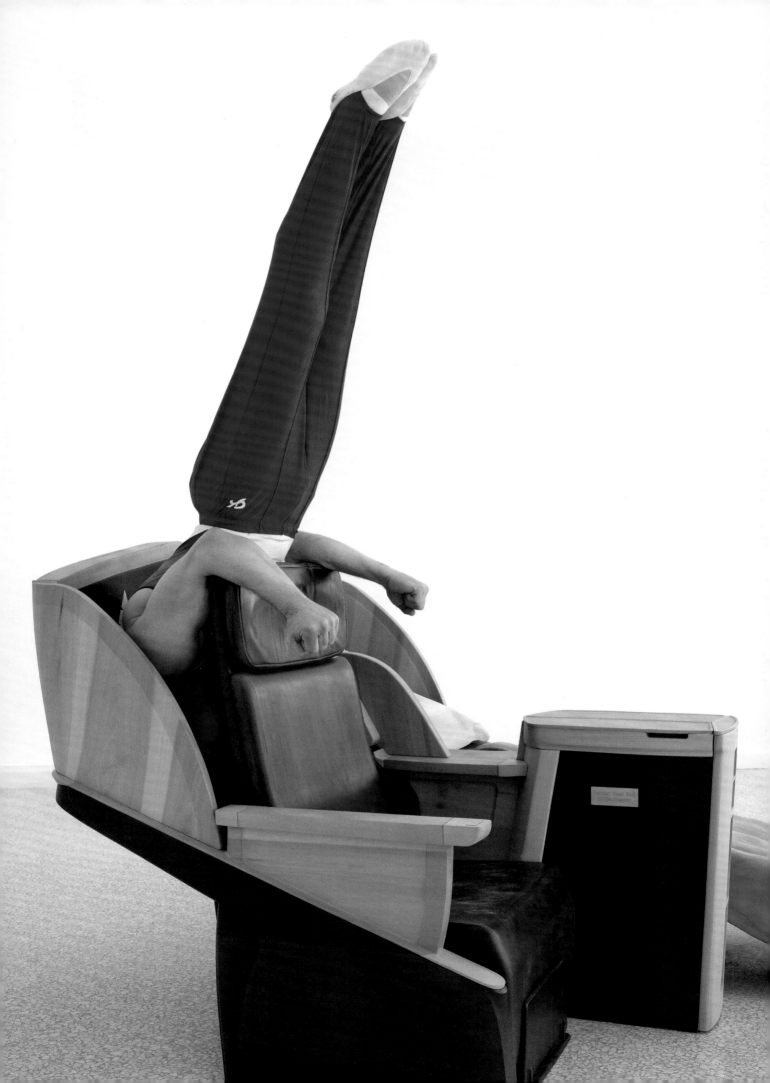

ARTISTS' BIOGRAPHIES

Jennifer Allora

b. 1974, Philadelphia

Guillermo Calzadilla

b. 1971, Havana

EDUCATION

Jennifer Allora

2001–2003

Massachusetts Institute of Technology (MS)
Cambridge

1998–1999

Whitney Independent Study Program
New York

1996

University of Richmond (BA)
Richmond, Virginia

Guillermo Calzadilla

1999–2001

Bard College (MFA)
Annandale-on-Hudson, New York

1998

Skowhegan School of Painting
and Sculpture
Skowhegan, Maine

1996

Escuela de Artes Plásticas (BFA)
San Juan

FELLOWSHIPS AND RESIDENCIES

2008–2009

DAAD, Deutscher Akademischer
Austausch Dienst
Berlin

2006

Couvent des Récollets, Résidence
Internationale aux Récollets
Paris

2004

Walker Art Center
Artist-in-Residence Program
Minneapolis

Civitella Ranieri Fellowship
Umbertide, Italy

Headlands Center for the Arts Bridge
Residency Program
Sausalito, California

1998–1999

P.S.1 Contemporary Art Center
National Studio Program
New York

AWARDS AND GRANTS

2006

Hugo Boss Prize Short List

Nam June Paik Award Short List

2004

Gwangju Biennial Prize

2003

Penny McCall Foundation Grant

2002

Joan Mitchell Foundation Grant

2000–2001

Cintas Fellowship

EXHIBITION HISTORY

SOLO EXHIBITIONS

2010

Performance 9: Allora & Calzadilla
Museum of Modern Art, New York

Compass
Kurimanzutto, Mexico City

Allora & Calzadilla
Galerie Chantal Crousel, Paris

2009

Stop, Repair, Prepare: Variations on "Ode to Joy" for a Prepared Piano
Gladstone Gallery, New York

Allora & Calzadilla
Nasjonalmuseet for Kunst,
Arkitektur og Design, Oslo

Allora & Calzadilla
Temporäre Kunsthalle, Berlin

Allora & Calzadilla
Kunstmuseen Krefeld,
Museum Haus Esters, Krefeld

2008

Allora & Calzadilla
Franco Soffiantino Gallery, Turin

Stop, Repair, Prepare: Variations on "Ode to Joy" for a Prepared Piano
Haus der Kunst, Munich

Wake Up, Clamor, Sediments, Sentiments (Figures of Speech)
Kunstverein München, Munich

Never Mind That Noise You Heard
Stedelijk Museum, Amsterdam

2007

Sediments, Sentiments (Figures of Speech)
San Francisco Art Institute, San Francisco

Allora & Calzadilla
Lisson Gallery, London

Allora & Calzadilla
Kunsthalle Zürich, Zurich

Clamor
Serpentine Gallery, London

Wake Up
Renaissance Society at the
University of Chicago, Chicago

*Whitechapel Laboratory:
Jennifer Allora & Guillermo Calzadilla*
Whitechapel Art Gallery, London

Unrealizable Goals
Center for Contemporary Art, Kitakyushu

2006

Clamor
The Moore Space, Miami

Land Mark
Palais de Tokyo, Paris

(En) Tropics
Galerie Chantal Crousel, Paris

Combine Platter
Screening Event
Museum of Contemporary Art, Los Angeles

Jennifer Allora & Guillermo Calzadilla
SMAK / Stedelijk Museum voor Actuele
Kunst, Ghent

Concentrations 50: Allora & Calzadilla
Dallas Museum of Art, Dallas

Under Discussion & Amphibious
Museo de Arte de Puerto Rico, Santurce

2005

Download
Art Basel, Miami Beach, Miami

2004

Unstable Atmospheres
Lisson Gallery, London

Ciclonismo
Galerie Chantal Crousel, Paris

Chalk
7th Annual ICA / Vita Brevis Project,
Institute of Contemporary Art, Boston

Radio Revolt: One Person, One Watt
Artist-in-Residence Project, Walker Art
Center, Minneapolis

2003

Puerto Rican Light
Americas Society, New York

GROUP EXHIBITIONS

2010

Epílogo
Museo de Arte de Zapopan,
Zapopan, Mexico

Pleated Blinds
Petach Tikva Museum of Art, Petach Tikva,
Israel

*ZUR NACHAHMUNG EMPFOHLEN!
Expeditionen in Ästhetik & Nachhaltigkeit*
Uferhallen, Berlin

Die Natur ruft!
DAAD Galerie, Berlin

*Nobody's Property: Art, Land, Space,
2000–2010*
Princeton University Art Museum,
Princeton, New Jersey

*29th Bienal de São Paulo: Há sempre um
copo de mar para um homem navegar /
There Is Always a Cup of Sea to Sail In,*
São Paulo

De frente al sol
Galerie Martin Janda, Vienna

*Fourth Plinth Programme:
Six New Proposals*
Crypt Foyer, St. Martin-in the-Fields,
Trafalgar Square, London

Cinéma du réel 2010
Bibliothèque publique d'information, Centre
Pompidou, Paris

Retro-Tech
San Jose Museum of Art, San Jose,
California

Traversing the Fantasy, Part 1
The Cube Project Space, Taipei

Adaptation: Between Species
Power Plant, Toronto

Manimal
Kaleidoscope, Milan

Restless Empathy
Aspen Art Museum, Aspen, Colorado

Hope!
Palais des Arts et du Festival, Dinard, France

La trama se complica...
Museo de Arte Contemporáneo de
Monterrey, Monterrey, Mexico

The Traveling Show
Galería de Fundación / Colección JUMEX,
Mexico City

After the Gold Rush
Charles H. Scott Gallery, Vancouver, British
Columbia

Contemplating the Void
Solomon R. Guggenheim Museum, New York

Number Three: Here and Now
Julia Stoschek Collection, Düsseldorf

It Is It
Espacio 1414, Santurce, Puerto Rico

Video Art: Replay,
Part 2—Everyday Imaginary
Institute of Contemporary Art, Philadelphia

2009

GAGARIN: The Artists
in Their Own Words
SMAK / Stedelijk Museum voor Actuele
Kunst, Ghent

100 Years (Version 1: Düsseldorf)
Julia Stoschek Foundation, Düsseldorf

Rethink Relations
Statens Museum for Kunst, Copenhagen

Art, Media, and Material Witness:
Contemporary Art from the Harn Museum
Collection
Samuel P. Harn Museum of Art, University
of Florida, Gainesville

Free as Air and Water
41 Cooper Gallery, Cooper Union, New York

Private Universes: Media Works
Dallas Museum of Art, Dallas

Wake Up, Please
Le Quartier, Centre d'Art Contemporain de
Quimper, Quimper, France

Musica ex Machina 09
Museo de Reproducciones Artísticas de
Bilbao, Bilbao

Panorama da arte brasileira
Museu de Arte Moderna de São Paulo,
São Paulo

Close Encounters 2
Nathan Cummings Foundation, New York

Art TLV 09
Tel Aviv

Teatri possibili
Palazzo Ferrero, Biella, Italy

Una fábrica, una máquina, un cuerpo:
Arqueología y memoria de los espacios
industriales
Centre d'Art la Panera, Lérida, Spain

Kréyol Factory
Grande Halle de la Villette,
Parc de la Villette, Paris

Un certain état du monde?
A Certain State of the World?
Garage Center for Contemporary Culture,
Moscow

Lisson Presents 4 / 29 Bell Street
Lisson Gallery, London

Videoarde, video crítico
en Latinoamérica y Caribe
Centro Cultural de España, Montevideo

Something else!!!!
Museo d'Arte Provincia di Nuoro, Nuoro, Italy

Puerto Rico: Geografía humana
Museo de Arte de Puerto Rico, Santurce

Rotating Views #1: Astrup Fearnley
Collection
Astrup Fearnley Museet for Moderne Kunst,
Oslo

2008

Exposición inaugural del nuevo espacio
Kurimanzutto, Mexico City

Prospect.1 New Orleans
New Orleans

Tragicomedia
Museo de Cádiz, Cádiz, Spain

Gustos, coleciones y cintas de video
CA2M / Centro de Arte Dos de Mayo,
Móstoles, Spain

Art Focus 5
Jerusalem

Mieux vaut être un virus que tomber
malade
Mains d´oeuvres, Saint-Ouen, France

Close Encounters: Facing the Future
American University Museum, Katzen Arts
Center, Washington, D.C.

An Unruly History of the Readymade
Galería de Fundación / Colección JUMEX,
Mexico City

7th Gwangju Biennale—Annual Report:
A Year in Exhibitions
Gwangju

After Nature
New Museum, New York

Quiet Politics
Zwirner & Wirth, New York

16th Biennale of Sydney
Sydney

Perplexed in Public
Lisson Gallery, London

Lugares comunes: La experiencia
colectiva en el vídeo latinoamericano
Centro José Guerrero, Granada

Peripheral Vision and Collective Body
Museion / Museo d'Arte Moderna e
Contemporanea, Bolzano, Italy

Fluid Street—Alone, Together
Kiasma Museum of Contemporary Art,
Helsinki

Viva la muerte
Centro Atlántico de Arte Moderno,
Las Palmas de Gran Canaria, Spain

Las implicaciones de la imagen
(The Implications of Image)
Museo Universitario de Ciencias y Arte,
Mexico City

Field Work: Part 1
Smart Project Space, Amsterdam

Revolutions
University Art Gallery, University of California
San Diego, La Jolla

Italia, Italie, Italien, Italy, Wochy
ARCOS / Museo di Arte Contemporanea del
Sannio, Benevento

Open / Invited ev+a 2008: Too Early for
Vacation
ev+a, Limerick

Martian Museum of Terrestrial Art
Barbican, London

Greenwashing
Fondazione Sandretto Re Rebaudengo, Turin

Resonant Visions: Contemporary Video
from Latin America
National Gallery of Victoria, Melbourne

Eastern Standard: Western Artists in China
Mass MoCA / Massachusetts Museum of
Contemporary Art, North Adams

Collection Videos & Films:
Jean-Conrad & Isabelle Lemaitre
Kunsthalle der Christian-Albrechts-Universität
zu Kiel, Kiel, Germany

Into the Atomic Sunshine: Post-War Art
under Japanese Peace Constitution Article 9
The Puffin Room, New York

2007

IKF Latin American Art Auction 2007
Cisneros Fontanals Art Foundation, Miami

Résidents
Espace EDF Electra, Paris

Video Trajectories: Selections from the
Pamela and Richard Kramlich Collection
and the New Art Trust
MIT List Visual Arts Center, Cambridge,
Massachusetts

For Sale
Cristina Guerra Contemporary Art, Lisbon

9e Biennale de Lyon 2007: The History
of a Decade That Has Not Yet Been Named
Lyon

10th International Istanbul Biennial:
Not Only Necessary but Possible:
Optimism in the Age of Global War
Istanbul

Stigma: An Exhibition of the San Juan
Poly/Graphic Triennial in the
27th Ljubljana Biennial of Graphic Arts
Cankarjev Dom Gallery, Ljubljana

Rencontres d'Arles 2007
Rencontres Internationales de la
Photographie, Arles

Valencia Biennial
Valencia

6a Bienal do Mercosul: A Terceira
Margem do Rio
Bienal do Mercosul, Porto Alegre, Brazil

Infinite Island: Contemporary Caribbean Art
Brooklyn Museum of Art, Brooklyn

Atlas Americas
Oi Futuro, Rio de Janeiro

Otra de Vaqueros
Laboratorio Arte Alameda, Mexico City; Centre
d'Édition Contemporaine Genève, Geneva

9th Thessaloniki Documentary Festival
Thessaloniki

Hay algo de revolucionario en todo esto
Sala Parpallo, Valencia

Double sens
Galerie Commune, Tourcoing, France

A Global Multitude in the Rotunda
APC and Luxembourg 2007, Luxembourg

Beyond Green: Toward a Sustainable Art
Contemporary Arts Center, Cincinnati;
Smith College Museum of Art, Northampton,
Massachusetts

Beneath the Underdog
Gagosian Gallery, New York

Rozamira '07 Festival
Winzavod Art Center, Moscow

8th Sharjah Biennial—Still Life: Art,
Ecology, and the Politics of Change
Sharjah, UAE

Wspolczesnej
Centre for Contemporary Art Ujazdowski
Castle, Warsaw

Après la pluie
Musée Départemental d'Art Contemporain
de Rochechouart, Rochechouart

2nd Moscow Biennale of Contemporary Art
Moscow

Depiction, Perversion, Repulsion,
Obsession, Subversion
Witte de With Center for Contemporary Art,
Rotterdam

All About Laughter
Mori Art Museum, Tokyo

Critically Correct (2)
Givon Art Gallery, Tel Aviv

Cosmologies
James Cohan Gallery, New York

2006

1. Bienal de Canarias
Bienal de Canarias, Las Palmas de Gran
Canaria, Spain

Beyond Green: Toward a Sustainable Art
University Art Museum, Long Beach,
California

Une vision du monde: La collection vidéo
d'Isabelle et Jean-Conrad Lemaitre
La Maison Rouge, Paris

La force de l'art
Grand Palais, Paris

2ème festival photo et vidéo de Biarritz
Biarritz

Empathetic
Temple Gallery, Philadelphia

Group Therapy
Museion / Museo d'Arte Moderna e
Contemporanea, Bolzano, Italy

Artificial Light: New Light-Based
Sculpture and Installation Art
Virginia Museum of Fine Arts, Richmond;
Museum of Contemporary Art, North Miami

2nd ICP Triennial of Photography and
Video: Ecotopia
International Center of Photography, New York

Nam June Paik Award
Museum für angewandte Kunst, Cologne

Home of the Free
Hyde Park Art Center, Chicago

5th Busan Biennale—A Tale of Two Cities:
Busan-Seoul / Seoul-Busan
Busan Museum of Art, Busan

26th Biennal of Graphic Arts: Thrust
Ljubljana Biennial of Graphic Arts, Ljubljana

Territory
Artspeak, Presentation House, Vancouver,
British Columbia

299 792 458 m/s: La luz en el arte
contemporáneo a partir de una selección
de obras de la colección Berezdivin
Espacio 1414, Santurce, Puerto Rico

Report (Not Announcement)
BAK / Basis voor Actuele Kunst, Utrecht

Globalización: indicaciones / efectos
secundarios / advertencies
Espacio 1414, Santurce, Puerto Rico

Mafia (Or One Unopened Packet of
Cigarettes)
Standard (Oslo), Oslo

Wrong
Klosterfelde, Berlin

Other Than Art
Provisions Library, Washington, D.C.

International Documentary Festival
Amsterdam
Amsterdam

Whitney Biennial 2006: Day for Night
Whitney Museum of American Art, New York

Beyond the Museum
Hamburger Bahnhof Museum, Berlin

Estrecho dudoso
TEOR/éTica; Museo Histórico Cultural Juan
Santamaría; Museo de Formas Espacios
y Sonidos; Casa de Cultura Popular José
Figueres Ferrer del Banco Popular; Museo
de Arte Costarricense; Museo de Arte y
Diseño Contemporáneo; Museo Nacional de
Costa-Rica y Museo Histórico Rafael Angel
Calderón Guardia, San José, Costa Rica

3rd Bishkek International Exhibition of
Contemporary Art—Zone of Risk: Transition
Bishkek, Kyrgyz Republic

2005

2nd Guangzhou Triennial
Guangdong Museum of Art, Guangzhou

T1 Torino triennale tremusei:
The Pantagruel Syndrome
Castello di Rivoli Museo d'Arte
Contemporanea; Galleria Civica d'Arte
Moderna e Contemporanea di Torino; and
Fondazione Sandretto Re Rebaudengo, Turin

I Love Art Vidéo
Le Forum Itinérant, Musée d'Art Moderne et
Contemporain de Strasbourg, Strasbourg

Utopia Station
World Social Forum, São Paulo

No Convenient Subway Stops
Art in General, New York

E-flux Video Rental
KW Institute for Contemporary Art, Berlin;
Arthouse at the Jones Center, Austin, Texas;
Extra City — Center for Contemporary
Art, Antwerp; Centre Culturel Suisse,
Paris; Carpenter Center for the Visual
Arts, Harvard University, Cambridge,
Massachusetts; Centro de Arte Moderna,
Fundação Calouste Gulbenkian, Lisbon

*Material Time / Work Time / Life Time:
Reykjavik Arts Festival*
Reykjavik

The Gesture: A Visual Library in Progress
Macedonian Museum of Contemporary Art,
Thessaloniki

*Uncertain States of America: American
Art in the 3rd Millennium*
Astrup Fearnley Museet for Moderne Kunst,
Oslo; Bard College, Annandale-on-Hudson,
New York; Serpentine Gallery, London;
Galerie Rudolfinum, Prague; Centrum Sztuki
Współczesnej / Centre for Contemporary Art,
Warsaw; Herning Kunstmuseum, Herning,
Denmark

Beyond Green: Toward a Sustainable Art
Smart Museum of Art, University of Chicago,
Chicago

*8e Biennale de Lyon: Expérience de la
durée / Experiencing Duration*
Lyon

inSite_05
San Diego; Tijuana

*51st International Art Exhibition: Always
a Little Further*
Venice Biennale, Venice

Tropical Abstraction
Stedelijk Museum, Amsterdam

That from a Long Way Off Looks Like Flies
Platform Garanti Contemporary Art Center,
Istanbul

The Mind Is a Horse (Part 2)
Bloomberg Space, London

Land Marks
Galerie Chantal Crousel, Paris

Monuments for the USA
CCA Wattis Institute for Contemporary Arts,
San Francisco

*Dedicated to You, But You Weren't
Listening*
Power Plant, Toronto

Contemporaneo liquido
Franco Soffiantino Gallery, Turin

*1st Moscow Biennial of Contemporary Art:
Dialectics of Hope*
Moscow

Ninguna de las anteriores
Museo de Arte de Puerto Rico, Santurce

Poesia in Forma di Rosa: Tribute to Pasolini
Galleria Comunale d'Arte Contemporanea di
Montefalcone, Montefalcone, Italy

Loop 05: La 3ème
LOOP Video Art Festival, Barcelona

Drivin
Exposition Frac-Collection Aquitaine,
Bordeaux

Videografías In(Visibles)
Museo Patio Herreriano de Arte
Contemporáneo Español, Valladolid

*International Documentary Festival
Amsterdam*
Amsterdam

Les Visiteurs
Château d'Oiron, Oiron, France

Irreducible: Contemporary Short Form Video
CCA Wattis Institute for Contemporary Arts,
San Francisco; Miami Art Central, Miami;
Bronx Museum of the Arts, Bronx, New York

2004

Ralentir Vite
Le Plateau / FRAC Île-de-France, Paris

Situations construites, attitudes
Espace d'Art Contemporain, Geneva

PARA SITES: When Space Comes Into Play
Museum Moderner Kunst Stiftung Ludwig,
Vienna

*5th Gwangju Biennale 2004: A Grain of
Dust / A Drop of Water*
Gwangju

Trienal Poli/gráfica de San Juan
Instituto de Cultura de Puerto Rico, San Juan

Island Nations
Museum of Art, Rhode Island School of
Design, Providence

6th Dakar Biennial: Le Monde
Dakar

Son et lumière
MIT List Visual Arts Center, Cambridge,
Massachusetts

Ailleurs, Ici
Musée d'Art Moderne de la Ville de Paris /
ARC and Couvent des Cordeliers, Paris

2003

*Only Skin Deep: Changing Visions of the
American Self*
International Center of Photography, New York

Common Wealth
Tate Modern, London

Away from Home
Wexner Center for the Arts, Columbus

Institution2
Kiasma Museum of Contemporary
Art, Helsinki, in collaboration with the
Contemporary Art Centre, Vilnius

10e Biennale de l'image en mouvement
Centre pour l'Image Contemporaine, Geneva

24/7
Contemporary Art Centre, Vilnius

None of the Above
Real Art Ways, Hartford, Connecticut

*How Latitudes Become Forms:
Art in a Global Age*
Walker Art Center, Minneapolis; Fondazione
Sandretto Re Rebaudengo per l'Arte, Turin;
Contemporary Arts Museum Houston,
Houston; Museo de Arte Contemporáneo de
Monterrey, Monterrey, Mexico

2002

Interplay
The Moore Space, Miami

Fair
Royal College of Art, London

III Bienal Iberoamericana
Lima

Bird's Eye View
The Arch at Grand Army Plaza, New York

2001

Zoning
The Project, New York

2000

VII Bienal de la Habana
Havana

Distinctions
Center for Curatorial Studies, Bard College,
Annandale-on-Hudson, New York;
Berrie Center for the Arts, Ramapo College,
Mahwah, New Jersey

1999

1999
P.S.1 Contemporary Art Center, New York

1998

XXIV Bienal de São Paulo
São Paulo

BIBLIOGRAPHY

SOLO EXHIBITION CATALOGUES AND PUBLICATIONS

2009

Allora, Jennifer, and Guillermo Calzadilla. *Allora & Calzadilla: Compass.* Berlin: Temporäre Kunsthalle Berlin, 2009.

Allora, Jennifer, and Guillermo Calzadilla. *Allora & Calzadilla & Etcetera.* Cologne: Verlag der Buchhandlung Walther König, 2009.

Allora, Jennifer, and Guillermo Calzadilla. *Guantanamo Bay Song Book.* Kitakyushu: Center for Contemporary Art, 2009.

Klerck Gange, Eva, and Hou Hanru. *Allora & Calzadilla.* Oslo: Nasjonalmuseet for Kunst, Arkitektur og Design, 2009.

Martin, Sylvia, ed. *Allora & Calzadilla: A Man Screaming Is Not a Dancing Bear, How to Appear Invisible.* Krefeld: Kunstmuseen Krefeld, Museum Haus Esters, 2009.

Ruf, Beatrix, ed. *Allora & Calzadilla.* Zurich: JRP Ringier, 2009.

2008

Lorz, Julienne, ed. *Allora & Calzadilla: Stop, Repair, Prepare: Variations on "Ode to Joy" for a Prepared Piano.* Cologne: Verlag der Buchhandlung Walther König, 2008.

2006

Allora, Jennifer, and Guillermo Calzadilla. *Land Mark.* Paris: Palais de Tokyo, 2006.

2005

Hernández Chong-Cuy, Sofía, ed. *Puerto Rican Light: Allora & Calzadilla.* New York: Americas Society, 2005

2004

Mckee, Yates. *Common Sense?* Boston: Institute of Contemporary Art, 2004.

GROUP EXHIBITION CATALOGUES AND PUBLICATIONS

2011

Adler, Phoebe. *Contemporary Art in North America.* London: Black Dog Publishing, 2011.

Alonzo, Pedro, and Alain Bieber, eds. *Political Art.* Berlin: Gestalten, 2011.

Bishop, Claire. *Artificial Hells: Participatory Art and the Politics of Spectatorship.* London: Verso, 2011.

Hoptman, Laura, Yilmaz Dziewior, and Uta Grosenick, eds. *The Art of Tomorrow.* Berlin: Distanz, 2011.

Slavick, Susanne. *Out of Rubble.* New York: Edizioni CHARTA, 2011.

Smith, Terry. *Contemporary World Art.* London: Laurence King Publishing and Pearson Prentice Hall, 2011.

2010

Baum, Kelly, Yates McKee, Uriel Abulof, Rachel DeLue, and Jonathan Levy. *Nobody's Property: Art, Land, Space, 2000–2010.* Princeton: Princeton University Art Museum, 2010.

Farias, Agnaldo, and Moacir dos Anjos. *29th Bienal de São Paulo: Há sempre um copo de mar para um homem navegar / There Is Always a Cup of Sea to Sail In.* São Paulo: Fundação Bienal de São Paulo, 2010.

Jacobson, Heidi Zuckerman, Christian Rattemeyer, and Matthew Thompson. *Restless Empathy.* Aspen: Aspen Art Press, 2010.

Reckitt, Helena. *Adaptation: Between Species.* Toronto: Power Plant, 2010.

2009

Bacot, Yolande, ed. *Kréyol Factory.* Paris: Éditions Gallimard, 2009.

Cajasol. *Tragicomedia.* Cádiz: Cajasol, 2009.

Kvaran, Gunnar B., Hanne Beate Ueland, and Grete Aabu, eds. *Rotating Views #1: Astrup Fearnley Collection / Rotasjoner #1: Astrup Fearnley Samlinen.* Oslo: Astrup Fearnley Museet for Moderne Kunst, 2009.

Phaidon Press. *Vitamin 3-D: New Perspectives in Sculpture and Installation.* London: Phaidon Press, 2009.

2008

Christov-Bakargiev, Carolyn. *Revolutions—Forms That Turn: Biennale of Sydney.* London: Thames and Hudson, 2008.

Del Vecchio, Gigiotto, Alessandro Rabottini, Elena Lydia Scipioni, and Andrea Viliani. *Italia, Italie, Italien, Italy, Wochy.* Milan: Electa, 2008.

Fondazione Sandretto Re Rebaudengo. *Greenwashing—Environment: Perils, Promises, and Perplexities.* Turin: Bookmakers Edition, 2008.

Holzwarth, Hans Werner. *Art Now 3.* Cologne and Los Angeles: Taschen, 2008.

Luckow, Dirk, and Gunda Luyken, eds. *Collection Videos & Films: Jean-Conrad & Isabelle Lemaitre.* Cologne: Verlag der Buchhandlung Walther König, 2008.

Manacorda, Francesco, Lydia Yee, and Corinna Gardener. *Martian Museum of Terrestrial Art.* London: Barbican Art Gallery; New York: Merrel, 2008.

Museo Universitario de Ciencias y Arte. *Las implicaciones de la imagen.* Mexico City: Museo Universitario de Ciencias y Arte, 2008.

Tappola, Taru, ed. *Fluid Street.* Helsinki: Kiasma Museum of Contemporary Art, 2008.

Whitney Museum of American Art. *Independent Study Program, 40 Years: Whitney Museum of American Art, 1968–2008.* New York: Whitney Museum of American Art, 2008.

2007

Enwezor, Okwui, Ralph Rugoff, Michel Houellebecq, and Paul Veyne, eds. *The History of a Decade That Has Not Yet Been Named: Lyon Biennial 2007.* Zurich: JRP-Ringier, 2007.

Feher, Michel, ed. *NonGovernmental Politics.* New York: Zone Books, 2007.

Gisborne, Mark. *Double ACT: Two Artists, One Expression.* Munich: Prestel Verlag, 2007.

Ice Cream: Contemporary Art in Culture. Curated by Sergio Edelsztein, Jens Hoffmann, Lisette Lagnado, Midori Matsui, Shamim Momin, Pi Li, Gloria Sutton, Olesya Turkina, Philippe Vergne, and the Wrong Gallery. London: Phaidon Press, 2007.

Sollins, Marybeth, and Wesley Miller, eds. *Art21: Art in the Twenty-First Century.* New York: Harry N. Abrams, 2007.

10th International Istanbul Biennial. Istanbul: Kültür Sanat Vakfi, 2007.

2006

Bistolfi, Marina, and Pietro Gagliano, eds. *The Gesture: A Visual Library in Progress—A Project by Marina Fokidis, Sergio Risaliti, Daphne Vitali.* Florence: Fondazione Fabbrica Europa, 2006.

Choi, Binna. *Report (Not Announcement).* Frankfurt: Revolver / Archiv für Aktuelle Kunst, and BAK / Basis voor Actuele Kunst, 2006.

Isles, Chrissie, and Philippe Vergne. *Whitney Biennial 2006: Day for Night.* New York: Whitney Museum of American Art, 2006.

Mead Earl, Edward, and Brian Wallis. *Ecotopia: The Second ICP Triennial of Photography and Video.* Göttingen: Steidl, 2006.

Obrist, Hans-Ulrich. *Dontstopdontstopdontstopdontstop.* Berlin: Sternberg Press, 2006.

Ravenal, John B., Paula Feldman, and Kathleen Forde. *Artificial Light: New Light-Based Sculpture and Installation Art.* Richmond: University of Virginia Press, 2006.

Sánchez, Osvaldo, and Donna Conwell, eds. *inSite_05: Art Practices in the Public Domain, San Diego–Tijuana.* San Diego: Installation Gallery, 2006.

Shohat, Ella. *Taboo Memories, Diasporic Voices.* Raleigh: Duke University Press, 2006.

Solomon R. Guggenheim Museum. *Hugo Boss Prize 2006.* New York: Solomon R. Guggenheim Foundation, 2006.

Van Assche, Christine, Mark Nash, and Chantal Pontbriand. *Une vision du monde: La collection vidéo d'Isabelle et Jean-Conrad Lemaitre.* Paris: Fage and La Maison Rouge, 2006.

2005

Bonami, Francesco, and Carolyn Christov-Bakargiev, eds. *The Pantagruel Syndrome: T1 Torino triennale tremusei.* Milan: Skira, 2005.

Bourriaud, Nicolas, and Jérôme Sans, eds. *Experiencing Duration: Lyon Biennial 2005.* Paris: Paris Musées, 2005.

De Corral, Maria, and Rosa Martinez, eds. *La Biennale di Venezia: 51st International Art Exhibition.* New York: Rizzoli International Publications, 2005.

Kvaran, Gunnar B. *Uncertain States of America: American Art in the 3rd Millennium.* Oslo: Astrup Fearnley Museet for Moderne Kunst, 2005.

Mariátegui, José-Carlos, and Jorge Villacorta, eds. *Videografías In(Visibles).* Valladolid, Spain: Museo Patio Herreriano de Arte Contemporáneo Español, 2005.

Molok, Nikolai, ed. *1st Moscow Biennial of Contemporary Art: Dialectics of Hope.* Moscow: Artchronika, 2005.

Morgan, Jessica, Björn Roth, and Dieter Roth. *Material Time / Work Time / Life Time.* Frankfurt am Main: Revolver, 2005.

Obrist, Hans-Ulrich. *Do It.* Frankfurt am Main: Revolver Verlag, 2005.

Rugoff, Ralph. *Monuments for the USA.* San Francisco: CCA Wattis Institute for Contemporary Art, 2005.

Smith, Stephanie, and Victor Margolin, eds. *Beyond Green: Toward a Sustainable Art.* Chicago: University of Chicago Press, 2005.

2004

CCA Wattis Institute for Contemporary Art. *Irreducible: Contemporary Short Form Video.* Introduction by Ralph Rugoff. San Francisco: CCA Wattis Institute for Contemporary Art, 2004.

5th Gwangju Biennale. *2004 Gwangju Biennale: A Grain of Dust / A Drop of Water.* Gwangju: Gwangju Biennale Foundation, 2004.

Obrist, Hans-Ulrich. *Ailleurs, Ici.* Paris: ARC / Musée d'Art Moderne de la Ville de Paris, 2004.

2003

Fusco, Coco, and Brian Wallis, eds. *Only Skin Deep: Changing Visions of the American Self.* New York: International Center of Photography in association with Harry N. Abrams, 2003.

García-Juez, Miguel Angel, ed. *Art to Come.* Madrid: Fundació Rafael Tous d'Art Contemporani, 2003.

Massie, Annetta. *Away from Home.* Columbus: Wexner Center for the Arts and Ohio State University Press, 2003.

Morgan, Jessica, ed. *Common Wealth.* London: Tate, 2003.

Vergne, Philippe, et al. *How Latitudes Become Forms: Art in A Global Age.* Minneapolis: Walker Art Center, 2003.

2002

Centro de Artes Visuales de la Municipalidad Metropolitana de Lima. *III Bienal Iberoamericana de Lima.* Lima: Municipalidad Metropolitana de Lima, 2002.

2000

VII Bienal de la Habana. Havana: Centro de Arte Contemporáneo Wifredo Lam, Consejo Nacional de Artes Plásticas, 2000.

1998

Herkenhoff, Paulo, and Adriano Pedrosa, eds. *XXIV Bienal de São Paulo.* São Paulo: Fundação Bienal de São Paulo, 1998.

SELECTED ARTICLES

2011

Jauregui, Gabriela. "Mexico City Report." *Frieze*, no. 136 (January–February 2011).

Smith, Roberta. "Hold That Obit; MoMA's Not Dead." *New York Times*, January 2, 2011.

Stefan Weiner, Andrew. "The Shapes I Remember from Maps." *X-TRA* 13, no. 2 (Winter 2011): 4–23.

2010

"Allora & Calzadilla @ Julia Stoschek Collection." www.eiskellerberg.tv/?p=2231 .

Davis, Ben. "Striking Political Notes: A Q & A with Performance Artists Duo Allora & Calzadilla." *Artinfo*, December 14, 2010.

Dellaia, Michaela. "Allora & Calzadilla." *Juliet*, no. 147 (April 2010): 77.

Everitt Howe, David. "Allora & Calzadilla's Embodied Instrument." *Art in America*, December 10, 2010, www. artinamericamagazine.com/news-opinion/ conversations/2010-12-10/allora-calzadilla-stop-repair-prepare.

Fernández, Homero. "Allora & Calzadilla." *Tomo*, December 8, 2010.

Garcia, Cornelia. "Allora & Calzadilla, Lisson Gallery." *Modern Painters*, Summer 2010, 17.

Gritz, Anna. "Julia Stoschek: Private Chronology." *Flash Art*, no. 274 (October 2010): 68–69.

Hasting, Rob. "The Battle of Trafalgar Square: Six Artists Vie for Fourth Plinth Spot." *The Independent*, July 20, 2010.

Hultkrans, Andrew. "Obscure Objects." *Artforum*, February 2010, 83.

Lockward, Alana. "Towards an Utopian Archeology." *Video Art World*, September 29, 2010.

McKee, Yates. "Wake, Vestige, Survival: Sustainability and the Politics of the Trace in Allora and Calzadilla's *Land Mark*." *October* 133 (Summer 2010): 20–48.

Smith, Roberta. "I Just Popped Out to Play Beethoven." *New York Times*, December 9, 2010.

Sutton, Benjamin. "Allora & Calzadilla's Eviscerated Piano Plays MoMA." *L Magazine*, December 8, 2010.

Yablonsky, Linda. "Two for One." *W Magazine*, November 2010, 61–64.

2009

"Allora & Calzadilla." *Monopol Magazin für Kunst und Leben*, no. 3 (March 2009).

Baier, Uta. "Stepptanz auf dem Zwischenboden." *Berliner Morgenpost*, July 11, 2009.

"Bones Beat: Allora & Calzadilla's *Stop, Repair, Prepare* at Gladstone Gallery." *VillageVoice.com*, February 5, 2009, http://blogs.villagevoice.com/music/ 2009/02/bones_beat_allo.php.

Cotter, Holland. "Art in Review: Allora & Calzadilla, *Stop, Repair, Prepare*." *New York Times*, January 30, 2009.

Currie, Nick. "Jennifer Allora & Guillermo Calzadilla." *The Wire*, September 2009, 73.

Droitcour, Brian. "Critics' Pick: Allora & Calzadilla." *Artforum.com*, January 2009, http://artforum.com/archive/id=21976.

Elles, Christoph. "Die Spuren der Verwüstung." *Westdeutsche Zeitung*, March 14, 2009.

Faguet, Michèle. "Allora & Calzadilla." *Artforum*, November 2009, 244.

Gohlke, Gerrit. "Allora & Calzadilla in der Temporären Kunsthalle Berlin. Die Zwischendecke als Zukunftsmodell." *Artnet*, July 11, 2009, www.artnet. de/magazine/reviews/gohlke/ gohlke07-11-09.asp.

Gondorf, Ulrike. "Prozesse der Zerstörung. Die Performance-Künstler Allora & Calzadilla stellen in Krefeld aus." *dradio. de*, March 15, 2009.

Khadivi, Jesi. "Like a Specter." *Arslant*, August 10, 2009, www.artslant.com/ber/ articles/show/9232.

Kuhn, Nicola. "Im Schlick der Geschichte. Blinde Tänze, suchende Hunde: Das Künstlerpaar Allora & Calzadilla in der Temporären Kunsthalle Berlin." *Der Tagesspiegel*, July 11, 2009.

Mack, Joshua. "Allora & Calzadilla: Stop, Repair, Prepare." *Art Review*, April 2009, 84–86.

Mendiola, Mojo. "Die Kraft der Bildsymbole." *Rheinische Post*, March 14, 2009.

Motta, Carlos. "Allora & Calzadilla." *Bomb*, no. 109 (Fall 2009): 65–71.

Nicola, Paola. "The Office." *Abitare*, no. 491 (April 2009), 213–15.

Pezzei, Kristina. "Der letzte Auftritt." *Die Tageszeitung*, July, 11 2009.

Probst, Carsten. "Zwischen Zerstörung und Aufbruch. *Compass* in der Temporären Kunsthalle." *dradio.de*, July 10, 2009, www.dradio.de/dkultur/sendungen/ fazit/997538/.

Ruthe, Ingeborg. "Suchhund in der Ruine. In der blau-weißen Kunsthalle auf dem Schlossplatz spielt ein sonderbares Requiem auf den geschleiften Palast der Republik." *Berliner Zeitung*, August 7, 2009, 24.

Saltz, Jerry. "Top of the Ninth." *New York Magazine*, February 23, 2009.

Schambelan, Elizabeth. "Being There." *Artforum*, January 2009, 172–77.

Stange, Raimar. "Allora & Calzadilla." *Artist Kunstmagazin*, August 2009, 4–9.

——. "Allora & Calzadilla." *Kunst Bulletin*, September 2009, 50–51.

Straub, Verena. "Allora & Calzadilla in der Temporären Kunsthalle." *Art in Berlin*, July 13, 2009, www.art-in-berlin.de/incbmeld. php?id=1710.

Taylor, Kate. "Nothing Lasts Forever." *Manhattan: Modern Luxury*, May–June 2009.

Wahjudi, Claudia. "Ein feines Gespür. Das Künstlerpaar Allora & Calzadilla in der Temporären Kunsthalle." *Zitty Berlin*, August 12, 2009, 80.

Weiß, Matthias. "Allora & Calzadilla im Museum Haus Esters." *Kunstzeitung*, no. 153 (May 2009).

Wiley, Chris. "The Party Is Over: Allora & Calzadilla's Monstrous Art." *Kaleidoscope*, March–April 2009, 18–22.

Yablonsky, Linda. "You Had to Be There." *Art News* 108, no. 6 (June 2009): 70–75.

2008

"Allora & Calzadilla." *Prinz München*, June 1, 2008.

"Allora & Calzadilla: Künstlerpaar im Doppelpack." *Bayerischer Rundfunk Online*, June 13, 2008, www.br-online.de.

"Allora & Calzadilla: Stop, Repair, Prepare: Variations on "Ode to Joy" for a Prepared Piano." *Art Tattler International*, www.arttattler.com.

Bäumer, Dörthe. "Relaunch der Formate." *IN München*, June 12, 2008.

Borcherdt, Gesine. "Preview." *Monopol*, June 1, 2008.

Bos, Kim. "Rots." *Vrij Nederland*, no. 6 (February 9, 2008).

Charlesworth, J. J. "Shaping Politics." *Art Review*, January 2008, 70–73.

De Righi, Roberta. "Es schallt von Jericho nach Guantanamo." *Abendzeitung*, June 13, 2008.

De Ruiter, Marinus. "Allora & Calzadilla." *The Wire*, no. 295 (September 2008): 16.

——. "The Twisted Soundtracks of War." *Amsterdam Weekly*, February 7–13, 2008.

Dijksterhuis, Edo. "Tegengeluiden." *Het Financieele Dagblad*, February 16, 2008.

Goetz, Joachim. "Musik als Waffe." *Straubinger Tagblatt*, June 20, 2008.

——. "Musik als Waffe." *donaukurier.de*, June 27, 2008, www.donaukurier.de.

Goosen, Moosje. "Allora Calzadilla: Never Mind That Noise You Heard." *Stedelijk Museum Bulletin*, no. 1 (2008): 32–37.

Grenzmann, Teresa. "Grieg statt Krieg." *Münchner Merkur*, June 14, 2008.

Hoch, Jenny. "Spiel mir das Lied vom Krieg." *Spiegel Online*, June 14, 2008, www.spiegel.de.

Holmes, Pernilla. "Allora & Calzadilla." *Art News*, March 2008, 149.

Hornman, Judith. "Allora & Calzadilla zijn dol op toeters en bellen: Vragen stellen bij een zingend sculptuur." *Dagblad De Pers*, February 8, 2008.

Karcher, Eva. "Foltern mit Springsteen." *Sueddeutsche.de*, June 16, 2008, www.sueddeutsche.de.

——. "Krieg und Lieder." *Süddeutsche Zeitung*, June 14, 2008.

Keijer, Kees. "Allora en Calzadilla in Stedelijk Museum CS." *De Witte Raaf*, no. 132 (March–April 2008): 9.

——. "Saddam Hoesseins speech in operastijl." *Het Parool*, February 8, 2008.

McDonough, Tom. "Use What Sinks: Allora & Calzadilla." *Art in America*, January 2008, 82–86.

"Musik des Krieges und der Folter: Künstlerduo spielt sie." *klamm.de*, June 15, 2008, www.klamm.de.

Perrée, Rob. "Allora & Calzadilla in het Stedelijk Museum Amsterdam: Engagement in beeld en geluid." *Kunstbeeld*, no. 2 (2008): 26.

"Prima personale Olandese di Allora & Calzadilla." *Arte e Critica*, no. 54 (March–May 2008).

Sachs, Brita. "Die Hymnen des Feindes." *Frankfurter Allgemeine Zeitung*, June 16, 2008.

Scherf, Martina. "Freude schöner Götterfunken." *Süddeutsche Zeitung*, June 12, 2008.

Schütz, Heinz. "Allora & Calzadilla." *Kunstforum* 192 (July–August 2008): 346–47.

Smallenburg, Sandra. "Herriekunst stemt tot nadenken." *NRC Handelsblad*, February 27, 2008.

Smolik, Noemi. "Allora & Calzadilla: Haus der Kunst / Kunstverein." *Artforum*, October 2008, 397–98.

Sonna, Birgit. "Die Waffengewalt der Musik." *Art*, June 1, 2008.

Spijkerman, Sandra. "Inspelen op angst." *Trouw*, April 18, 2008.

Tegenbosch, Pietje. "Allora & Calzadilla: Bazuingeschal." *Museumtijdschrift*, no. 2 (March–April 2008).

Van de Velde, Paola. "Geluidssculpturen van Allora & Calzadilla in Stedelijk: De macht van de muziek." *De Telegraaf*, March 18, 2008.

"Variationen zur Ode, An die Freude." *Süddeutsche Zeitung*, June 11, 2008.

Verhagen, Marcus. "Slow Time." *Art Monthly*, July 2008, 9–12.

Vesters, Christel. "Allora & Calzadilla: Never Mind That Noise You Heard." *Metropolis M*, no. 3 (June 18, 2008).

2007

"Art & Market, Allora & Calzadilla." *Tema Celeste*, no. 121 (May–June 2007): 88.

Artner, Alan. "Intersection of Minimalism, Politics." *Chicago Tribune*, March 22, 2007.

Campell-Johnston, Rachel. "Clamor at the Serpentine Gallery." *(London) Times*, April 10, 2007.

Charlesworth, J. J. "Allora & Calzadilla: Power Plays." *Art Review*, no. 15 (October 2007): 82–85.

Cripps, Charlotte. "Military Songs Do Battle in the Art of War." *The Independent*, April 2, 2007.

Curiger, Bice. "The Prolific Pleasures of Paradox." *Parkett*, no. 80 (Fall 2007): 5.

Falguières, Patricia. "Archipelago." *Parkett*, no. 80 (Fall 2007): 30–35.

Feldman, Hannah. "Sound Tracks: The Art of Allora & Calzadilla." *Artforum*, May 2007, 336–41, 396.

"Hot Pick of the Week." *Chicago Weekly*, March 1, 2007.

Lopez, Ruth. "Smell the Coffee." *Time Out Chicago*, March 22–28, 2007.

McKee, Yates, and Jaleh Mansoor. "The Sediment of History: An Interview with Allora & Calzadilla." *Parkett*, no. 80 (Fall 2007): 42–48.

Myers, Terry. "Allora & Calzadilla." *Modern Painters*, March 2007, 95.

O'Reilly, Sally. "Trumpets & Turtles." *Frieze*, no. 108 (June–August 2007): 204–7.

Ruf, Beatrix. "Allora & Calzadilla." *Monopol Magazin für Kunst und Leben*, January 2007, 88.

Santacatterina, Stella. "Allora & Calzadilla: A Lateral Gaze on the Real." *Portfolio*, no. 45 (June 2007): 56–59.

Shapiro, Rose. "A Spring Reveille." *Chicago Weekly*, March 29, 2007.

Walker, Hamza. "Wake-Up Call." *Parkett*, no. 80 (Fall 2007): 56–62.

2006

"Allora & Calzadilla 'Questionnaire.'" *Frieze*, no. 96 (January–February 2006): 164.

Bauchère, Marion, and Charlotte Pudlowski. "Un Paris tropical et contemporain." *Le Figaro*, July 29, 2006.

Bonnet, Frédéric, Jennifer Allora, and Guillermo Calzadilla. *Le Journal des Arts*, no. 240 (June 23–July 6, 2006).

Burnham, Clint. "Territory." *C: International Contemporary Art* 91 (Autumn 2006): 47.

Champenois, Michèle. "Dans la jungle de l'art." *Le Monde 2*, June 3, 2006.

Cirauqui, Manuel. "Jennifer Allora & Guillermo Calzadilla: Reading the Territory." *LAPIZ*, no. 226 (October 2006): 48–57.

Hernández Chong Cuy, Sofía. "Allora & Calzadilla: Música Marcial." *Arte Al Dia*, no. 117 (December 2006).

——. "Interview: Allora & Calzadilla." *UOVO Magazine*, no. 12 (December 2006): 26–47.

Pecker, Julia. "Lieu d'art." *Parisart.com*, June 10, 2006.

Spiegler, Marc. "Allora & Calzadilla: Sonic Warfare." *Art Newspaper*, December 8, 2006.

Yabroff, Jennie. "This Land Is My Land: Capturing Humanity's Conflict with Nature." *Newsweek*, November 20, 2006.

2005

Allen, Jennifer. "Moscow's Sprawling Biennial." *Artforum: International News Digest*, February 7, 2005.

Baker, Kenneth. "Short Videos Can Pack Multiple Meanings into Little Time." *San Francisco Chronicle*, January 29, 2005.

Griffin, Tim. "Remote Possibilities: A Round Table Discussion on Land Art's Changing Terrain." *Artforum*, Summer 2005, 288.

Iles, Chrissie, Tirdad Zolghadr, and Ralph Rugoff. "Venice Biennial 2005." *Frieze*, no. 93 (September 2005): 98–101.

Jansen, Meike. "Diskursfreie Zone: Moskau feiert unter dem Motto 'Dialektik der Hoffnung' einen Monat lang seine erste Kunst-Biennale." *Die Tageszeitung*, February 5, 2005.

Karman Cubiña, Silvia. "Allora & Calzadilla's Floors." *Art Nexus*, no. 55 (January–March 2005): 74–77.

Kastner, Jeffrey. "Two for the Show." *Artforum*, May 2005, 141.

Manacorda, Francesco. "Entropology: Monuments to Closed Systems." *Flash Art*, no. 241 (March–April 2005): 76–79.

McKee, Yates. "Allora & Calzadilla: The Monstrous Dimension of Art." *Flash Art*, no. 240 (January–February 2005): 96–99.

Millot, Lorraine. "Toupet russe: Première Biennale d'art contemporain de Moscou." *Libération*, February 9, 2005.

Obrist, Hans-Ulrich. "1000 Words: Allora and Calzadilla Talk about Three Pieces in Vieques." *Artforum*, March 2005, 204–5.

2004

Breerette, Geneviève. "Exposition l'art contemporain 'Ailleurs' aux Cordeliers." *Le Monde*, February 14, 2004.

Dagen, Philippe. "L'oeil des caraïbes." *Le Monde*, April 17, 2004.

Dethridge, Anna. "The Control of Territory and Social Imagery." *Domus*, no. 868 (March 2004): 108–9.

Dusini, Matthias. "Para-Sites: When Space Comes into Play." *Springerin*, April 2004.

Ericson, Men Lars O. "Följ medi l Paris tidsmanskin." *Dagen*, January 31, 2004.

Feinstein, Roni. "Miami Beach in December: Cool Stuff." *Art in America*, December 2004, 33–34.

Fyfe, Joe. "Jennifer Allora and Guillermo Calzadilla at Chantal Crousel." *Art in America*, November 2004, 189–90.

Leibovic, Elisabeth. "Frissons au couvent." *Libération*, February 2, 2004.

Mascina, Audret. "Lima (Pérou): Pétite leçon d'expression libre." *Modzik*, no. 23 (March–April 2004).

Michelon, Olivier. "Lieu transitoire: Les Cordeliers en orbite." *Le Journal des Arts*, no. 186 (February 6, 2004).

"None of the Above." *Tema Celeste*, no. 104 (July–August 2004).

"Paris in Winter." *Art Monthly*, January–February 2004.

Ramonatxo, Ophélie. "Circonvolutions, une exposition cubano-américaine." *Mouvement*, April 15, 2004.

Schmelzer, Paul. "Insurgent Inquiry: The Art of Allora & Calzadilla." *Adbusters*, April 2004.

2003

Cotter, Holland. "In Uptown Galleries and Museums: Heat and Light Aplenty." *New York Times*, May 30, 2003.

Douglas, Kris. "How Latitudes Become Form: Art in a Global Age." *Tema Celeste*, no. 98 (Summer 2003).

Vasquez Zapata, Larissa. "Instalaciones de Luz Pura." *El Nuevo Dia*, July 12, 2003.

Wilson, Michael. "New York." *Contemporary*, no. 55 (2003).

2001

Leon, Dermis P. "Havana, Biennial, Tourism: The Spectacle of Utopia." *Art Journal*, no. 4 (Winter 2001): 68–73.

Sholette, Gregory. "Affirmation of the Curatorial Class." *Afterimage*, March–April 2001, 6–8.

Turner, Grady. "Cuba II: Sweet Dreams." *Art in America*, October 2001, 72–77.

2000

Ackley, Brian. "Reading Distinctions." *Bard Observer*, May 8, 2000.

1999

Leffingwell, Edward. "Cannibals All." *Art in America*, May 1999, 46–55.

1998

Benitez, Marimar. "Neurotic Imperatives, Contemporary Art from Puerto Rico." *Art Journal*, Winter 1998, 75–85.

Fonesco, Celso, and Luis Chagas. "A Bienal do Seculo." *Istoeé independente*, September 30, 1998.

Nascimento, Iolanda. "O Elogio de Bacon, Bienal de São Paulo." *Manchette*, October 1998.

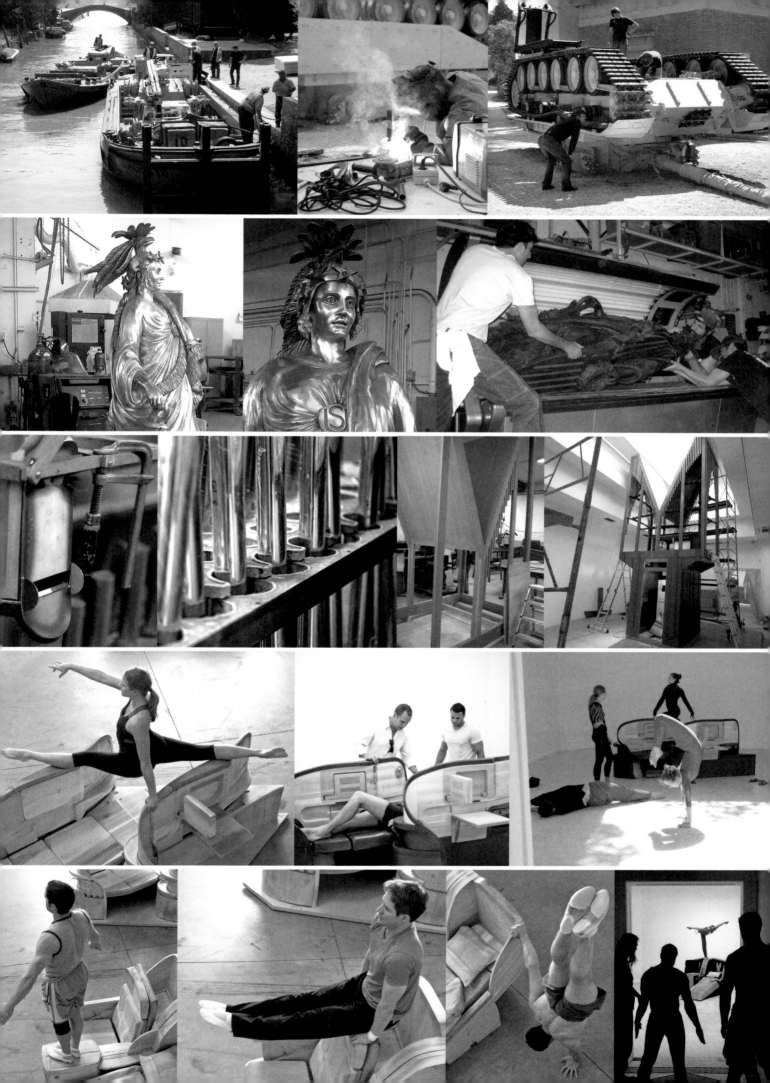

NOTES ON THE CONTRIBUTORS

Lisa D. Freiman is senior curator and chair of the Department of Contemporary Art at the Indianapolis Museum of Art. During her nine-year tenure at the IMA, Freiman has actively commissioned, collected, and researched emerging and established artists, effectively transforming the role of contemporary art in Indianapolis and creating a widely renowned contemporary art program. Freiman has published extensively on contemporary art, including the books *Amy Cutler*; *María Magdalena Campos-Pons: Everything Is Separated by Water*; and *Type A*. She is currently editing the first collection of Claes Oldenburg's writings from the 1960s, to be published in 2013. She is also preparing the first scholarly monograph on Claes Oldenburg, titled *Claes Oldenburg and the Sixties*.

Carrie Lambert-Beatty is an art historian at Harvard University and the author of *Being Watched: Yvonne Rainer and the 1960s*. Her writing on performance, political art, minimalism, and other topics has appeared in magazines such as *Artforum* and *Art Journal*. She also publishes in *October*, of which she has been a coeditor since 2008. Lambert-Beatty is writing a book about deception in political and performance art.

Yates McKee is an instructor of contemporary civilization and a PhD candidate in art history at Columbia University. He has taught contemporary art history at Parsons, Cooper Union, and Ohio University, and his writing has appeared in *October*, *Grey Room*, *Artforum*, *Art Journal*, *Oxford Art Journal*, *Texte zur Kunst*, and the *Journal of Aesthetics and Protest*.

REPRODUCTION AND PHOTOGRAPHY CREDITS

Courtesy of the artists:
pp. 24 (top left), 44 (top), 46 (top and bottom)

Courtesy of the artists and Galerie Chantal Crousel, Paris:
pp. 38 (left), 125–36

Courtesy of the artists and Gladstone Gallery, New York:
pp. 30 (left), 34 (bottom), 36, 40, 44 (bottom), 68 (top and bottom), 97–99, 101–3, 111–23

Courtesy of the artists and Lisson Gallery, London:
pp. 18, 91–95

Courtesy of the artists and Lisson Gallery, London; Gladstone Gallery, New York; Galerie Chantal Crousel, Paris; Kurimanzutto Gallery, Mexico City:
pp. 64, 82–83, 105–9

Courtesy of Barnacle Bros. Sculpture & Custom Fabrication, Inc.:
pp. 148–49 (second row; fourth row, frames 1 and 2; fifth row, frame 1)

Photo by Andrew Bordwin, © Andrew Bordwin:
pp. 18, 30 (left), 38 (left), 40, 44 (bottom), 91–136, 138, 148–49 (top row, frame 5; fourth row, frames 3 and 4; fifth row, frames 2–6)

Courtesy of the Architect of the Capitol:
p. 30 (top right and cropped image bottom right)

Photo by Will Collin:
p. 2

Photo by Nick D'Emilio:
pp. 148–49 (fourth row, frames 5 and 6; fifth row, frame 7)

Courtesy of Galleria Borghese, Rome; photo: Scala/Ministero per i Beni e le Attività culturali/Art Resource, NY:
p. 32 (right)

Photo by David Heald, © The Solomon R. Guggenheim Foundation, New York; © 2011 Artists Rights Society (ARS), New York/ADAGP, Paris:
p. 38 (right)

Photo by Kandido/Grappa Studio:
pp. 148–49 (top row, frames 3 and 4)

Photo by Archive Klais:
pp. 148–49 (third row)

Photo by Peter Moore, © Estate of Peter Moore/VAGA, New York, NY:
p. 56

Digital Image © The Museum of Modern Art/Licensed by SCALA/Art Resource, NY; © 2011 Artists Rights Society (ARS), New York/ProLitteris, Zürich:
p. 22

Digital Image © The Museum of Modern Art/Licensed by SCALA/Art Resource, NY; © 2011 Richard Serra/Artists Rights Society (ARS), New York:
p. 76 (top)

Courtesy of the Oldenburg van Bruggen Studio, photo by Attilio Maranzano, © 1969 Claes Oldenburg:
p. 24 (right)

Courtesy of the Dennis Oppenheim Estate:
p. 76 (bottom)

RF2107 Photo by Franck Raux. Réunion des Musées Nationaux/Art Resource, NY:
p. 32 (left)

Photo by David Regen, © Jennifer Allora and Guillermo Calzadilla and Gladstone Gallery. Courtesy of Gladstone Gallery, New York:
p. 52 (top)

Photo by Daniele Resini:
pp. 148–49 (top row, frame 6)

Courtesy of Martha Rosler and Mitchell-Innes and Nash, New York:
p. 28 (top)

© Estate of Robert Smithson /Licensed by VAGA, New York, NY. Images courtesy of James Cohan Gallery, New York/Shanghai:
p. 72 (all)

Courtesy of the Smithsonian National Postal Museum:
p. 34 (top right)

Photo by Andrea Soffientino/ Grappa Studio:
pp. 148–49 (top row, frames 1 and 2)

Photo by Kathleen Stocker:
cover

Courtesy of the United States Air Force website:
p. 52 (bottom)

Courtesy of the United States Army; photo by Maureen Rose:
p. 24 (bottom left)

Courtesy of the United States Marine Corps official Flickr site:
p. 28 (bottom)

Photos by Michael Zabé, © Jennifer Allora and Guillermo Calzadilla, Kurimanzutto. Courtesy of Gladstone Gallery, New York, and Kurimanzutto, Mexico City:
p. 58 (top and bottom)

Gloria: Allora & Calzadilla, the official United States entry in the 54th International Art Exhibition—La Biennale di Venezia, was organized by the Indianapolis Museum of Art and is presented by the Bureau of Educational and Cultural Affairs of the U.S. Department of State, which supports the official United States participation at selected international exhibitions.

U.S. Pavilion at the Giardini della Biennale, Venice
June 4 – November 27, 2011

Lead supporters of the U.S. Pavilion at the 54th International Art Exhibition—La Biennale di Venezia are the U.S. Department of State, Bureau of Educational and Cultural Affairs, and Hugo Boss.

HUGO BOSS

The Pavilion is also made possible through the generous support of the following: Diana and Moisés Berezdivin, Ignacio J. López and Laura Guerra, Donald R. Mullen Jr., Christina and Carlos Trápaga, Café Yaucono, Christie Digital Systems USA, Inc., and Diebold.

This publication was funded in part by a grant from the U.S. Department of State. The opinions, findings, and conclusions stated herein are those of the authors and do not necessarily reflect those of the U.S. Department of State.

For more information on the exhibition, see www.imamuseum.org\venice.

Published in 2011 by the Indianapolis Museum of Art and DelMonico Books, an imprint of Prestel Publishing.

Prestel, a member of Verlagsgruppe Random House GmbH

Prestel Verlag
Neumarkter Strasse 28, 81673 Munich, Germany
Tel: 49 89 41 36 0 Fax: 49 89 41 36 23 35

Prestel Publishing Ltd.
4 Bloomsbury Place, London WC1A 2QA, United Kingdom
Tel: 44 20 7323 5004 Fax: 44 20 7636 8004

Prestel Publishing
900 Broadway, Suite 603, New York, NY 10003
Tel: 212 995 2720 Fax: 212 995 2733
E-mail: sales@prestel-usa.com
www.prestel.com

Library of Congress Cataloging-in-Publication Data

Freiman, Lisa D.

Gloria : Allora & Calzadilla / Lisa D. Freiman ; essays by Lisa D. Freiman, Carrie Lambert-Beatty, and Yates McKee.

p. cm.

Official United States entry in the 54th International Art Exhibition of La Biennale di Venezia, organized by the Indianapolis Museum of Art and presented at the U.S. Pavilion at the Giardini della Biennale, Venice, Italy, June 4 – Nov. 27, 2011.

ISBN 978-3-7913-5137-7

1. Allora, Jennifer, 1974—Exhibitions. 2. Calzadilla, Guillermo, 1971—Exhibitions. I. Lambert-Beatty, Carrie. II. McKee, Yates. III. Indianapolis Museum of Art. IV. Biennale di Venezia (54th : 2011) V. Title.

N6537.A463A4 2011

709.2'2-dc23

2011019661

CURATORIAL ASSISTANT Amanda York
DESIGN Abbott Miller and Kimberly Walker, Pentagram
PRINCIPAL PHOTOGRAPHER Andrew Bordwin
PHOTO EDITOR Tascha Horowitz
EDITOR Michelle Piranio
PROOFREADER Ryan Newbanks
PRINTING AND BINDING Conti Tipocolor

Printed and bound in Italy